# THE HOUSE & GARDEN BOOK OF
# BEDROOMS
## AND BATHROOMS

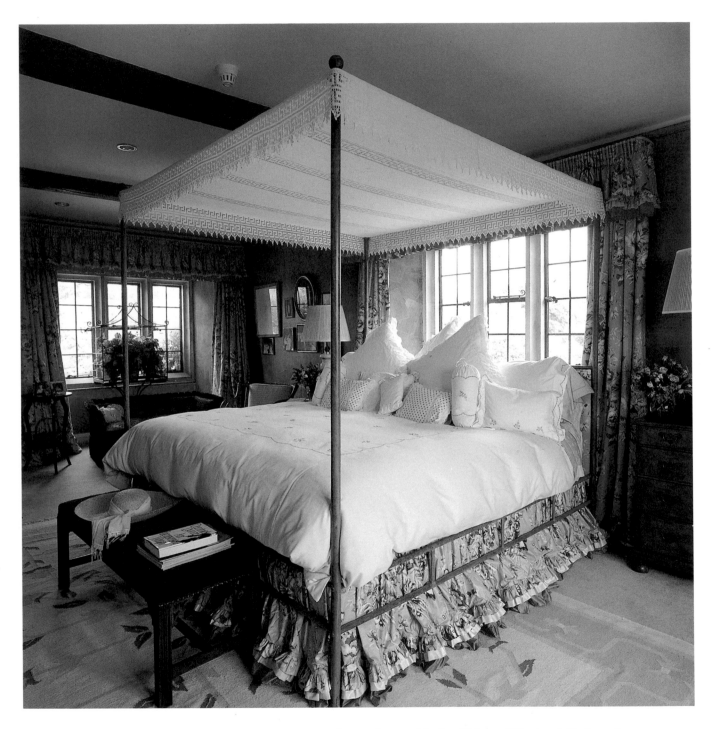

*In this romantic bedroom in a Cotswolds manor-house, decorated by Ian Walton of Woodstock Designs, the modern four-poster is canopied with antique lace. As the room has limited areas of solid wall, the bed is placed in front of a window where it also takes maximum advantage of the splendid views.*

# THE HOUSE & GARDEN BOOK OF
# BEDROOMS
## AND BATHROOMS

LEONIE HIGHTON

THE VENDOME PRESS
NEW YORK

Graphic Design: Alison Shackleton
Printing and Binding: Tien Wah Press Ltd, Singapore

First published in the USA by The Vendome Press
1370 Avenue of the Americas
New York, NY 10019

Distributed in the USA and Canada by Rizzoli International Publications
through St. Martin's Press, 175 Fifth Avenue
New York, NY 10010

Library of Congress Cataloging-in-Publication Data
Highton, Leonie
House & garden book of bedrooms / by Leonie Highton.
p. cm.
ISBN 0-86565-961-3 (hard cover)
1. Bedrooms. 2. Interior Decoration I. House & garden.
II. Title
NK2117.B4H54 1995

747.7'7--dc20 95-15365
CIP

# Contents

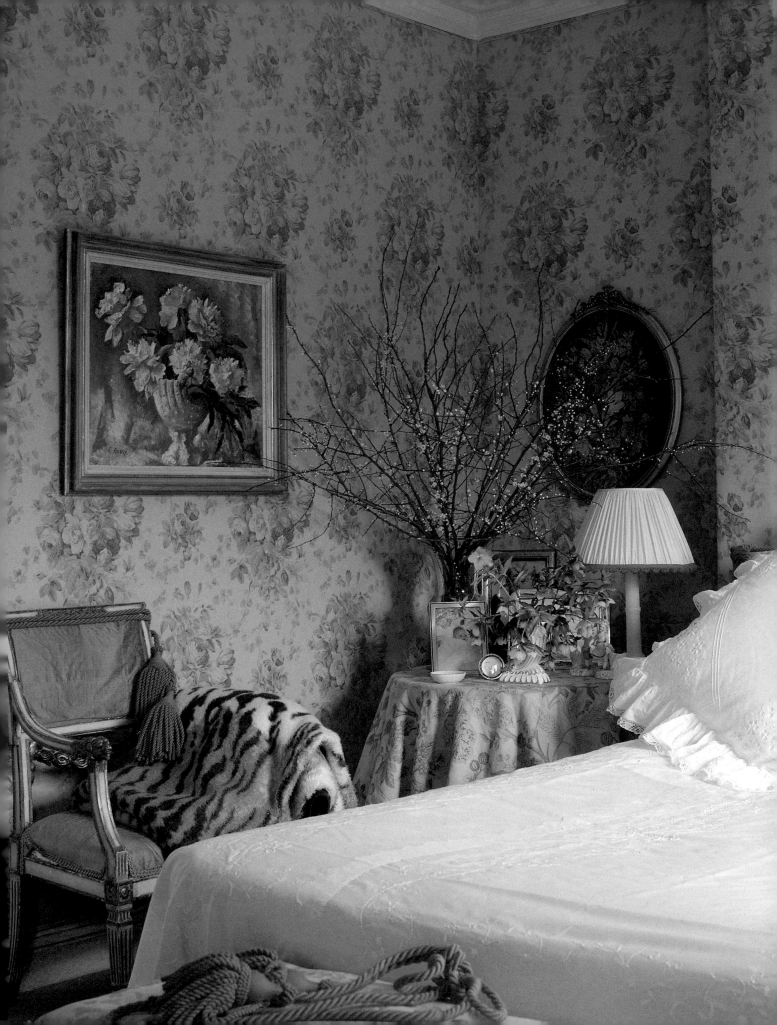

# Introduction

If bedrooms served no other purpose than a place in which to sleep, they would be the simplest of rooms to design and decorate. After all, in sleep we are unaware of our surroundings, so they should be of little importance. But is that really the case? Isn't it true that in those few moments after we turn off the lights, as we float between being awake and asleep, we are aware, almost subliminally, of the last glimpses of our whereabouts? And in the mornings, when we first open our eyes, don't we have an immediate, almost intuitive perception of the room we are in? If those late-night images and early impressions are pleasing and reassuring, might they not enhance the quality of the whole of our waking lives?

If that sounds far-fetched and fanciful, what is surely not mere whimsy is that, for most people, the bedroom is much more than a room for rest and sleep – it is a very active place. Most of us use our bedrooms as places in which to keep our clothes, brush our hair, listen to the radio, maybe watch television, sometimes eat, often read and, of course, indulge in that other important activity which few people refer to when talking about decorating their bedrooms: romance. Intimacy is inseparable from the adult concept and aura of bedrooms but I only know of one interior designer with a client who was teasingly frank about it. She suggested that all the surfaces in her bedroom - walls, ceiling, cupboard fronts, blinds and, especially, doors – should be covered in the same all-over-patterned chintz. The idea, you see, was that once she got the man of her choice in there, and had closed the door behind him, she didn't want him to be able to find the way out.

Well, maybe that's not most people's objective when decorating a bedroom, but there's no doubt that the bedroom is the most personal of all rooms in a home, and its decoration and contents are something of a give-away of our inner selves and our way of life. The books we keep in the bedroom include the sort of trivia we may not be too happy to leave around for public observation in the drawing-room, and the style of furnishing often tends to be more sentimental than we would indulge in elsewhere. In our bedrooms we can, or should, feel totally at ease and free to decorate exactly as we wish. We can surround ourselves with family photographs, frills, flounces and flowers, and not worry a jot about the world outside.

Amidst all these personal trifles, however, there should also be practicality. Indolence and habit often lead us to accept in our homes the sort of poor design we would complain loudly about in hotels. Behind our own front doors we get used to things as they are and put up with discomfort year after year, but a single night in a strange bedroom sharpens our critical faculties no end and makes us think seriously about design. This is especially true in hotels, where we expect everything to be of a high standard, both practically and aesthetically. The best of the smaller, individually-designed, country-house hotels usually score highest here, having resolved the twin demands of functionalism

*(Opposite) Exuding a real sense of comfort, this room combines a variety of traditional elements in a contemporary manner. A beautifully faded-looking linen is used on the walls; mementos are clustered on the table; the bed has a pristine white cover; and there is a pleasingly unpredictable touch in the twiggy arrangement in the vase. It is a very personal room – exactly what a bedroom should be.*

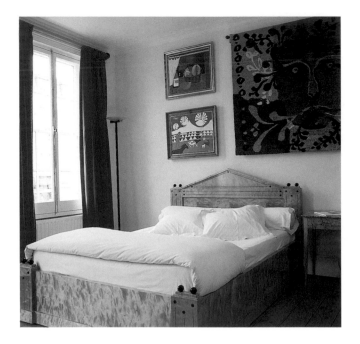

*Based on the nineteenth-century continental Biedermeier style, this bed was specially designed by Rupert Cavendish and looks particularly well in a town-house setting with modern paintings by Mary Fedden and a tapestry by John Piper.*

and – what most people prefer – a fairly traditional style of decoration. Interestingly, nearly all of them now provide that *sine qua non* of country-house bedroom luxe – a four-poster bed. The four-poster is a continuing draw, but whatever the design or appearance of a bed, the really important thing, at home or away, is that it should be exquisitely comfortable.

A minority of people will always be prepared to sacrifice comfort in the pursuit of a visual effect, but in the bedroom, of all places, that is a hard line to take. Comfort is more than a luxury in the bedroom; it is essential. And it has to be considered in tandem with all the different ways the room is used. There is no point having a bank of feather pillows or a relaxing armchair for reading if there is poor lighting, and a bathroom without masses of hot water and efficient heating is intolerable, however pretty the decoration. As in the best hotel bedrooms, every design scheme should take into account more-than-adequate cupboard and drawer space, first-rate lighting, and bedside tables of generous size and of the right height. And if the plan also allows for a television, a fridge or any other form of large, unattractive (albeit use-

ful) equipment, these things should be unobstrusive or artfully concealed – unless, that is, you are an out-and-out modernist who insists on everything expressing its role.

Although the benefits of modern technology are welcome in hotel bedrooms, we are often pretty old-fashioned (or snobbish?) about them in our own homes. How many people have a fridge in their bedrooms? Yet a cold drink during a hot summer night, or a cool orange juice within an arm's stretch of your bed when you wake up in the morning, could be extremely agreeable. All you need is a tiny fridge hidden in a cupboard -not expensive and much less effort than having to make the trek from bedroom to kitchen just when you're feeling at your least energetic. Anyone who lives in a town house, where life is conducted vertically on four or more floors, will understand this – but few do anything about it. Even televisions are comparatively rare in bedrooms, let alone high-tech lighting or built-in sound systems. Which is strange. We spend a great deal of our lives in our bedrooms, far longer than in our cars, yet we expect cars to have radios with such simple controls that we can operate them without even looking. We expect to be able to alter the rake (and even the height) of car seats, but we accept that beds are completely unalterable. You *can* buy beds with electronic controls – that raise the head end so you can sit up, or the foot end so you can, literally, sleep with your feet up – but such purchases are one in a million.

Although the bedrooms shown in this book are hardly in the forefront of technological innovation, that's not to say there is no sense of originality in their decoration. Many of the rooms illustrated are traditional in the broadest sense, simply because the bias of bedroom taste happens to be in that direction, but every scheme illustrated has interest and individuality.

Those rooms which are more contemporary in style tend to have a plainer, more tailored look – and they are usually in cities. Perhaps that is because cities attract younger people as well as the sort of older generations who prefer the chic, sharper quality of urban life. Or perhaps there is another factor here. Perhaps the severe appearance of most office blocks and street architecture

influences the interior design of urban homes.

For anyone interested in interior decoration, all this variety and the contrasts between town and country influences are a source of inspiration and pleasure. Occasionally, people see an illustration of a room in a book or magazine which they like so much that they want to recreate it down to the last detail. But, more frequently, people find ideas in lots of different sources, and they are very selective in putting them together in a scheme of their own creation. Over the years *House & Garden* magazine has been a photographic record of some of the world's most beautiful interiors but it has also been a great inspirer of rooms which have never been photographed, though they have given their owners untold pleasure. Inspiration and originality in interior decoration look to the future – of course – but they also draw on the past. Throughout this book, which shows some of the best bedrooms recently published in *House & Garden,* there are many historical resonances, not least in the chapter on four-poster beds. The four-poster no longer fulfils its original function of protecting its occupants from draughts and prying eyes, but its nostalgic, romantic image lingers, even in those modern examples which have only vestiges of curtains – if they have curtains at all. Here, the bare frame is a skeletal reminder of earlier times, and it seems curiously in keeping with today's more avant-garde metal furniture.

So many styles of decoration are fashionable nowadays that it would be impossible to cover them all, though certain trends are discernible throughout this book. They emerge in all the chapters, but the themes of the chapters should not be taken as definitive. In 'City Chic', for example, there are rooms which have more than the occasional element of country decoration, and in 'Away from it All', where the rooms are on remote islands or in alpine valleys, there are occasional suggestions of urban design. There are no rules, as they say, but there are masses of ideas.

One of the most extensive chapters is on bedrooms with bathrooms *en-suite*. Not so long ago, the bathroom was hardly thought about in terms of interior decoration. Providing it functioned well and looked clean, that was enough. Now, it has become a focus for good design, not just for the fit-

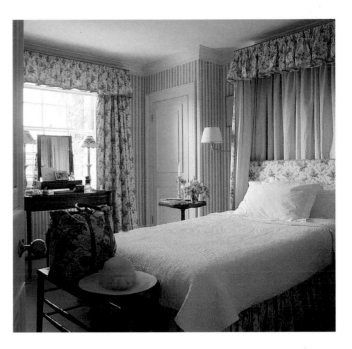

*Stripes and flowers make pretty partners in this refreshing scheme by Roger Banks-Pye of Colefax & Fowler. The room is in London but the decoration shows the influence and charm of the country-house look.*

ments but also for pretty wallpapers, elegant curtains and stylish paint finishes. To be truly *en-suite*, the bathroom and bedroom should relate to each other decoratively as well as logistically, and all the examples illustrated here do just that.

Finally, it's the detail that counts. At the very end of the book there are illustrations showing aspects of bedrooms which make all the difference to comfort and visual harmony. There are ideas for making cupboards look attractive, for different styles of headboards, bedside tables (though, strictly speaking, not all are tables) and dressing-tables.

In a book about interior decoration, words can help to direct the reader's eye to a particular element in an illustration but, ultimately, it's all about pictures. No text can ever be anything like as useful or as inspiring as an image. This, then, is essentially a picture-book – one which I hope will please and stimulate.

# THE EVER-PLEASING FOUR-POSTER

*No other design for a bed can match the four-poster for its air of grandeur and romance. Whether made of traditional carved oak or modern burnished metal, it is touched with nostalgia and fantasy, and it gives unparalleled scope for interior decoration.*

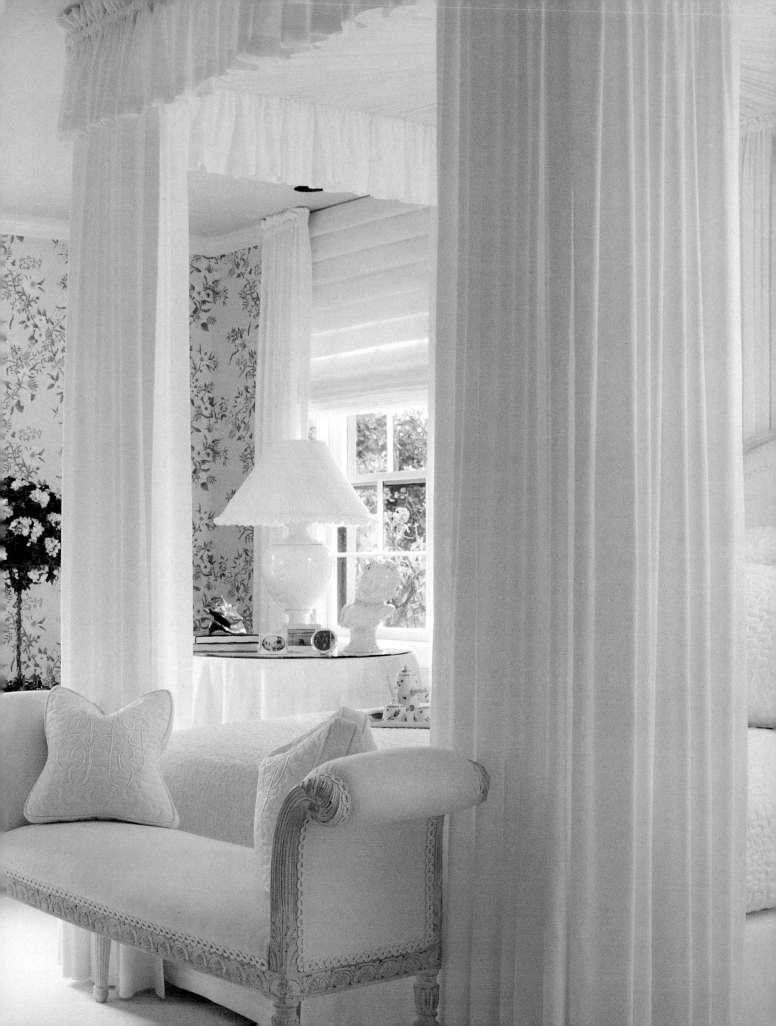

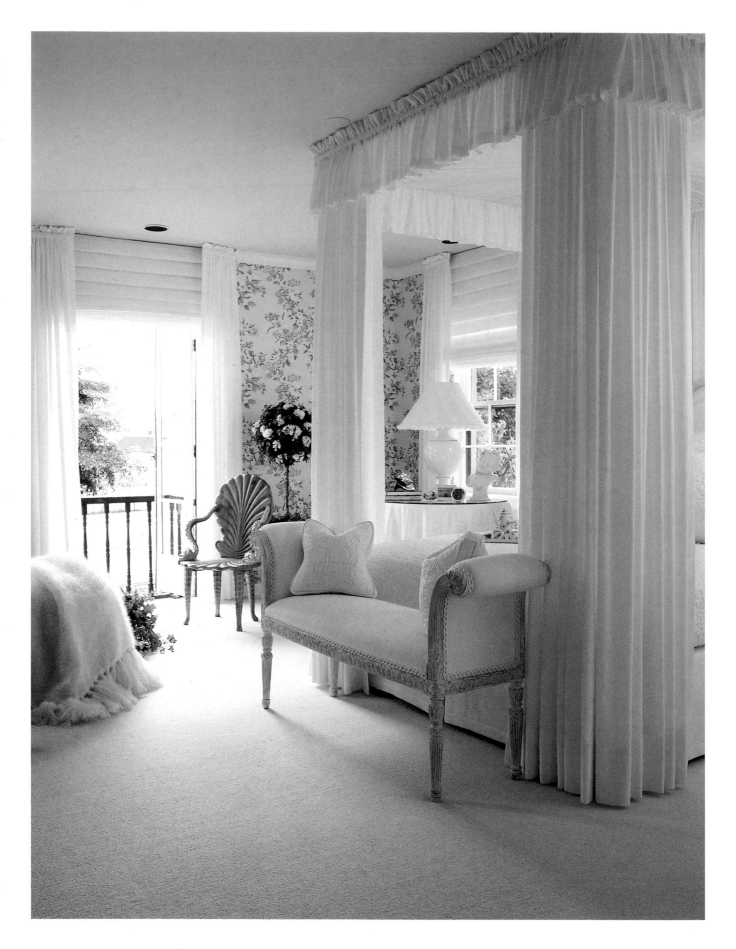

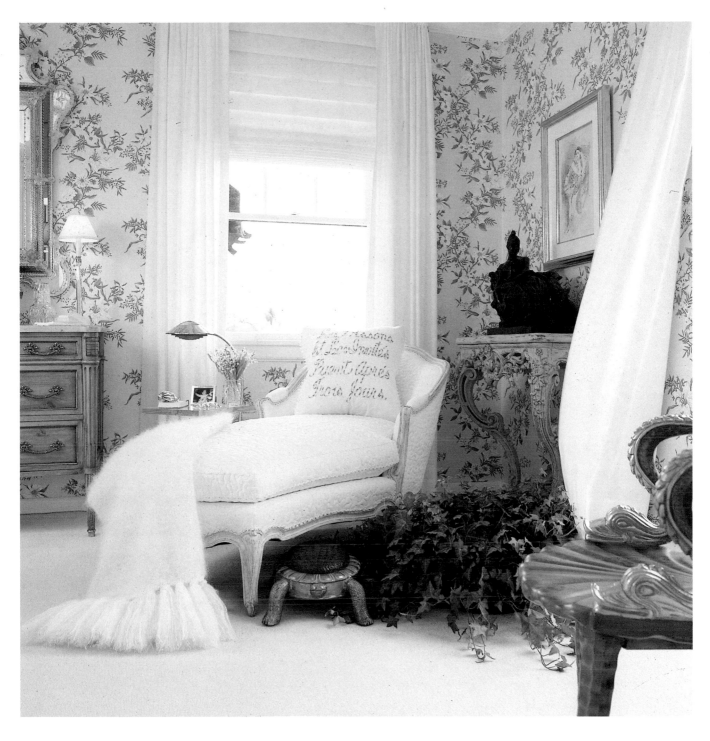

# Sleek and refined

When Benn Theodore was commissioned to redecorate this guest bedroom in a 1925 Spanish-style house in Palm Beach, he was inspired by the setting and its ambience which comprised lots of clean, white, tropical light with touches of green glimpsed through the terrace doors. 'The scheme then came together very easily,' he says, 'because I realised the treatment would be dictated simply by what was outside.' Aiming for a 'tropical feel that is very sleek and very refined',

he has used 260 metres of fine Swiss cotton which has been minutely quilted for the upholstery, bedding and cushions. The hangings enclosing the bed are suspended directly from the ceiling, giving the impression of a four-poster as well as forming a harmonizing alignment with the window curtains. The ivory-and-green colouring of the wallcovering was specially devised for the room and makes a natural union between interior and exterior vistas.

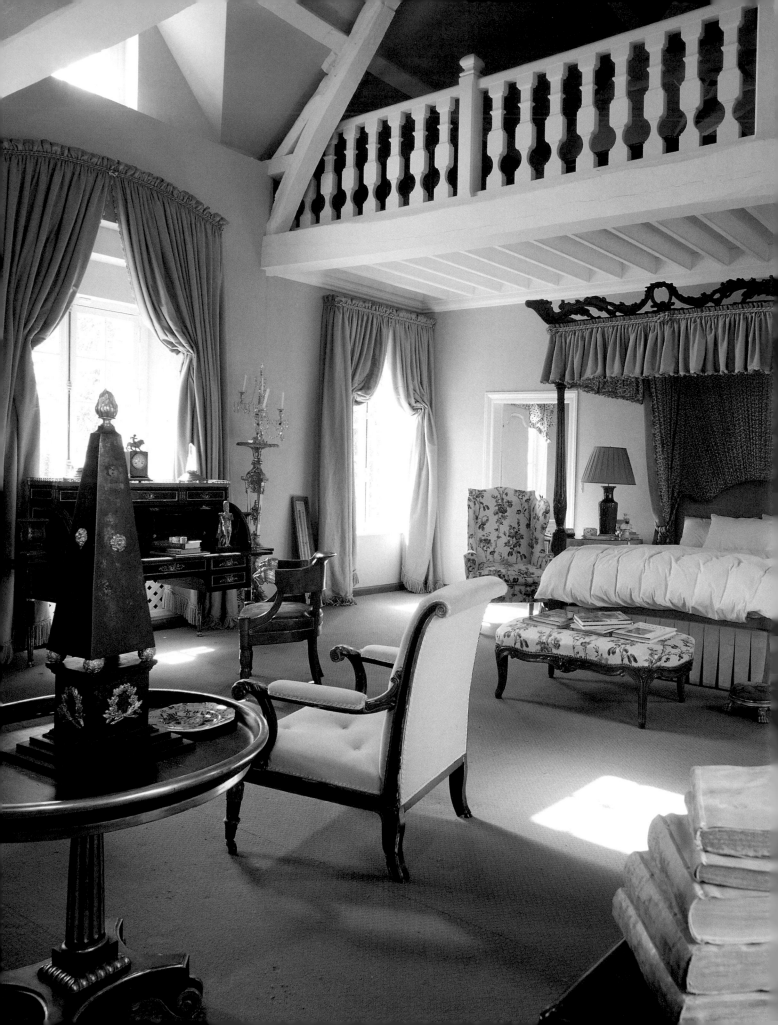

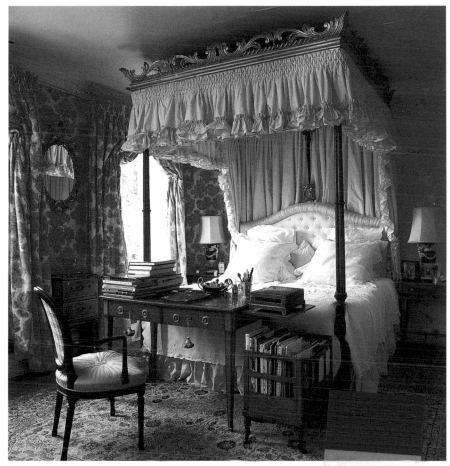

# Elaborate crestings

One of the most elegant phases in the history of English beds was in the mid to late eighteenth century when finesse in design was matched by excellence in craftmanship. Made in mahogany, these two examples from that period have testers with finely carved, scrolled cresting, an elaborate flourish which contrasts with the tall, slender posts. The blue bedroom was decorated by Tommy Kyle and Jerome Murray, who inserted a gallery in the roof-space to serve as a dressing-room. The pink bedroom is a feminine confection of peonies and embroidered linen, complemented by the unusual smocked heading on the bed-pelmet. In both rooms, the window curtains are reefed back at high level.

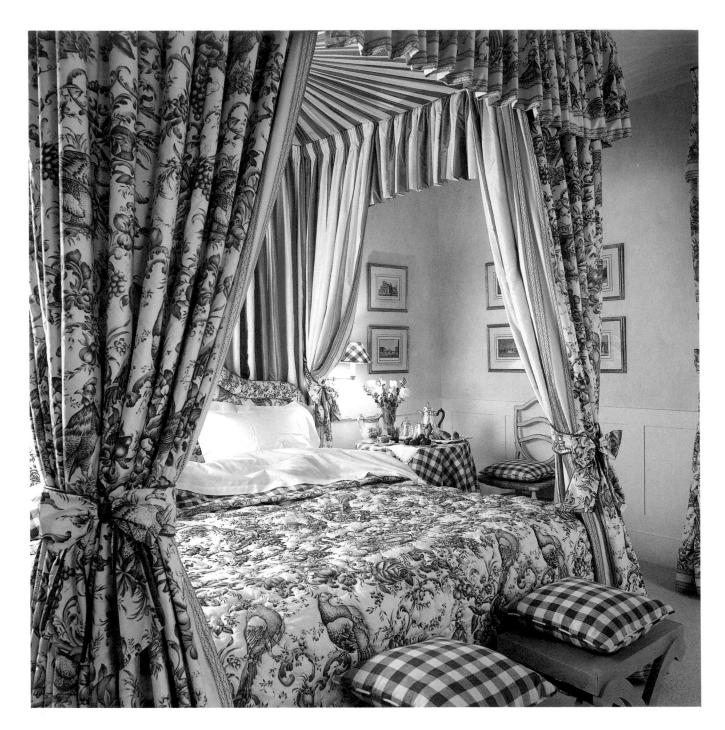

# The joy of print

Two rooms by the same designer, Monica Apponyi, show two different ways of using *toile de Jouy* on a four-poster. In the bedroom above, the print is on the outside of the hangings; in the one opposite, it is on the inside, echoing the walls and creating

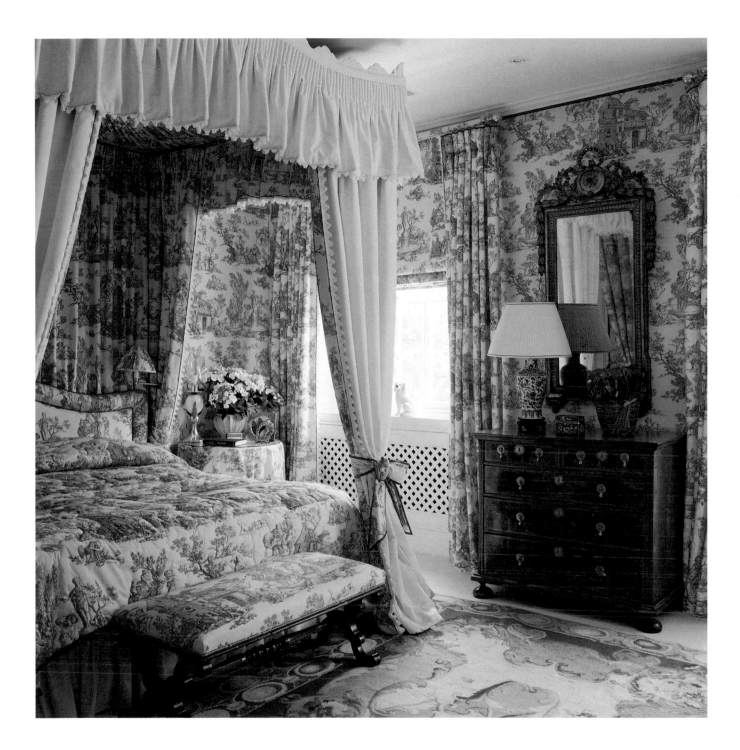

the effect of a red *toile*-lined room-within-a-room. Here, the bed canopy has a decorative cresting, and a simple white gimp with a similarly crested outline is used for the pelmet and curtain edging. The red *toile* is applied profusely – it even covers the curtain poles and blinds – whereas the aubergine *toile* is teamed with a complementary check for the cushions and tablecloth.

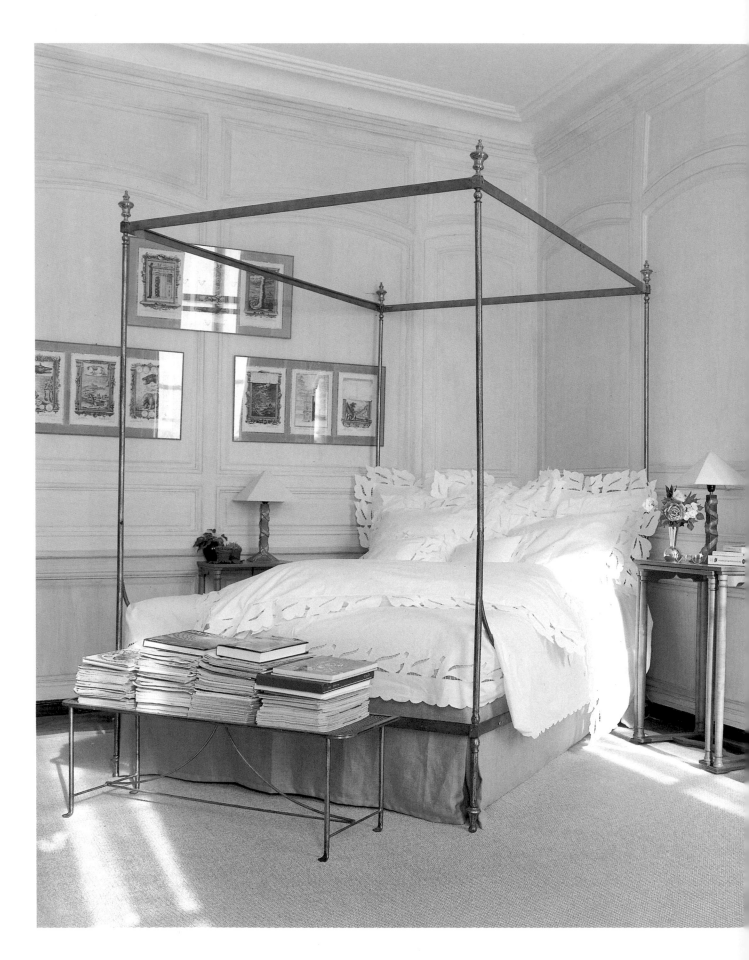

# Pared-down elegance

Agnès Comar, one of France's most chic decorators, has evolved a style which is contemporary but rooted in traditional French elegance. The bedroom in her apartment in Paris (left) reflects her philosophy of using colours which are soft and neutral, and materials which are natural and simple. The eighteenth-century panelling is painted in the gentlest shades of eau-de-nil and beige. The iron bed, placed unconventionally across a corner, is left unadorned. The look is pared-down and chaste but filled with historical resonances. In the London bedroom illustrated below, John Minshaw has also chosen a spare, modern elegance whilst paying homage to the past with his design for a classically-inspired four-poster which rests on silver globe feet and is hung with silk. The chest at the foot of the bed is made to look like blocks of stone (a reference to the exterior of the building in which the bedroom is situated) and houses a television.

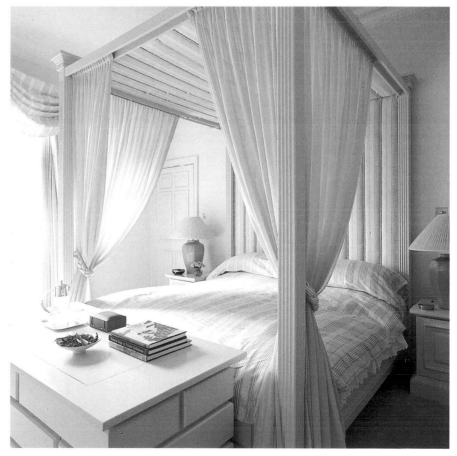

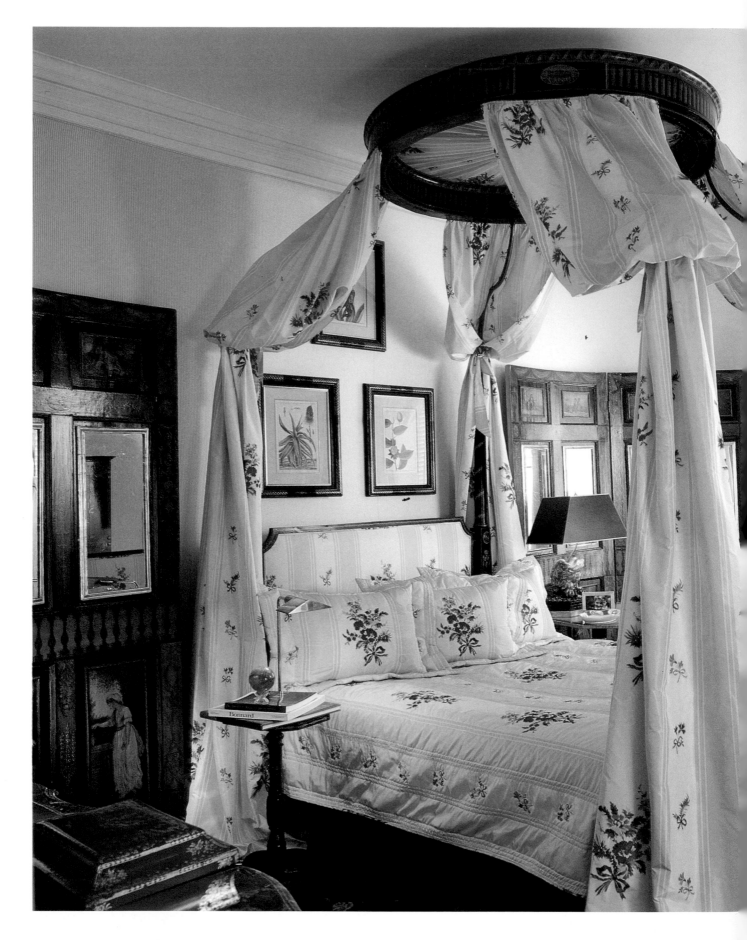

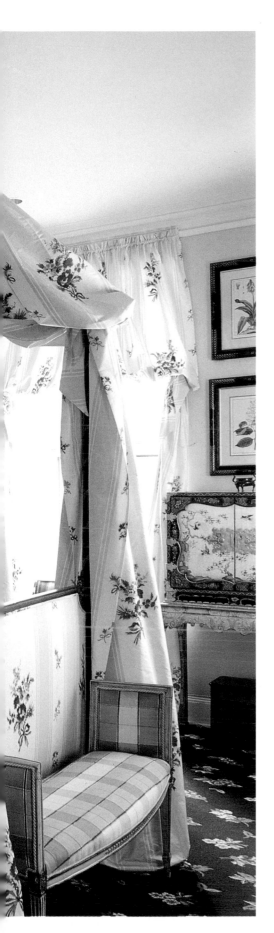

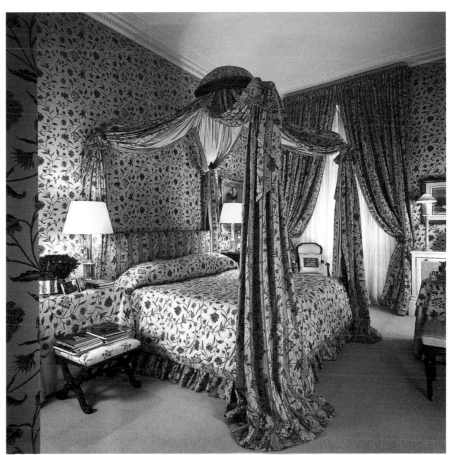

# Crowning glory

A less-than-refined modern four-poster was transformed, Pygmalion-like, into the striking bed *à la polonaise* seen in the bedroom above. The metamorphosis was the idea of interior designer Lars Bolander, who decked out the entire room with an exuberant duo of co-ordinating prints to create a romantic bower within a London *pied à terre*. The *lit à la polonaise* in the guest-room of Dotty Cherry's Fifth Avenue apartment, shown left, is an authentic and exceptionally fine example of the genre, dating from the eighteenth century and attributed to Robert Adam. The frame is decorated with carving and paintwork in the neoclassical style, while the headboard and footboard are upholstered in the same fabric as the drapes and bedcover.

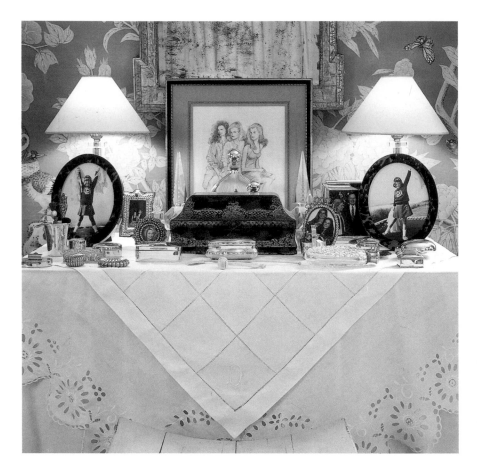

# Polite hues

Few rooms in the centre of a city could equal this one for its air of quietude and repose. Mark Hampton, in the heart of New York, has staged a world of exquisite calm, using a Chinese-style wallpaper and polite, unassertive hues. Apart from the set of red-bound volumes in the bookcases and the exotic birds and butterflies flitting through the foliage on the walls, there is very little bright colour. Creamy shades predominate for the textiles and lozenge-pattern carpet, while antique white linen is spruce and pretty, especially on the dressing-table where several different cloths are layered diagonally. The hint of Chinoiserie in the painted and gilded ornament on the bed tester correlates with the oriental stamp of the wallpaper.

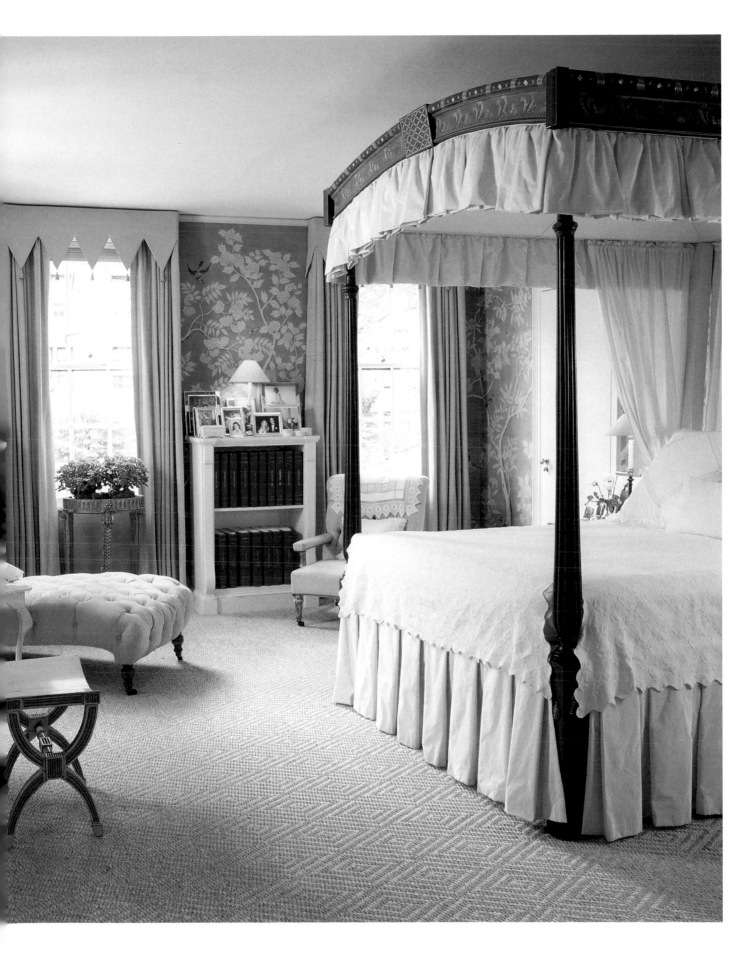

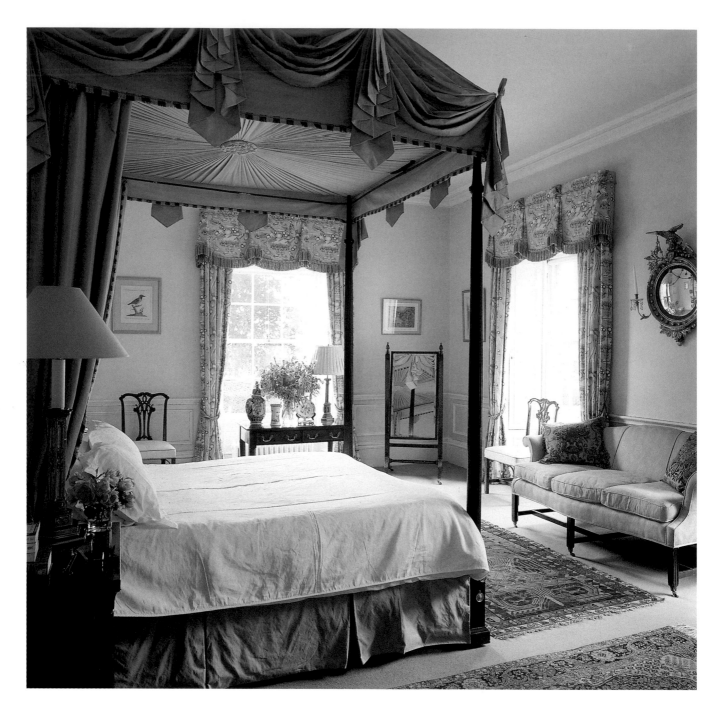

# Quintessentially English

The English country-house look has been copied throughout the world – and often in places which are far from rural. These two rooms, however, are very definitely in England and in the country, and as a result they both have that particularly pleasing quality of being 'the real thing'. They are extremely understated and have good furniture, oriental rugs and decorative objects which live together with ease. The crested four-poster in the room shown opposite was dressed in crisp white and yellow by the great master of the English country-house style, John Fowler. Charmingly decorated with a collection of framed silhouettes, a small triple-panel folding screen is placed in front of the open fireplace in summer. The splendid George III four-poster seen in the room above is upholstered in yellow and apple-green silk, and is central to the room's harmonious colour scheme devised by another renowned exponent of the English style: Jean Monro.

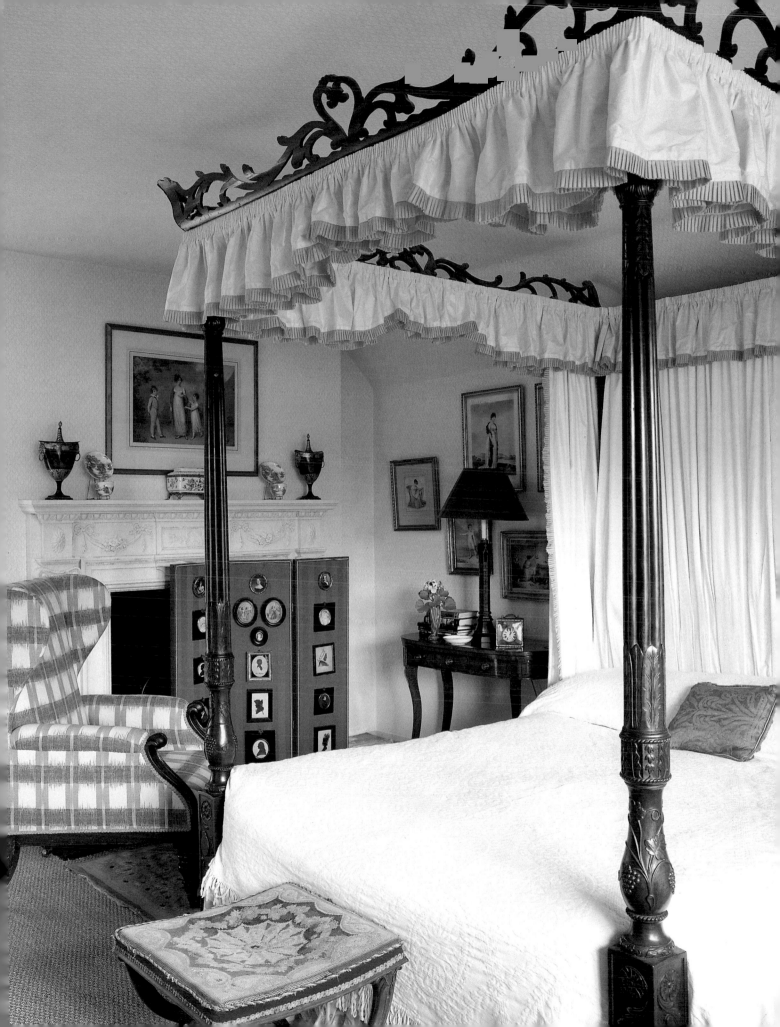

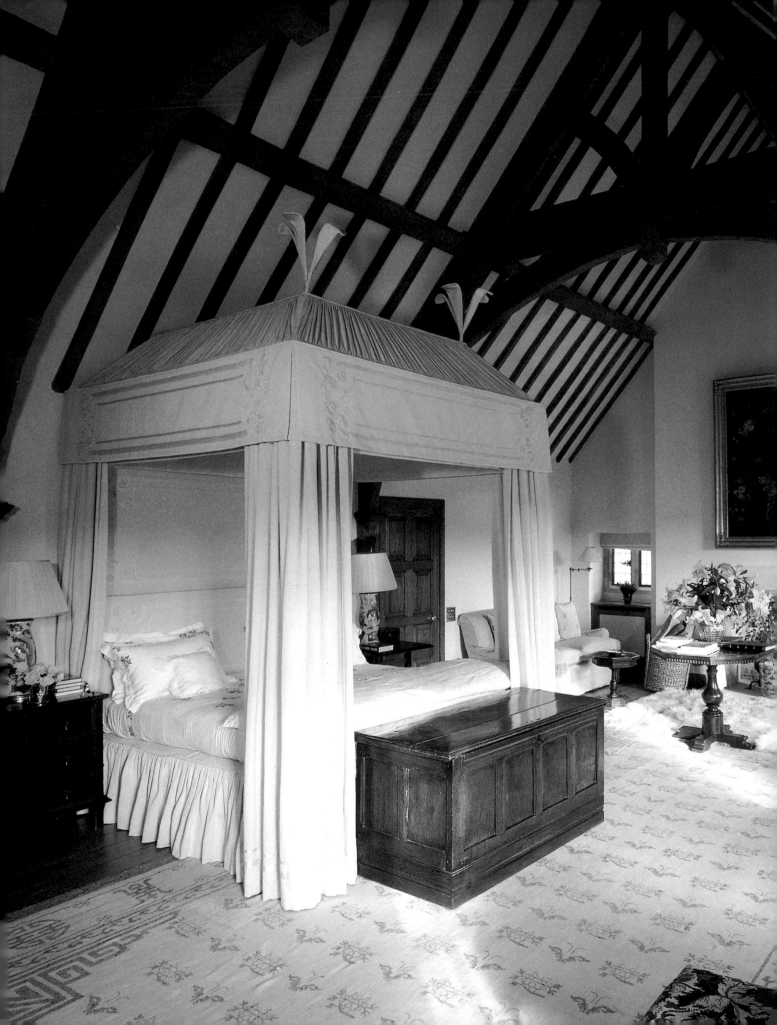

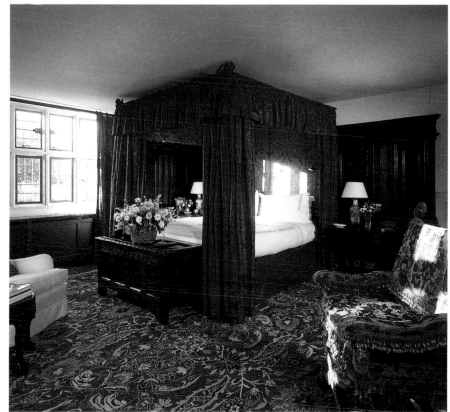

# Chivalric plumes

These four-poster beds hark back to the flamboyance and theatricality of the Elizabethan era, as befits their setting in an English manor-house with origins traceable to 1560. In the room on the left, which has a spectacularly beamed roof and an almost exclusively cream colour scheme, the bed is reminiscent of a chivalric jousting tent. The silk hangings are hand-embroidered with a ribbon motif, and the canopy is finished with decorative plumes. The room shown above has overtones of Venice, derived from the Venetian bed and brocade-upholstered chair, and from the Italian walnut panelling. The silk damask bed-hangings were specially dyed an unusual rust-magenta which tones with the rich colouring of the Ziegler carpet. Both rooms were designed by David Mlinaric and Hugh Henry.

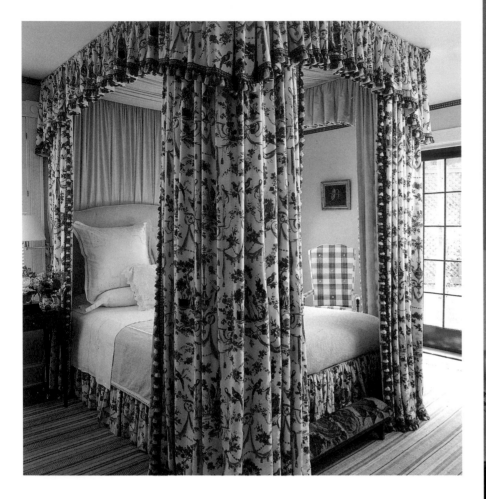

# Romantically dressed for summer

The colours and emblems of summer make joyful contributions to these two rooms with romantically-dressed four-posters. In Murray and Albert Douglas' home in upstate New York, the bed in the pink guest-room (above) is hung with a delectable cotton print by Brunschwig of flowers and birds, edged with toning fringe. The floor-covering has multi-coloured stripes, striking just the right note of informality in a country-house setting. In the yellow bedroom shown on the right, Cynthia Clarry has used hangings made of a butterfly print in vivid yellow which reinforces the sunny atmosphere. Here, too, the floor-covering has a country character – though the room is in central London. Surprisingly, the bed is not a real four-poster but an ordinary divan to which a superstructure for hangings has been added.

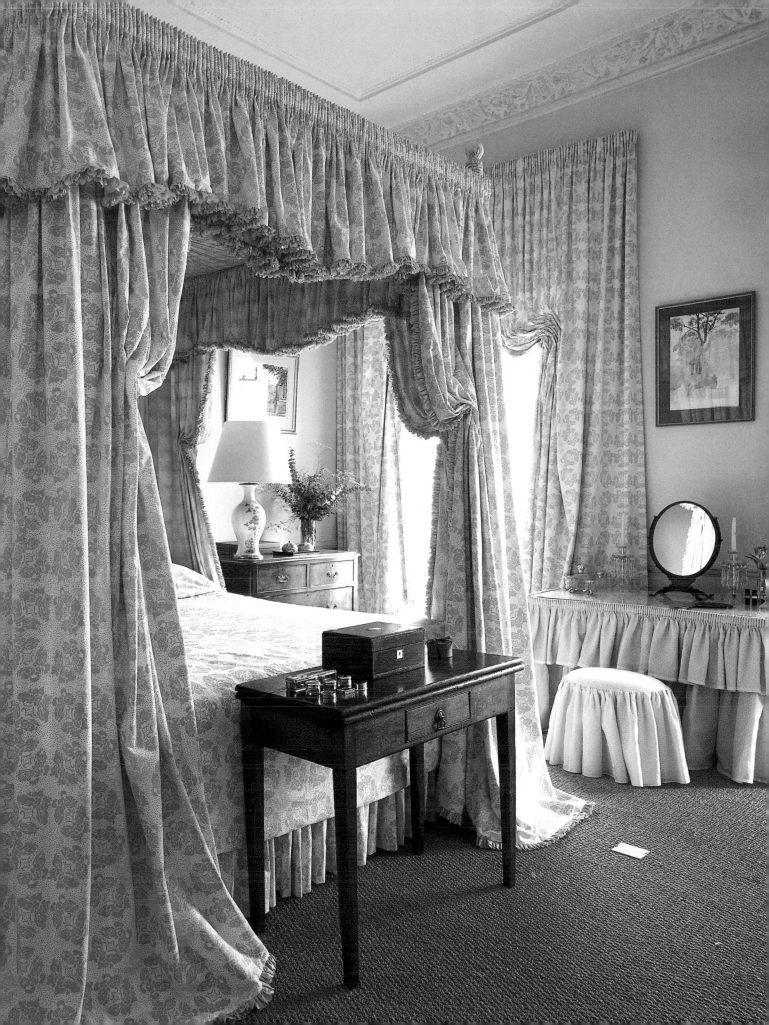

# Softened by texture

White is the major theme in this bedroom designed by Monica Apponyi, but any risk of starkness has been softened by texture. The walls above the dado rail are covered with woven fabric which imparts a discreet luxury and integrates with the white fabrics used for the curtains and bed-hangings. Blue is the secondary theme, appearing in several co-ordinating paisley, striped and floral fabrics. There is a classic elegance in the general design of the room, but modern lighting technology has been used to enhance the ambience. Interesting pools of brilliance and shade give a sense of daylight and dappled sunshine, even when the shutters are closed. French cane-back chairs and an elaborate mirror contrast with the simplicity of the bed, with its plain frame and tied, white hangings. The room was created specially for a British Design Exhibition and exemplifies Monica Apponyi's fresh, original style which is traditionally based, often with continental associations.

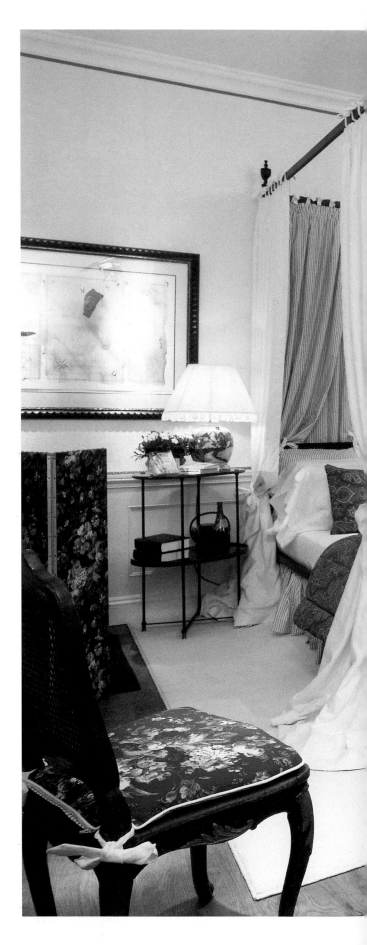

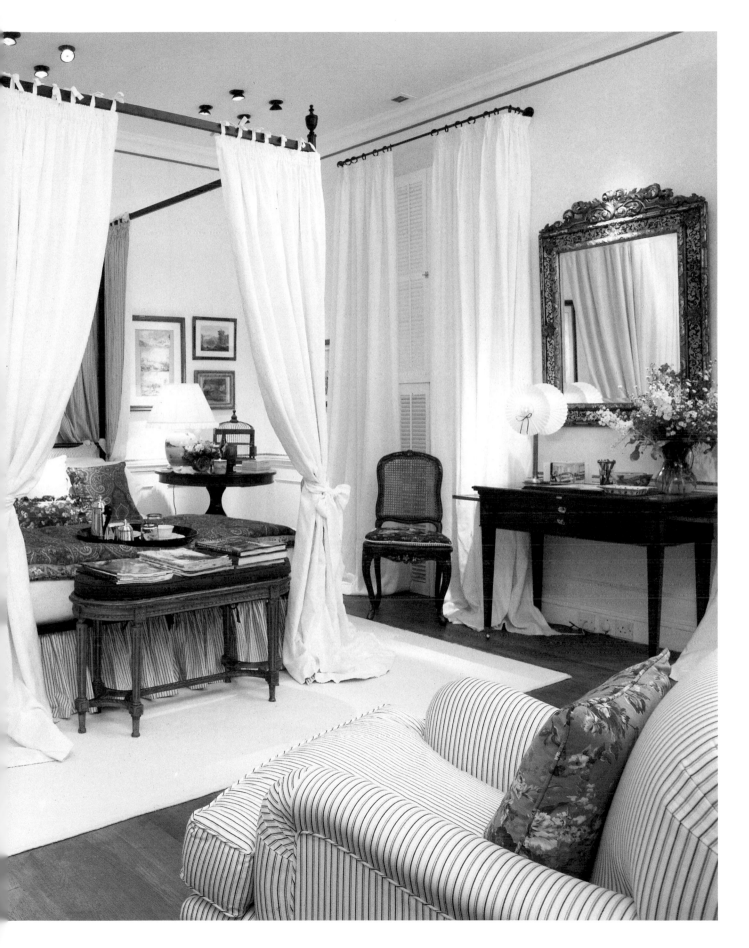

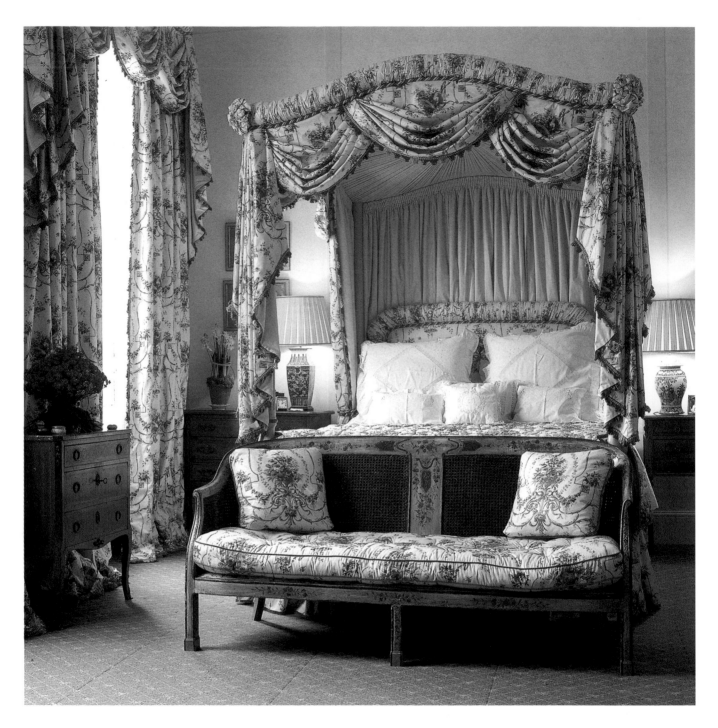

# Versatile chintz

Chintz is an incomparably pretty choice for dressing a four-poster
bed, and it is highly accommodating in the way it can be draped.
In the scheme shown above, by Grant White of O.F. Wilson, it is
swagged beneath the padded top rail of the tester, then arranged
in tails which fall elegantly down the posts. The canework seat is

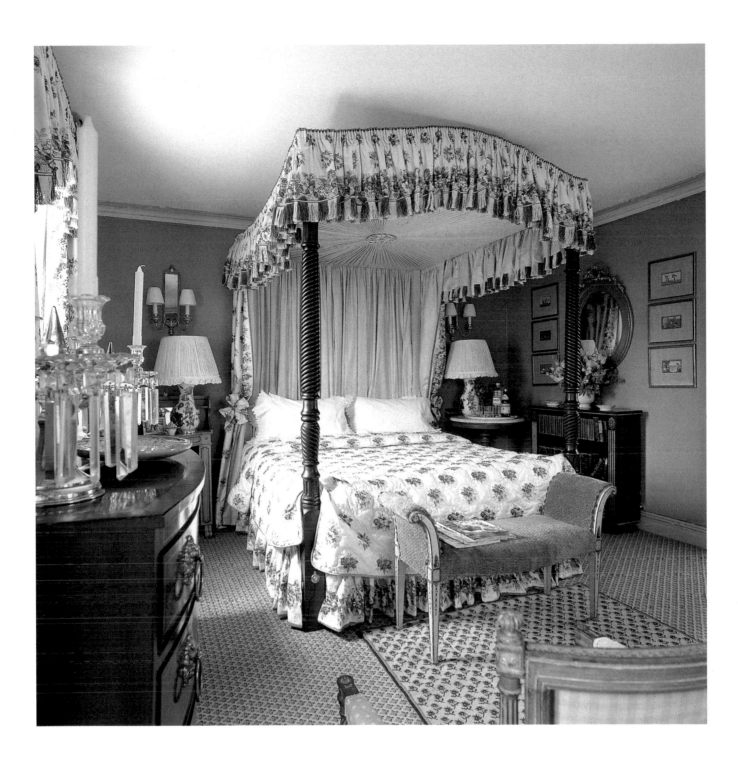

a charming complement to the floral theme of the chintz. Brian Juhos' treatment for the hangings in the blue bedroom shown on this page is less elaborate and leaves exposed the handsome spiral-carved mahogany posts. To prevent the room from becoming altogether too flowery or fussy, a plain fabric in Wedgwood blue was decided on for the walls, and green cut velvet for the stool at the foot of the bed.

# Southern vernacular

American country-style decorating has become synonymous with pine dressers and colourful quilts, but the home of Atlanta designer Nancy Braithwaite shows a completely different style of vernacular furnishing. Simpler and much more tailored, it evokes the straightforward, functional spirit of the houses lived in by yeomen farmers in the anti-bellum South. She is a knowledgeable collector of the solid, no-nonsense furniture used by these 'plain folk', and her design for the heart-of-pine four-poster bedroom (right) pays tribute to the simplicity of her antique pieces. It has hangings made of burlap and linen which are natural complements to the sisal floorcovering. Particularly striking is the hand-painted chequer-board on the walls. The pattern is found in early American homes and works extremely well in this context. The walls in Nancy Braithwaite's guest-room (below) are sponged in a pale, earthy yellow which contrasts with the dark furnishing fabrics. The painted maple bed, neatly positioned between the windows, is from New England.

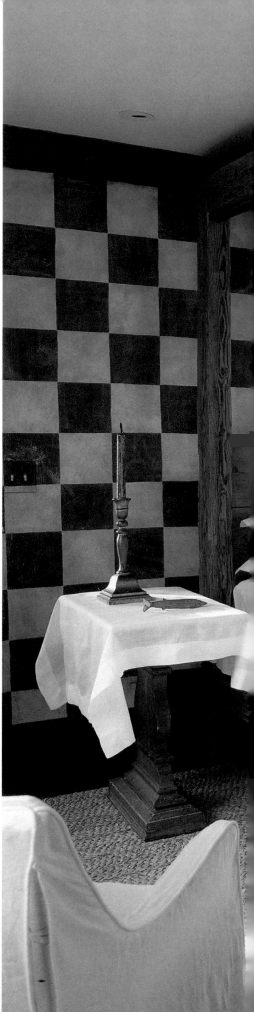

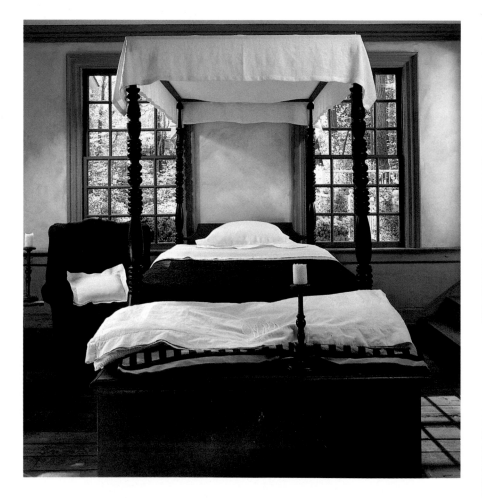

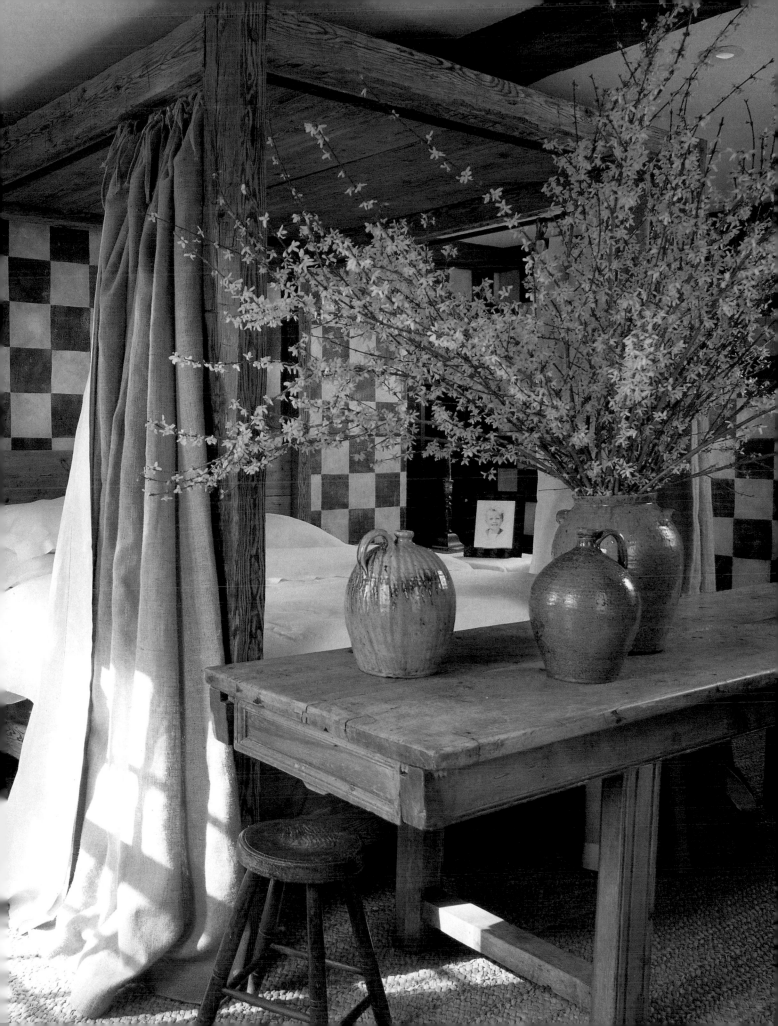

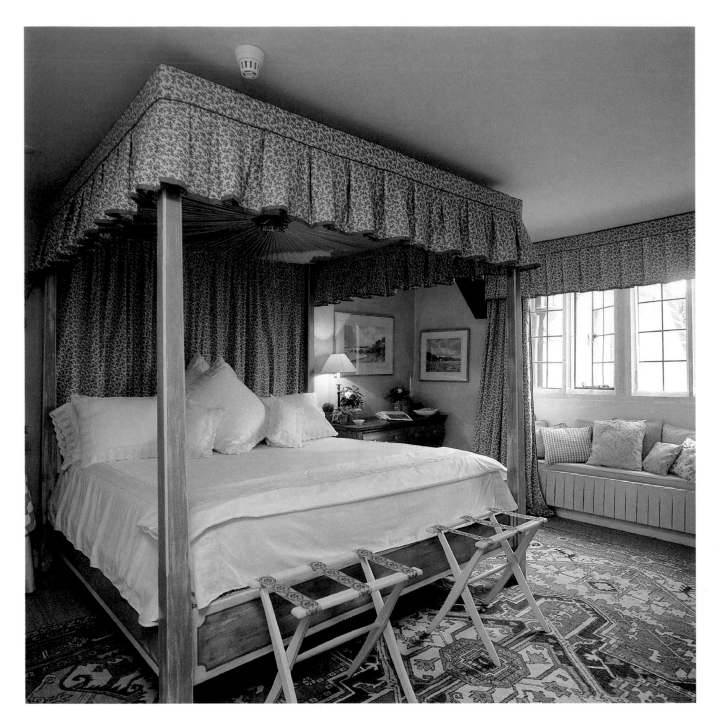

# Complementing
# the season

With sprigged chintz and leafy vistas, these bedrooms have lyrical
connotations of summer. In Ian Walton's design (above), the
modern four-poster has a distressed paint-finish, giving it an aged

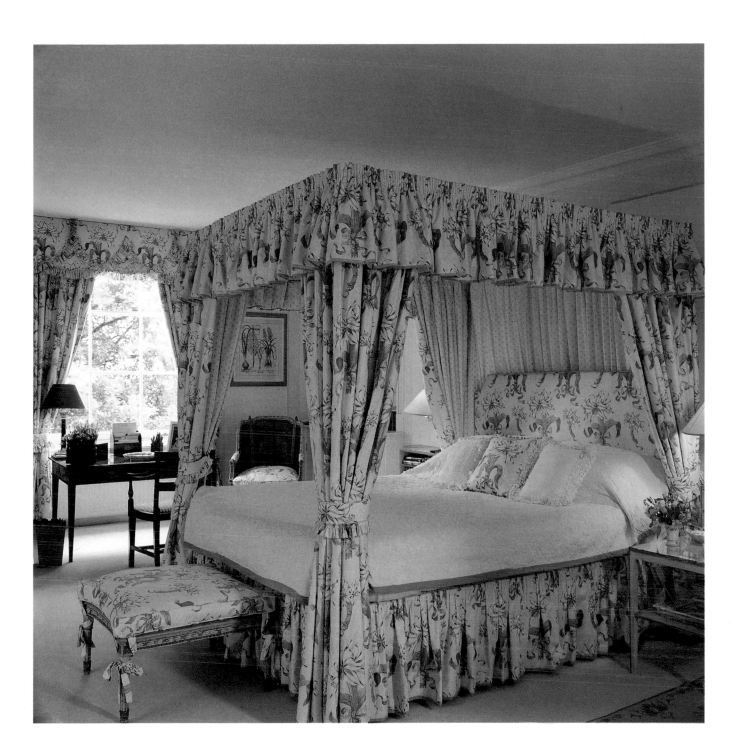

appearance which is fashionable and appropriately sturdy-looking for its setting in an old stone-built manor-house. In the room shown on this page, which was designed by Lucy Manners, the blue-and-cream panelled walls heighten the summery freshness and and *joie de vivre*. The antique white bedcover, trimmed with blue, is an attractive contrast to the lively pattern of the sprigged chintz.

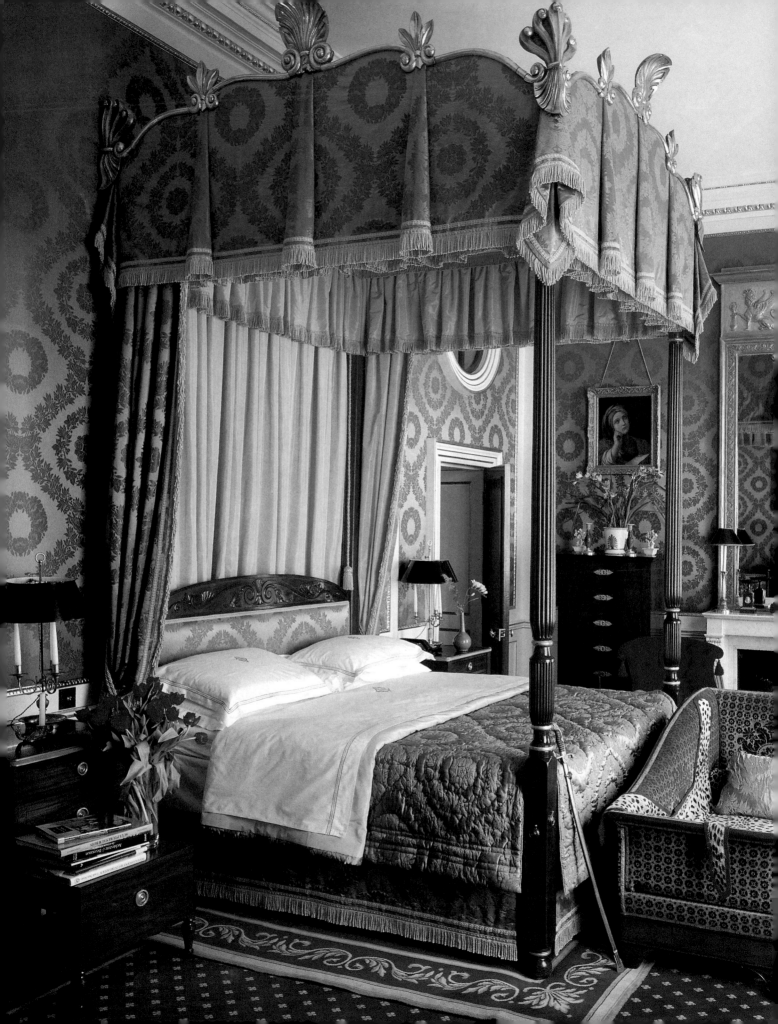

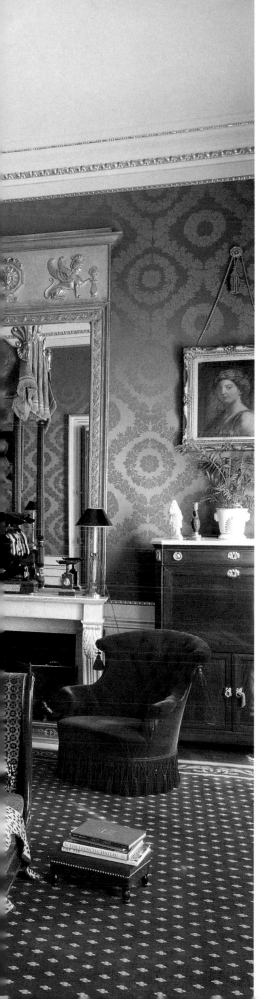

# After Napoleon

Designer André de Cacqueray's home in London is a paradigm of French Empire and English Regency design. His sumptuously decorated bedroom uses the same Lyons silk damask as that ordered for Napoleon's *salon du déjeuner* in the Grand Trianon and for Louis Philippe's *salon de famille*. The Regency bed, with elaborately carved and gilded finials, has been altered to suit the proportions of the room and to accommodate an inner dome which gives the design additional splendour. Within the dome hangs a small chandelier (switched on by a silk rope) which provides light for reading. In contrast to the widely spaced pleating of the green silk pelmet, the gold silk taffeta used for the lining is softly gathered.

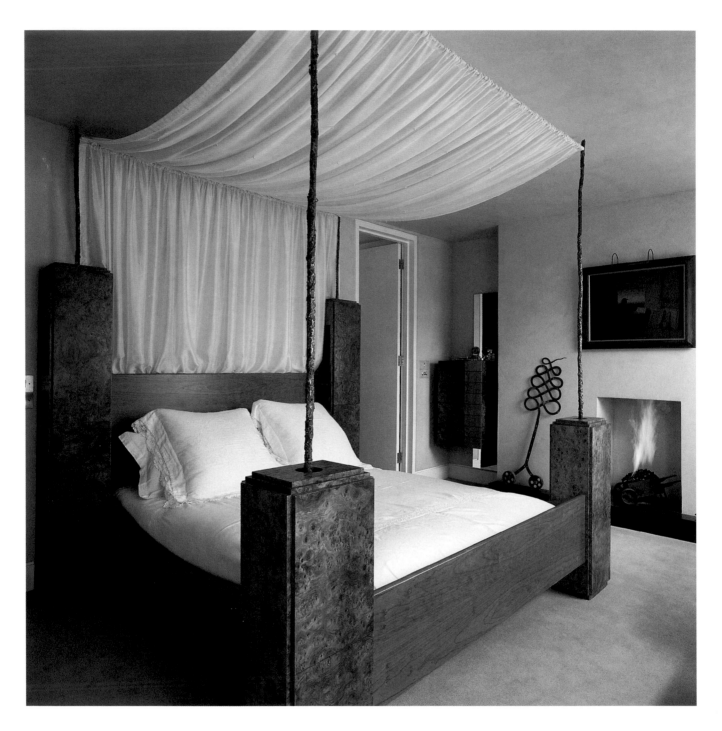

# Castle-like contours

Although this bed is totally of our time, its design retains the grand, ceremonial air of a traditional four-poster. The white silk canopy, scattered with crystal and pearl beads, is supported by rough-finished metal posts which disappear into sturdy columns veneered in burr elm. The latter give a castle-like contour to the bed's massive base, and they ingeniously incorporate drawers for the telephone, stereo and bottled water. The bed was devised by MC$^2$, the design partnership of Martha Fellowes and Colm Delaney, for Martha Fellowes' own home, an updated mid-nineteenth-century terraced house in London. The Victorian origins of the house are still apparent in the concept of an open fire – although now the firebasket is a witty design in the shape of a miniature cart, by Paul Robert Holmes, who also made the sculpture. For privacy, the window has a net curtain across the lower half, with a dark-red blind providing a keen colour contrast.

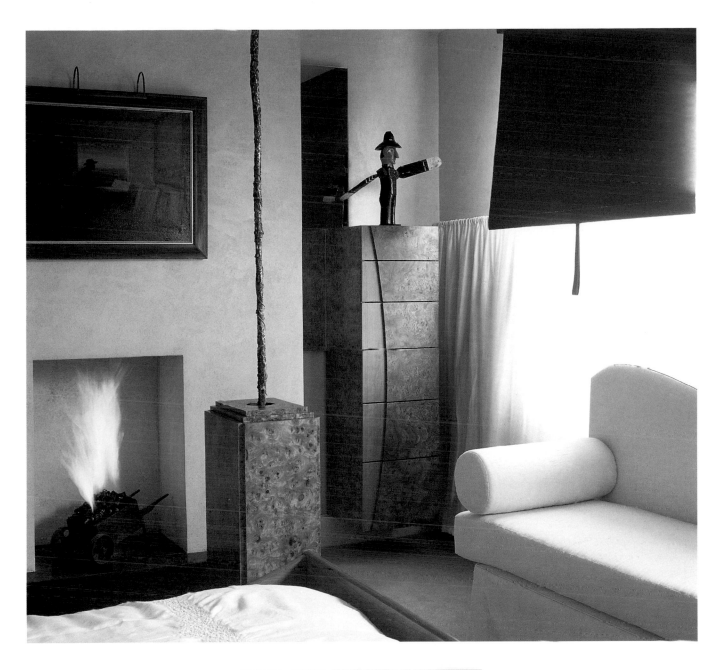

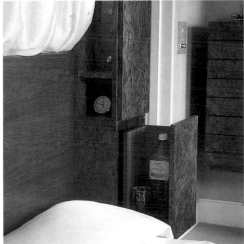

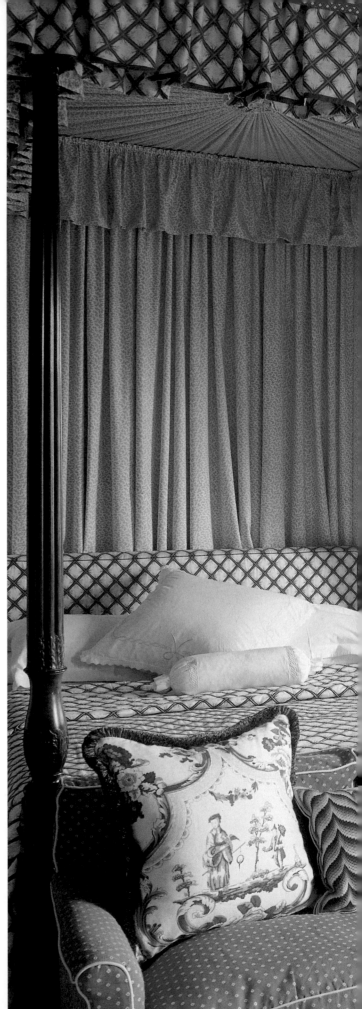

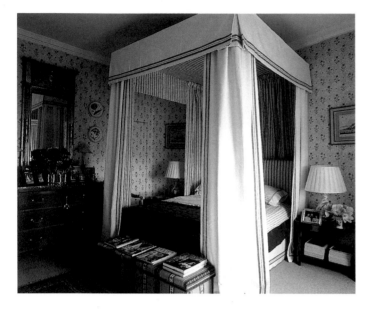

# In a blue mood

These two bedrooms in Edinburgh clearly disprove the cliché view that blue is too cold for a northern climate. It all depends on the way it is used. Combining different tones and patterns prevents it from looking cheerless, and adding white keeps everything sharp and fresh. In the room shown on the right, walls are dragged in a pale denim blue, providing a comparatively simple background for the variously scaled motifs on the carpet and fabrics. The bedroom above takes a reverse stance, with the more intricate patterning being seen on the walls, while the floorcovering and curtain fabrics are much plainer. The bed is a smart display of linen and stripes – very tailored, very graphic. Both rooms were designed by James Thompson of A. F. Drysdale.

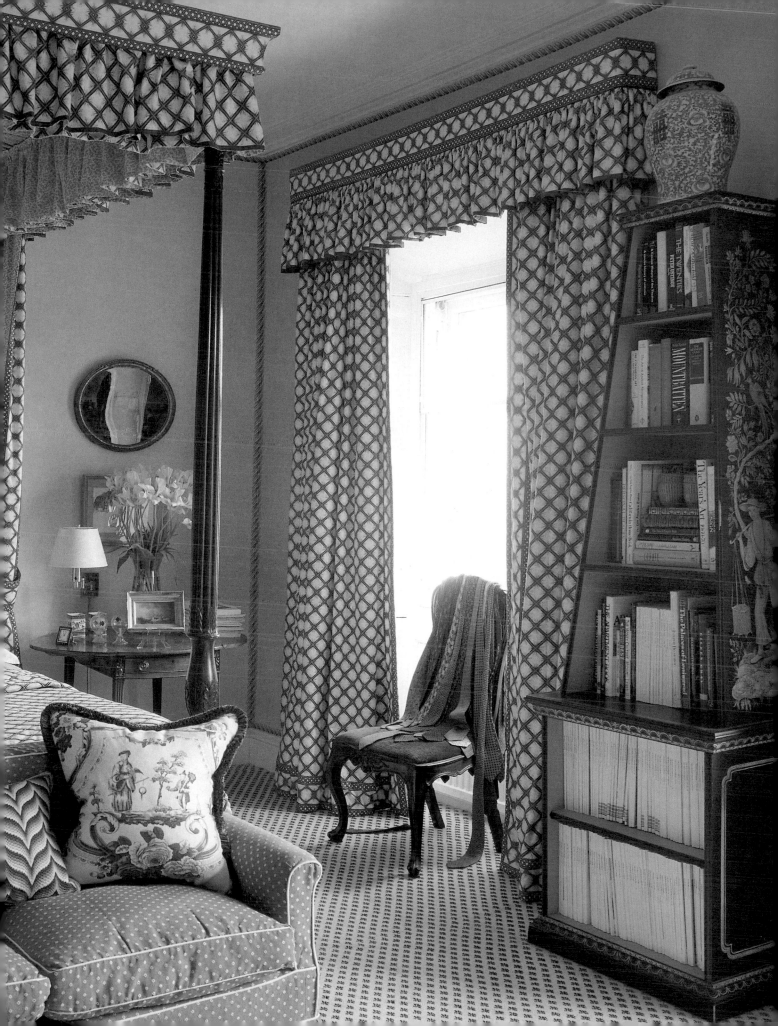

# A robust statement

Carved wood furniture and panelling are potent reminders of an earlier, more robust era, and they make a strong statement in today's interior decoration. In the Suffolk home (right) of antiques dealer Keith Skeel, the eighteenth-century Flemish walnut bed, with its compartmented head-panel and vigorously turned posts, has hangings in an appropriately rich crimson. At the foot of the bed is a brass-bound leather trunk dating from the late sixteenth century. The carved wooden chest at the end of the bed in the London room shown below is in fact a practical housing for a television which, at the touch of a button, rises to the perfect height for viewing. The specially made bed is a copy of an antique four-poster but the dimensions have been adapted to meet twentieth-century ideas of comfort.

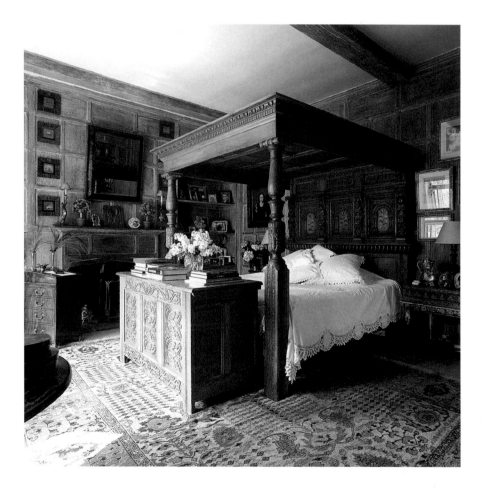

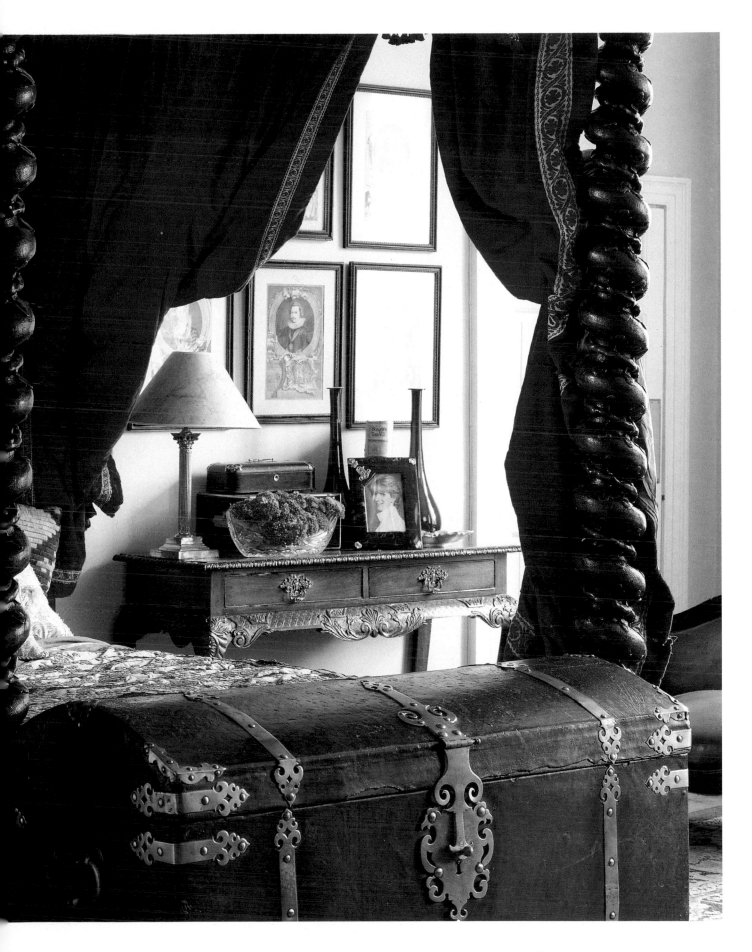

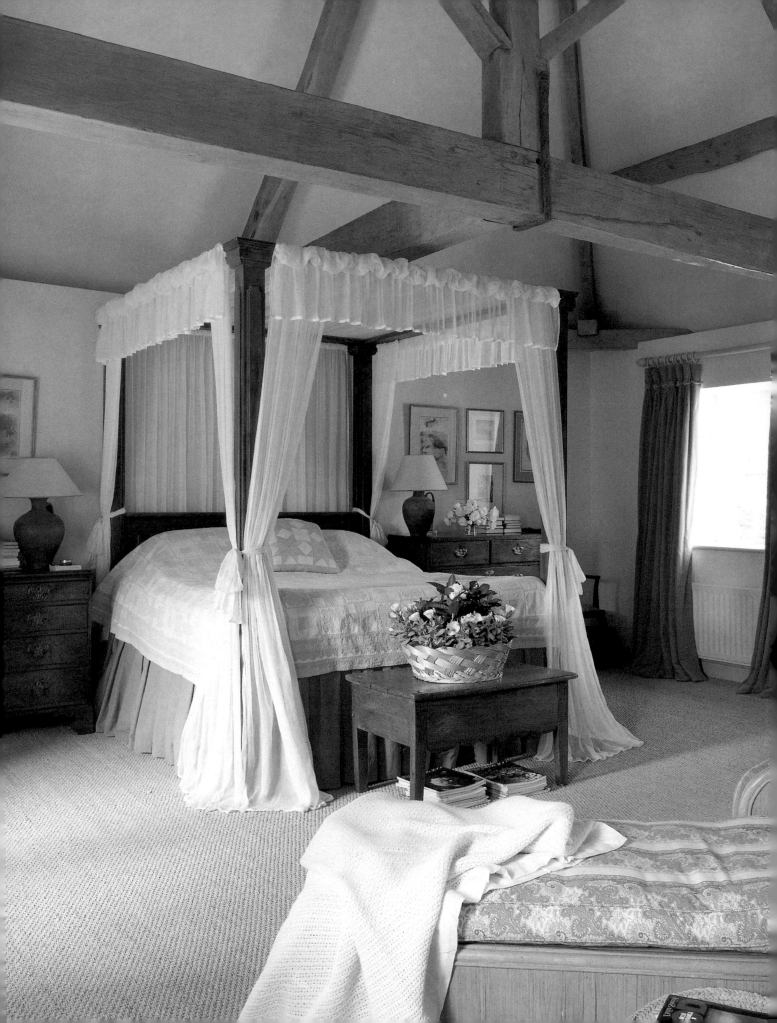

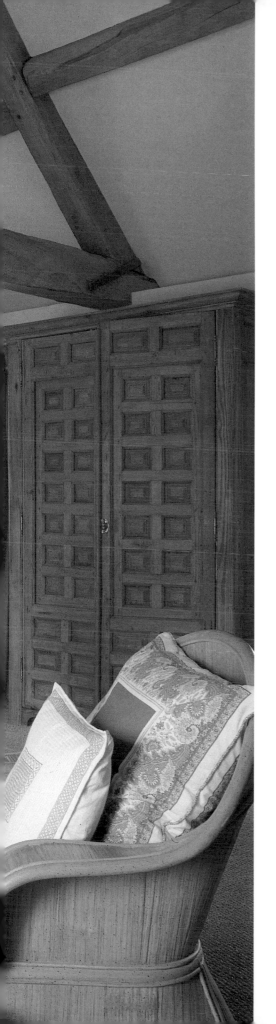

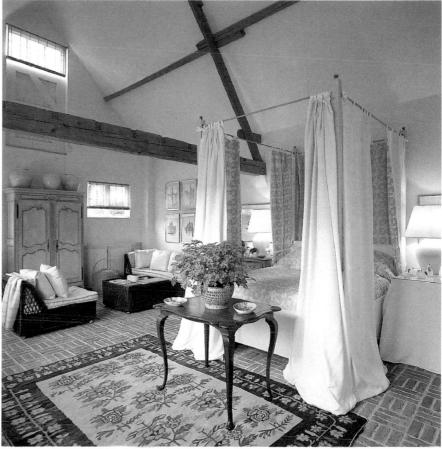

# Rusticity and suavity

In these two bedrooms, rough-hewn beams establish a strong, rural identity, consolidated by country-style flooring – bricks in one case, and natural seagrass in the other – and by continental, carved-wood cupboards. The room shown on the left, designed by Hugh and Anne Millais, is in a converted stable-block in Oxfordshire and has a Spanish four-poster bed draped with white muslin. The seventeenth-century cupboard with panelled doors is also Spanish. The bed in the room above is dressed in white cotton piqué lined with the same yellow-and-white cotton as the bedcover. With its eclectic combination of wicker seating, piqué-covered bedside-table and eighteenth-century cabriole-legged Dutch table, all within an architectural setting of agrarian functionalism, this attic room designed by John Stefanidis shows a masterly blending of rusticity and suavity.

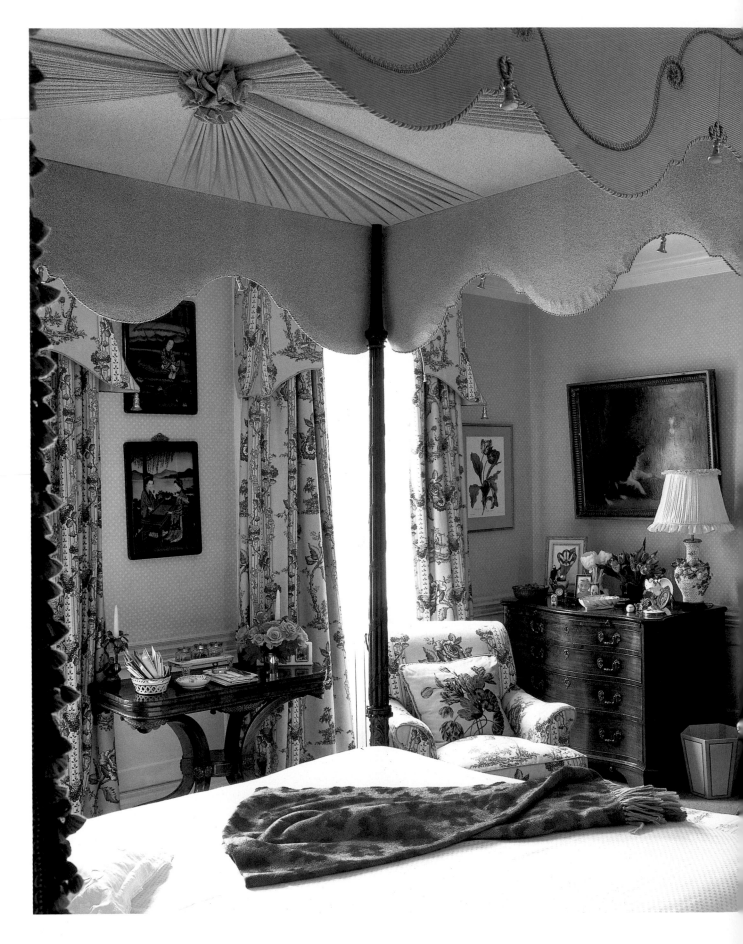

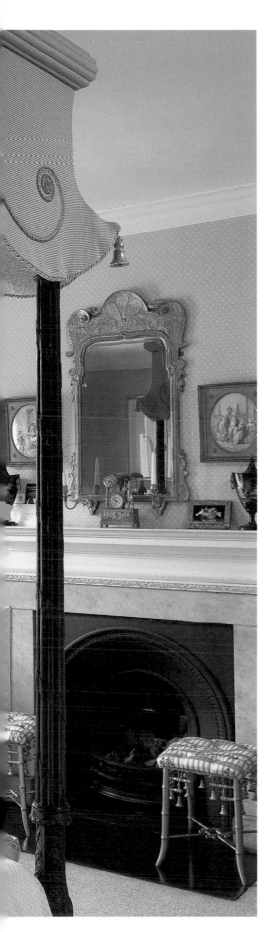

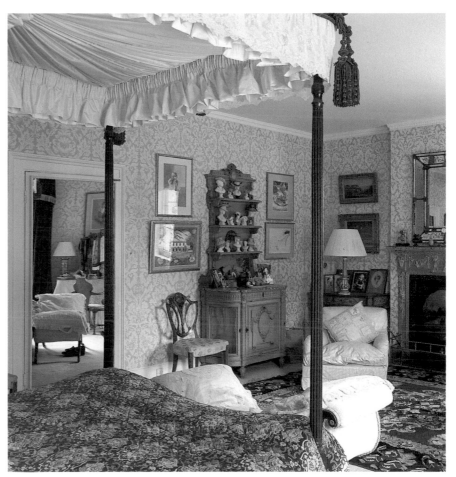

# Bells and bibelots

The four-poster bed in the 'Chinese' bedroom (left) of the Earl and Countess of Wilton's eighteenth-century house – an old vicarage in Essex – has a pagoda-shaped canopy upholstered in heavy ottoman and hung with little gilt bells. The window pelmets have an equally exotic outline and they, too, have bells echoing those on the pair of fireside stools originally made for the Brighton Pavilion. The dominant colour for the fabrics is a beautiful celadon green, picked up in the Chinese paintings on glass which are hung between the windows. Sally Metcalfe of George Spencer Designs advised on the room's decoration. The bedroom shown above is in a house in the West Country and dates from a similar period. Apart from reflecting a delight in collecting pretty and unusual things, the interior is particularly notable for its antique textiles.

# Into the country

For a room in the centre of London, this interior is unusually
large and well proportioned, and it has the bonus of a light,
south-facing outlook. Commissioned to make it look as much like
a country bedroom as possible, Bob Perkins decided to give the
panelled walls a soft yellow paint finish (carried out by
Christopher Galloway and David Mendel) and he chose a rich
red-and-cream fabric for the curtains and bed. To get away from
the built-in look, he designed a pedimented cupboard which is
Georgian in inspiration. Rush matting and a marble fireplace,
topped with Chinese armorial plates, enhance the rural tone.

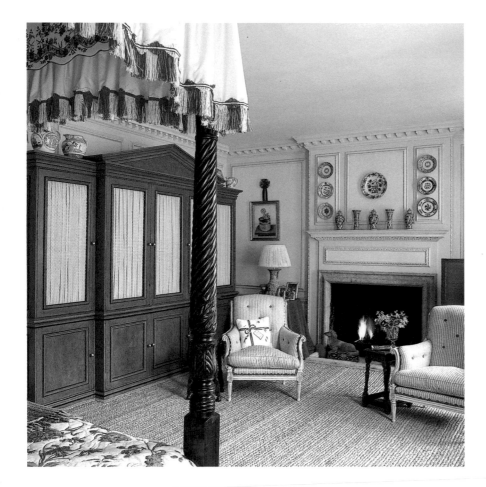

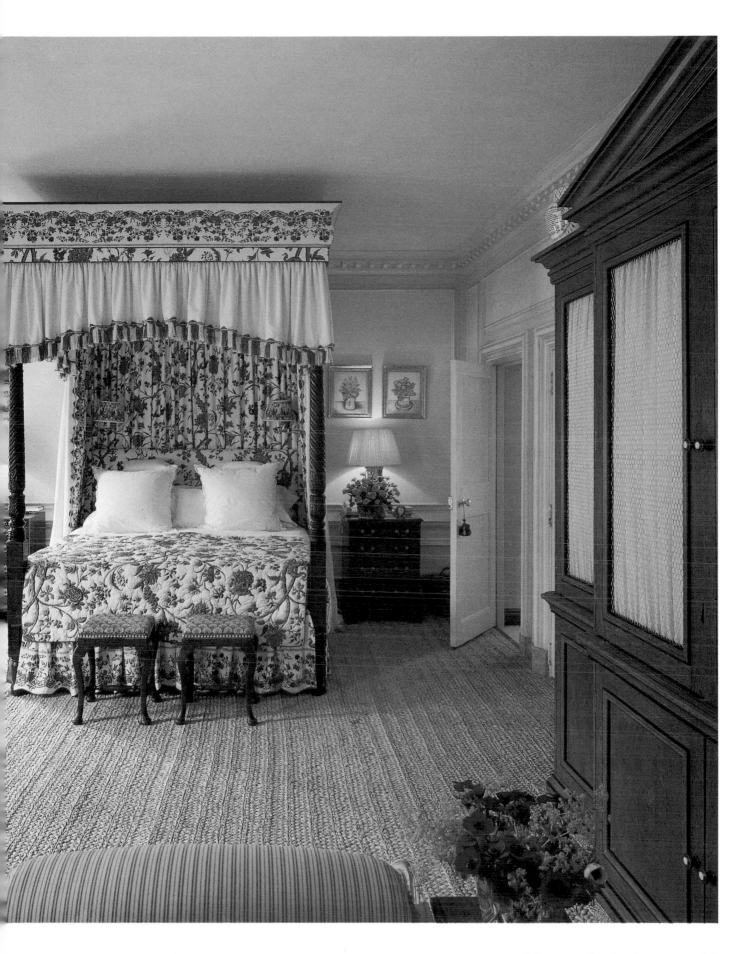

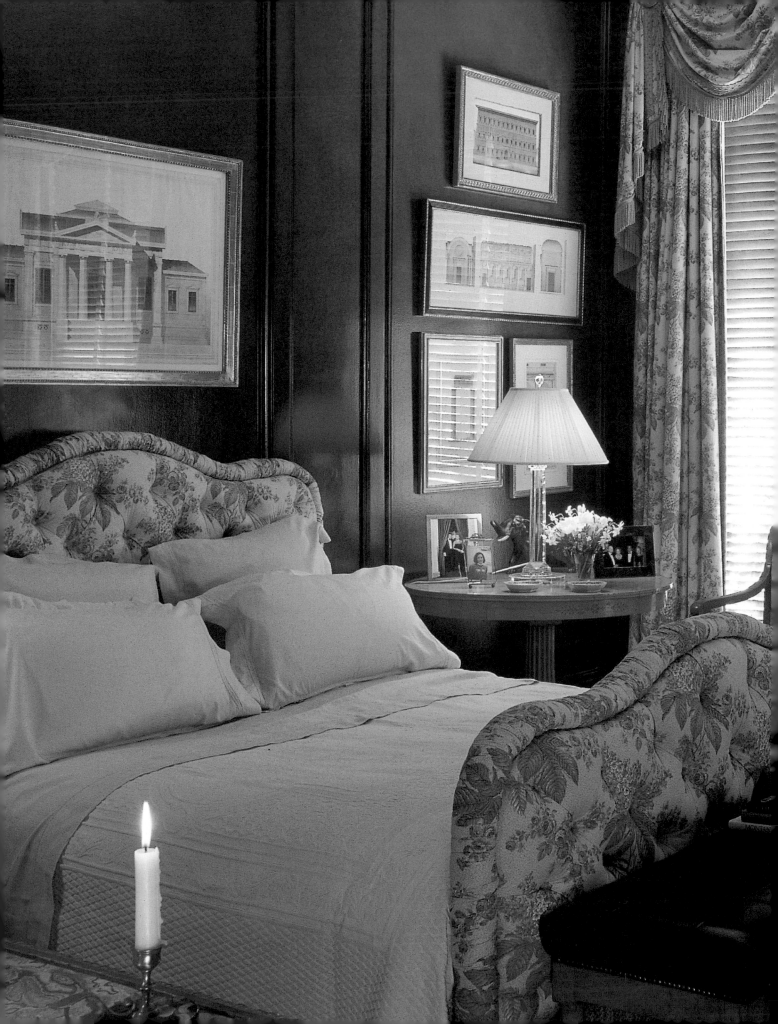

# CITY CHIC

*A sophisticated, tailored style of interior decoration suits the architecture and ambience of a city environment. Forget nostalgically-patterned wallpapers and endless frills. Choose a plainer, sharper look with a contemporary, soigné edge to it.*

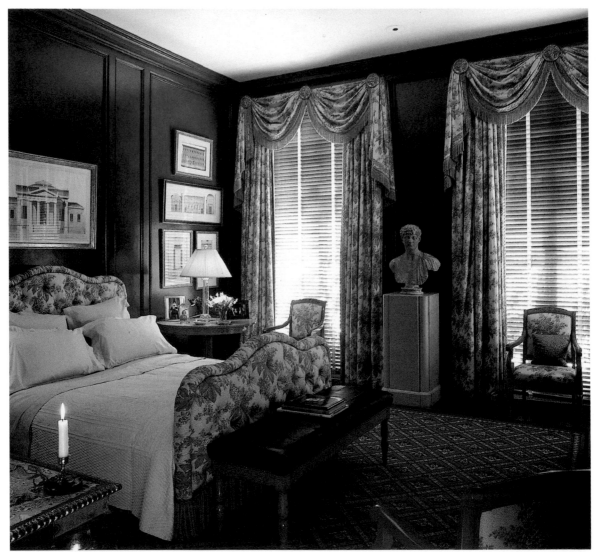

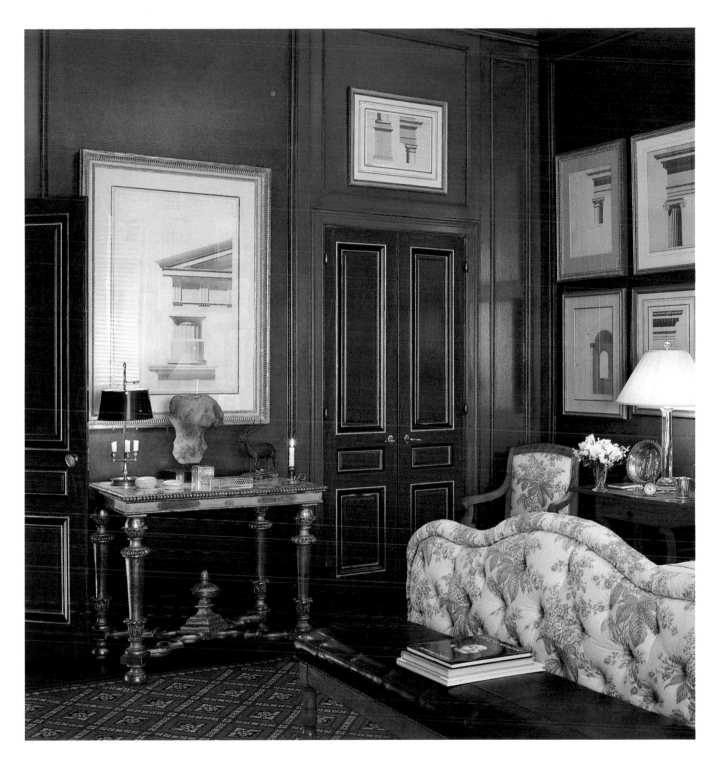

# Decisively orchestrated

An exceptional collection of architectural drawings is given extra definition by being hung against deep-toned walls in this bedroom in San Francisco decorated for Vincent Friia by Albert Hadley and Gary Hager of the New York based design team, Parish-Hadley. The contrast between the clarity of the pictures and the richness of the green lacquer has a dramatic directness and intensifies the almost three-dimensional impact. The curtains and pelmets, swagged and tailed from golden rosettes, are elegantly simple and skilfully proportioned to the room. In keeping with the apartment's city setting and decisively orchestrated style of interior decoration, the slatted wood blinds are smart alternatives to sheer curtains. The bed is upholstered in the same fabric as that used for the curtains and Charles X chairs.

# Black and white

One of the hallmarks of designer Stephen Ryan's style is discipline. Even when he uses several different patterns in the same room, he never creates confusion. The look is tailored and organized, as seen in the bedroom in his flat in an 1860s house in London. The scheme holds together well because of the limited colour range – if you can call black-white-and-grey a colour range – and the neat detailing. Above the bed is a canopy adapted from a window pelmet, which has hangings of grey flannel lined with black-and-white check. The same grey flannel is used for the window curtains; and the same check appears on the bed valance. Black is used for edgings, tasselled tie-backs and lampshades, as well as for the alcove, throwing into relief the white plaster bust of George III.

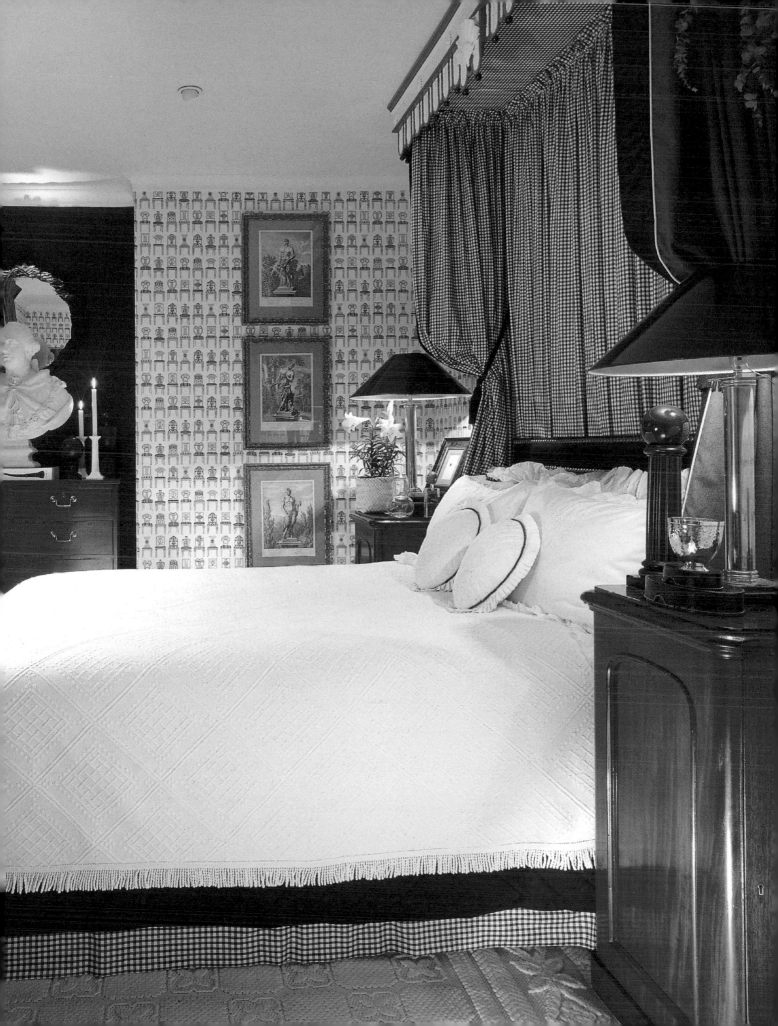

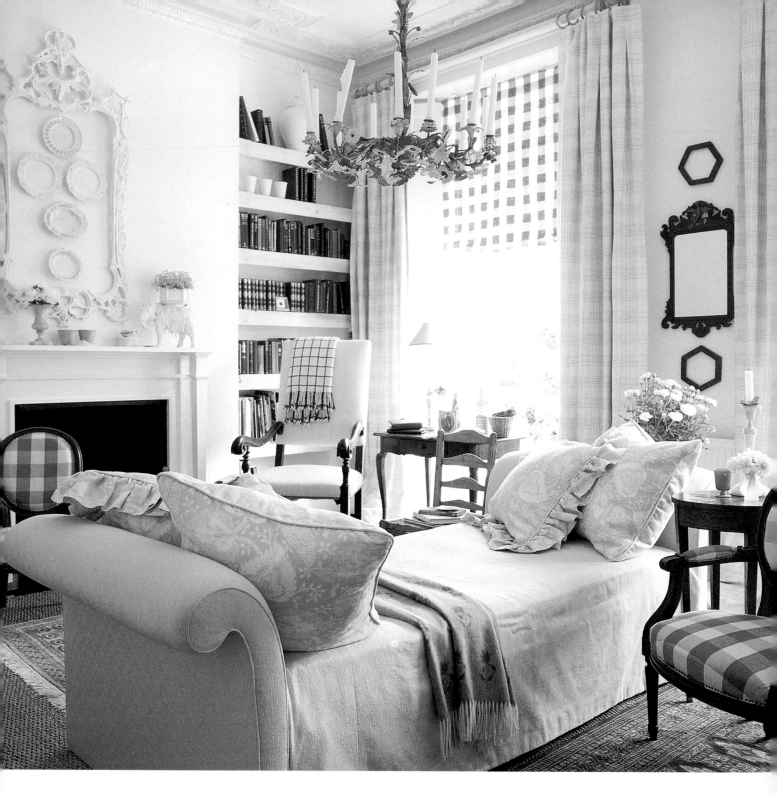

# One room, many solutions

Trudi Ballard's studio flat, designed with the help of Roger Banks-Pye – her friend and colleague at Colefax and Fowler – is a triumph of ingenuity and good looks. Apart from a small kitchen, this apartment comprises a single room which stylishly copes with myriad demands. The day-bed (which can be pulled out to become a double trundle bed) is positioned in the centre of the room so that it can also be used as seating.

The cupboard doors are a brilliantly original solution to storage – just limewashed planks with fabric stretched behind them. A rococo mirror frame (sans glass, sans gilding) is hung asymmetrically above the chimneypiece and is as feminine in character as the antique chandelier. Throughout this small but highly flexible living-space, colour is a harmonious suffusion of creamy whites and honeyed beiges.

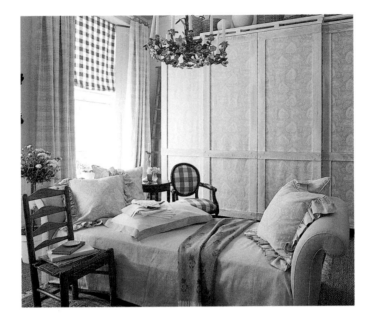

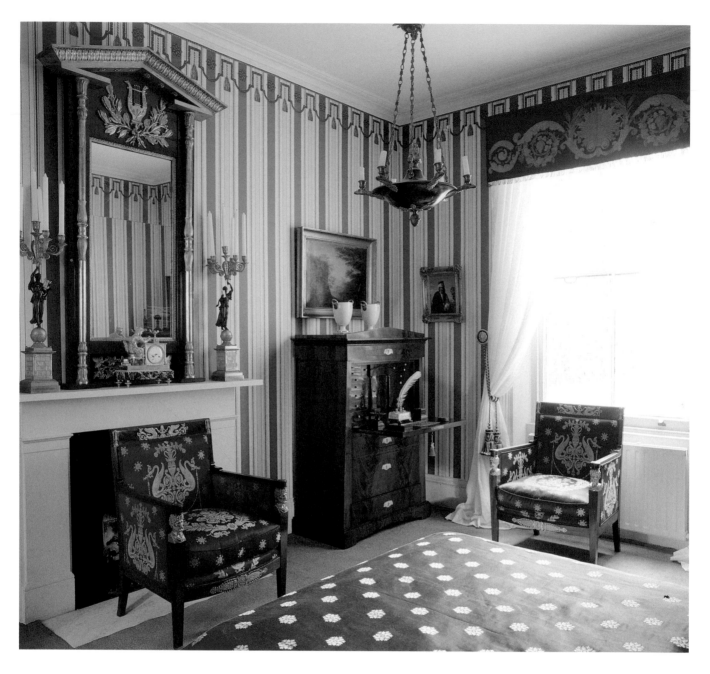

# Imperial grandeur

These two interpretations of the French and Swedish Empire styles are authentically bold in their amalgamation of intensely coloured silks, Napoleonic campaign-tent stripes and severe furniture. In the bedroom shown above, the 1810 French chairs have brilliant cerise-and-gold upholstery, while the French silk pelmet is off-set by a pair of simple white muslin curtains, held back by tasselled ropes reiterating the motif on the frieze. The small bedroom illustrated oppposite has a swagged and fringed pelmet of vibrant blue silk taffeta, with curtains again made of muslin. Crowned by a gilded eagle and muslin canopy, the Swedish Empire mahogany bed is perfect for the room's narrow proportions. The chest-of-drawers and armchair are also Swedish Empire. Both interiors were designed by Rupert Cavendish.

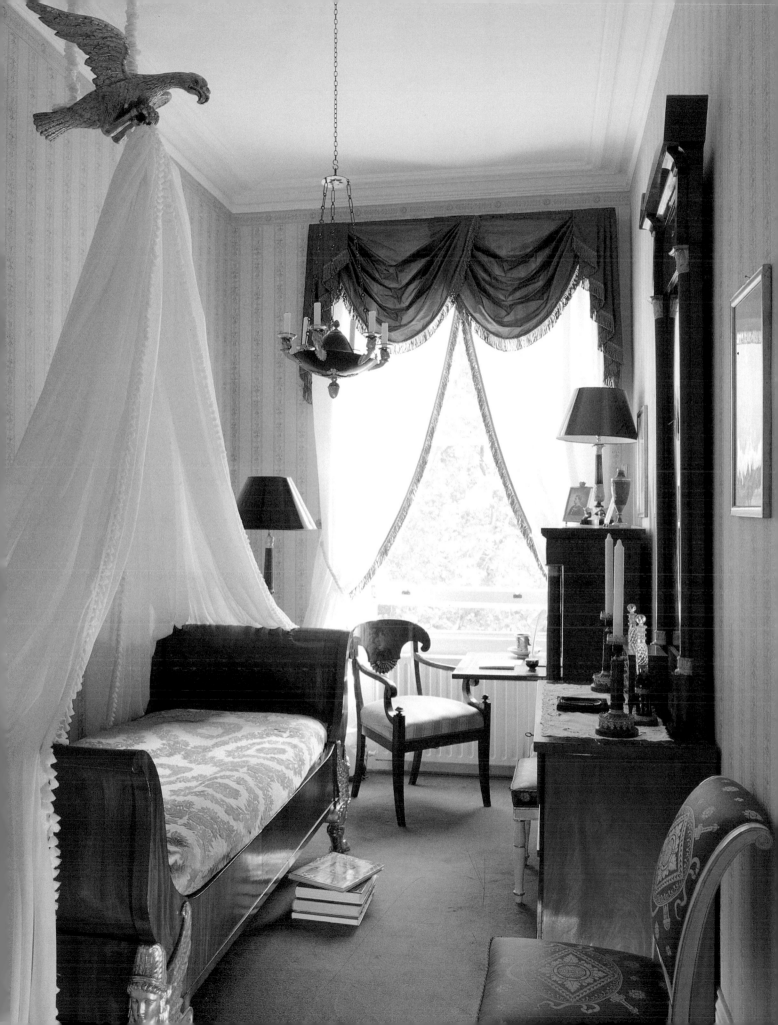

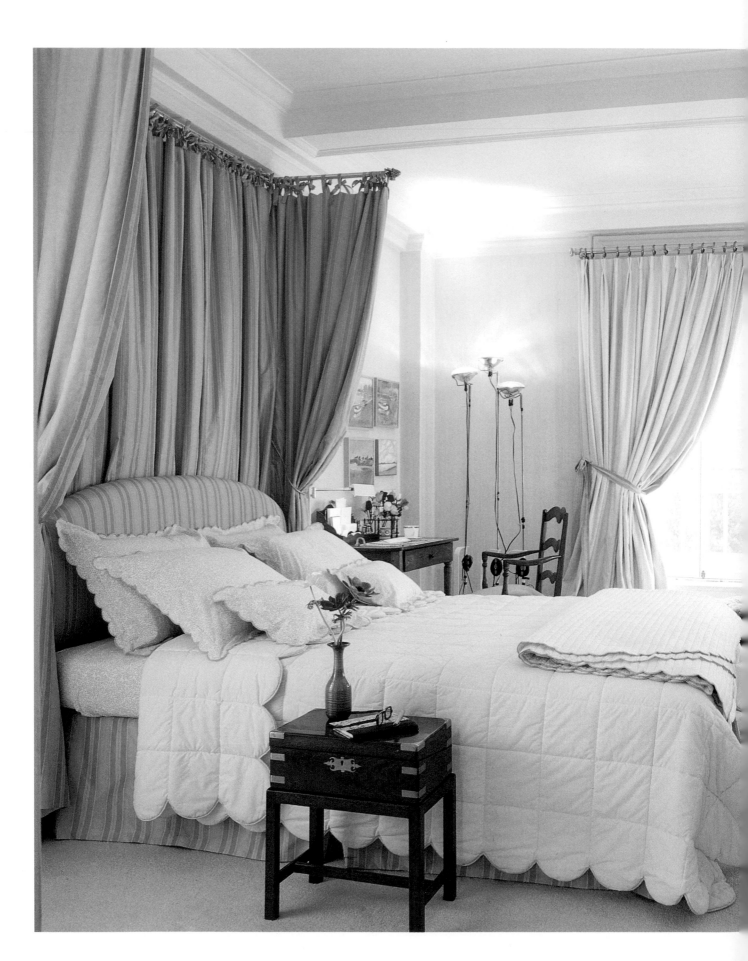

# Complete retreat

For artist Renée Graubart, the most important feature of the bedroom in her apartment in New York is that it is a tranquil, cosseting haven from the frenetic clamour of Manhattan. The colours are utterly serene, and although all the room's major surfaces are plain, there is sufficient texture to imbue the interior with interest and voluptuous comfort. The heavy curtains at the window fan out onto the carpet; the bed is covered with layers of scalloped quilts and pillows; and the bed-head is hung with gathered sage-green-and-peach striped silk. A nineteenth-century tapestry-covered ottoman, a French marble chimneypiece and a writing-table complete the retreat.

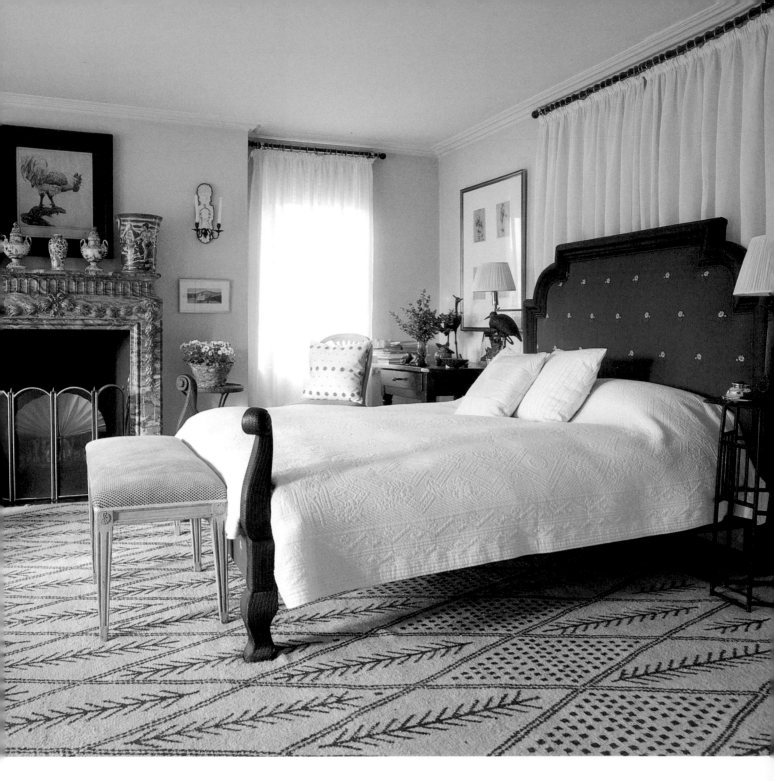

# Cohesive and well composed

The reason why this room in central London looks so serene and well composed is explained partly by the continuity of curtain treatment. The diaphanous fabric suspended from slim black poles at the windows is also used as a hanging behind the bed. In the latter context, it softens the transition between the wall and bedhead. Another factor contributing to the room's poise and cohesion is the discriminating choice of colours, based mainly on pale ivory-beige and blue,

highlighted by black. The geometrically patterned carpet underpins the scheme whilst maintaining its essential lightness. The bed is a handsome Spanish design in carved wood, but the 'carved' frame of the Thirties mirror above the chest-of-drawers is in fact painted canvas. The room is in a flat in a converted Victorian mansion, replanned and redecorated with advice from architect Nicholas Johnson and interior designer Hugh Henry.

# An elegant geometry

This room has the sort of individual, off-beat chic that confirms it is the province of people with a confident and discerning eye for design. It belongs to photographer Keith Scott Morton and his journalist/designer wife Chris Churchill who live in a sunny twelfth-floor apartment in a 1927 block in New York's Upper East Side. The room has good proportions, with sufficient ceiling height to warrant a four-poster bed - but this is a four-poster with a difference. With its elegant geometric interplay of curved and straight lines, it is a finely-tuned, contemporary variation on the traditional theme. The bed and many other pieces of furniture in the room were designed by Chris Churchill, and some (such as the cupboard seen in the picture above, have been given a simulated parchment finish which was popular in the Thirties. There is a subtle cross-reference between the open, arched design of the base of the cupboard and the bedhead.

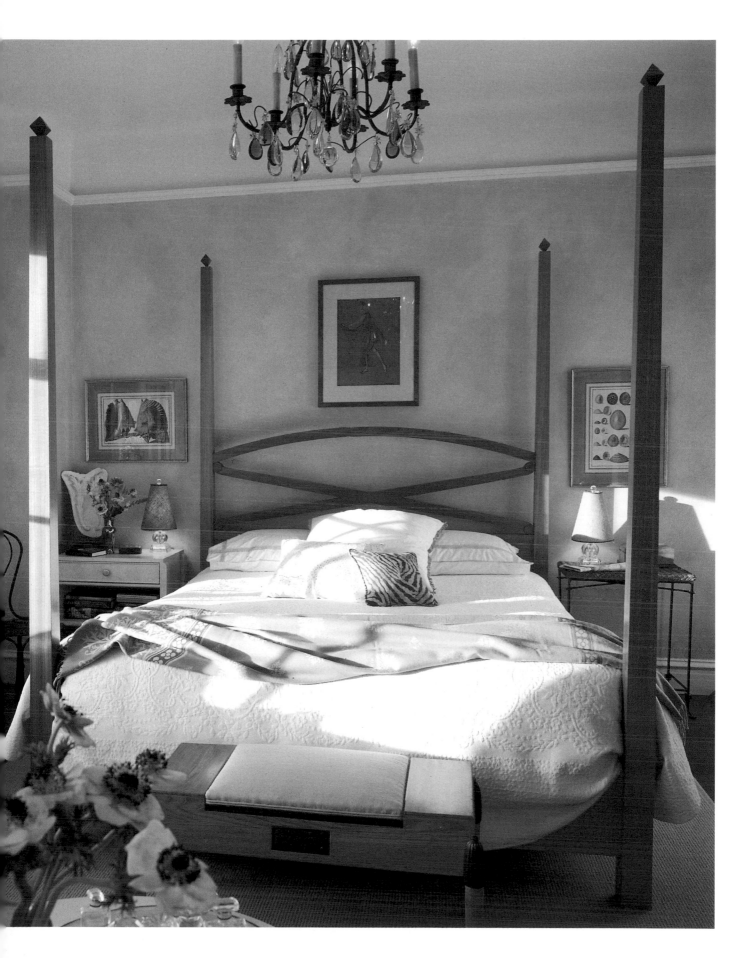

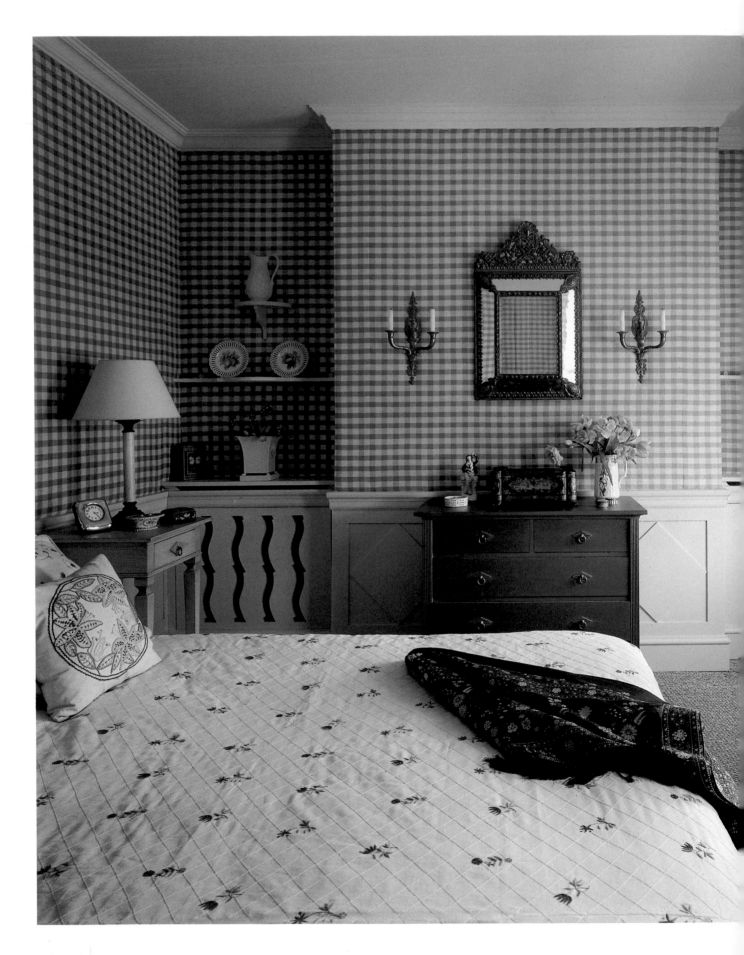

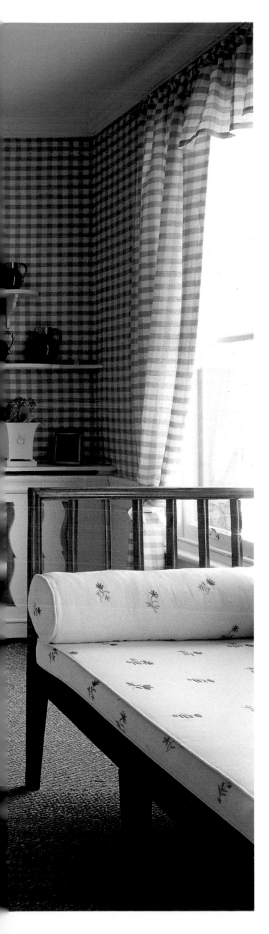

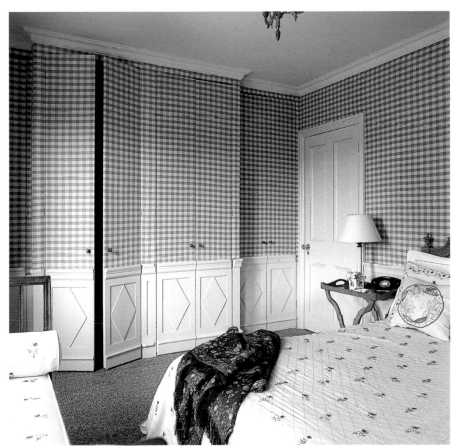

# Unfussy patterns and gentle colours

The formality of stripes and checks looks especially well in rooms in urban settings. Direct and unfussy, these patterns have no grand country-house pretensions and are quiet, controlled counterpoints to the bustle outside. In Sasha Waddell's London bedroom, checked fabric is used on the walls and repeated for the curtains. The colour-scheme is restrained, forming an effective backdrop for decorative antique ornaments as well as for some of Sasha Waddell's own furniture designs. The dado (which cleverly includes open-work panels concealing radiators in the recesses) prevents the check motif from becoming overpowering. Another clever decoration point to note is the treatment of the cupboard doors.

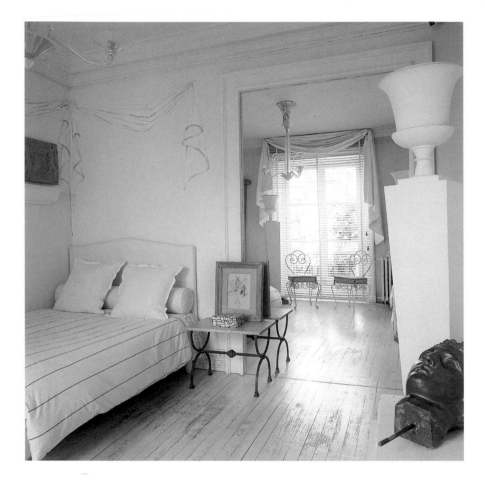

# Exploiting and enhancing light

Simple but packed with panache, this all-white interior in Paris is a sophisticated exploitation of the natural light coming through the large window and of the reflected light from the similarly-sized panel of mirror on the opposite wall. Designed by Frédéric Méchiche, the room has a pelmet made of plaster, echoed by *trompe l'oeil* drapery painted on the walls. The minimal, modern furniture – a bed, two curlicue metal chairs, a stool and a low X-frame table – is eclectic and fashionably in accord with the classical urn and sculptured head.

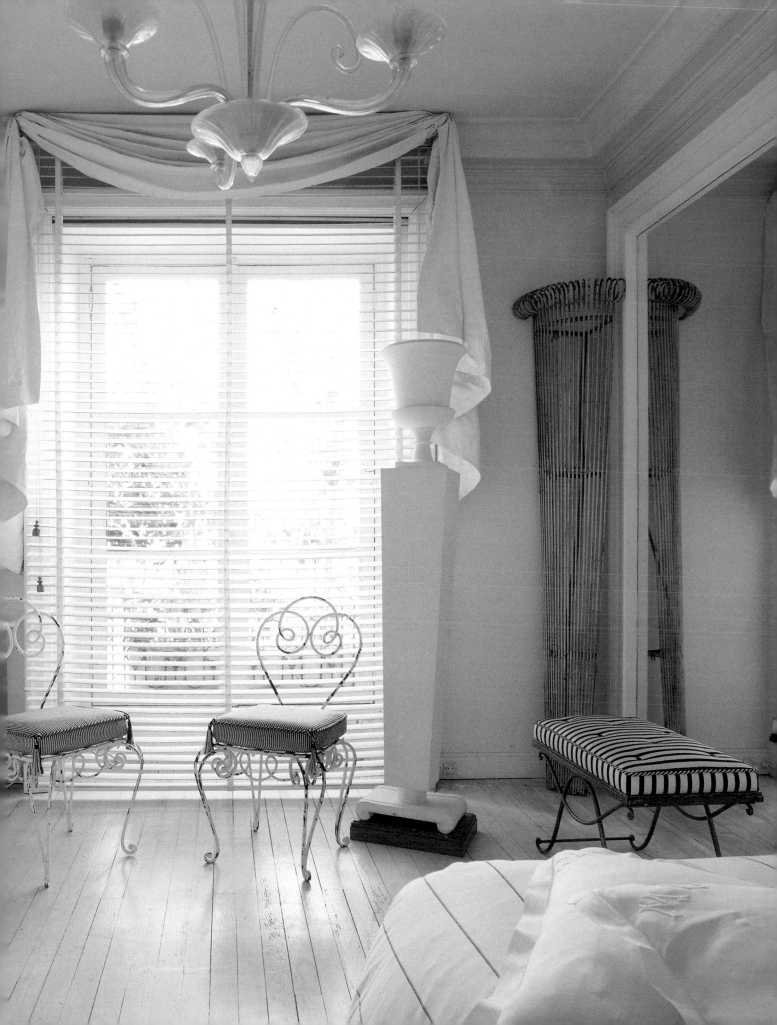

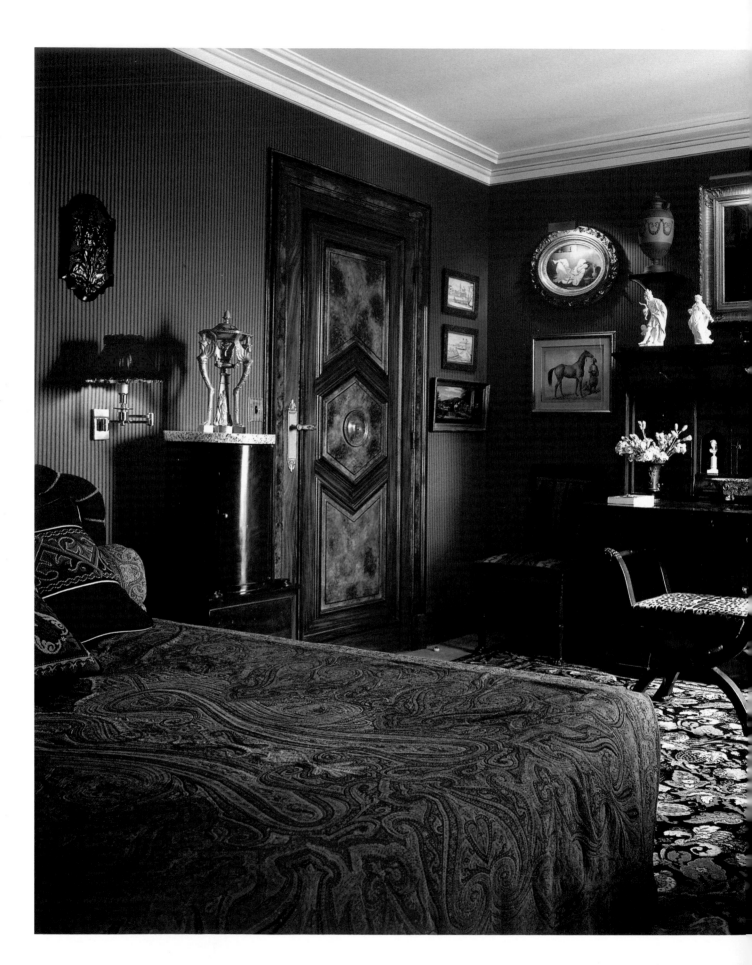

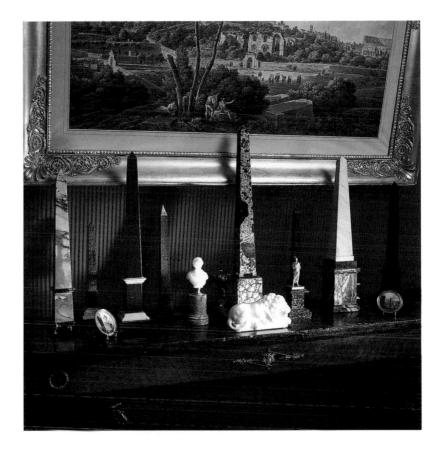

# Decoration for connoisseurs

This room, decorated by Claude Bouzon and Michel Badiller, is rich in antiquarian interest, combining early nineteenth-century furniture with collections of obelisks, figures, pictures and urns. The setting for these groups is intensely coloured in deep reds and greens, with further enrichment derived from the wood-graining on the door which skilfully imitates walnut and mahogany. The compatibility of the room's contents and its decoration suggests connoisseurship and an understanding of interior design which is urbane as well as urban in character.

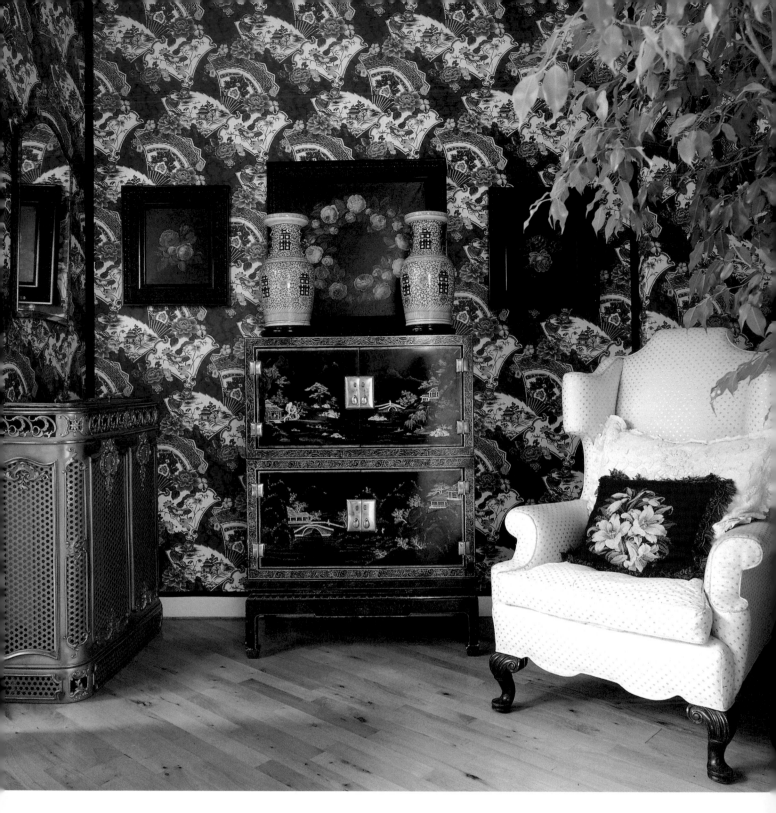

# Playing to the gallery

A gallery inserted in the converted ballroom of an Edwardian mansion in London makes a compact bedroom (opposite, below) with stepped cupboards acting as a base for a lion and Chinese pots. Against the mirror-faced wall behind the bed is seen one of a pair of reeded half-columns which, in reflection, looks completely round and intriguingly appears to support two vases. Beneath the bedroom is a small study (this page and opposite, above), the two areas being linked by a curved staircase and an integrated decoration scheme of blue and white. Making a virtue out of a necessity, the radiator in the study is concealed behind a decorative French brass grille. Interior designer: Michael Reeves.

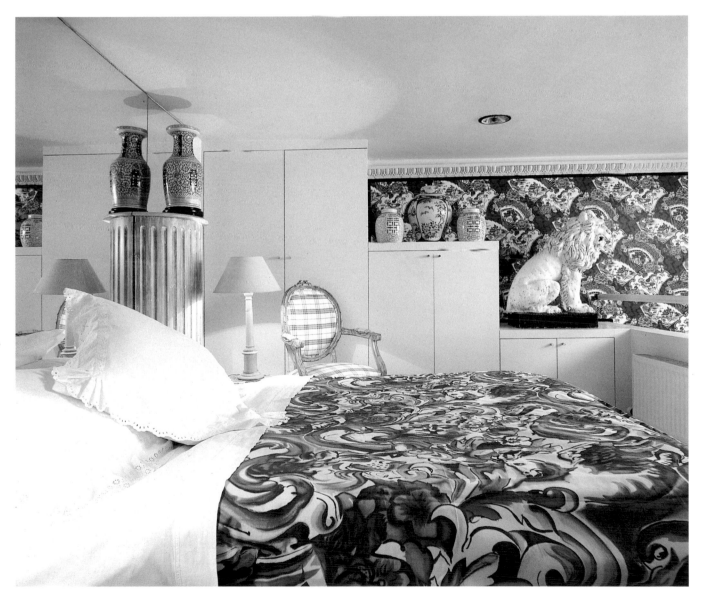

# Spatial challenge

The design challenge of placing a large Japanese bed in the centre of a window bay was overcome by building a low wall which acts as a bedhead and allows natural light to reach the writing-desk behind. The desk, designed by Mark Brazier-Jones, is made of bronze, steel and marble, while the Thirties cabinet beneath the window is of glass and sycamore. To give a more symmetrical form to the bay, a pair of niches has been carved out of the wall on either side of the window. These house artworks, reflecting the contemporary taste of Elizabeth Delacarte, the owner and designer of the apartment. With painted floor-boards and pale stuccoed wall finish, the flat also demonstrates its designer's philosophy that neutral colours create the illusion of space and are the perfect background for modern art.

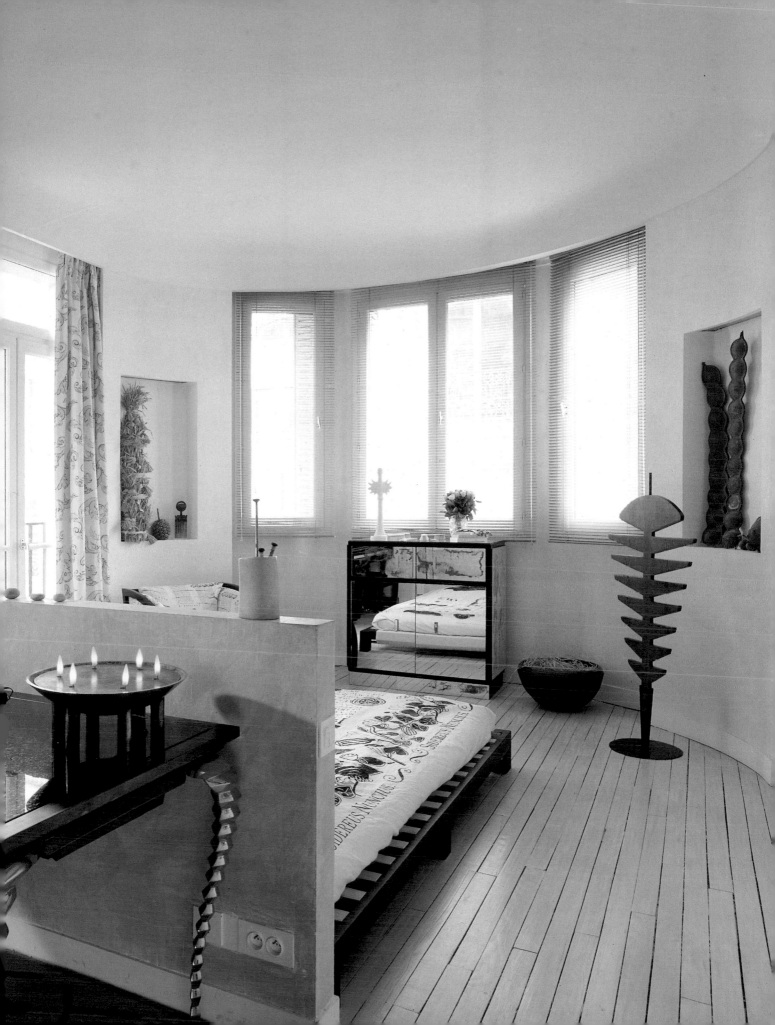

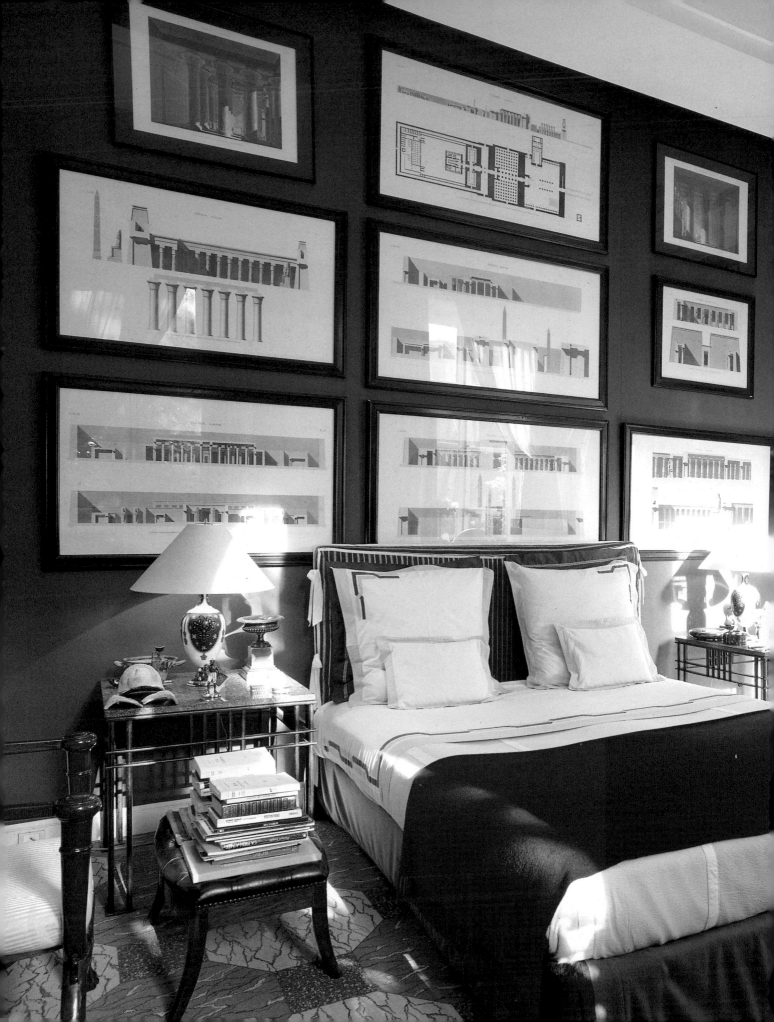

# Egyptomania

In a supremely confident scheme by François Catroux,
architectural drawings and watercolours of Egypt recall the
French fascination for Egyptian archaeology at the end of the
eighteenth and beginning of the nineteenth centuries. Massed in
formal, aligned arrangements, the pictures are hung against
cinnamon-coloured felt, providing a soft-textured counterbalance
to the austere style of the illustrations. The architectural theme is
dramatically interpreted in three-dimensional form in the deep
cornice and a pair of fluted columns. Vivid red lends vitality to
the otherwise neutral colour scheme. The carpet was inspired by
the marble foyer in the Théatre de l'Odéon.

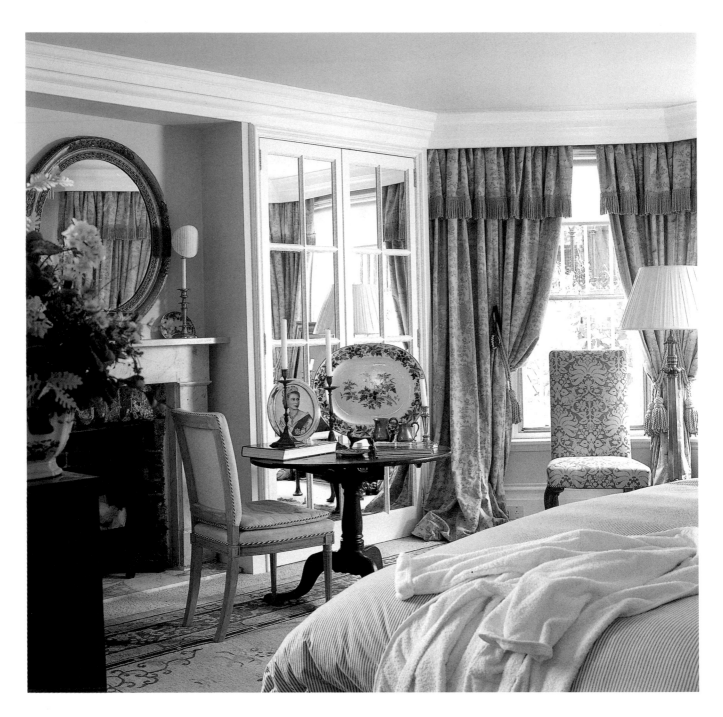

# Mirror images

With its black-and-gilt furniture and strong colour scheme, the bedroom of interior designer David Easton (right) has a distinct masculinity about it, but that does not mean it lacks comfort or personal touches. To either side of the Regency bed are tall cabinets which serve the dual purpose of bedside tables and bookcases. Most importantly for reading in bed, there are well-placed wall lights on hinged arms. The room shown above also has a rather masculine character allied with comfort. And here, too, mirror makes an interesting contribution, enhancing the daylight and adding sparkling reflections within a scheme of subdued colouring. The panels of mirror used to face the doors of the cupboards are sized to follow the pattern of the window glazing. The room is in the London flat of designer Ivan Speight.

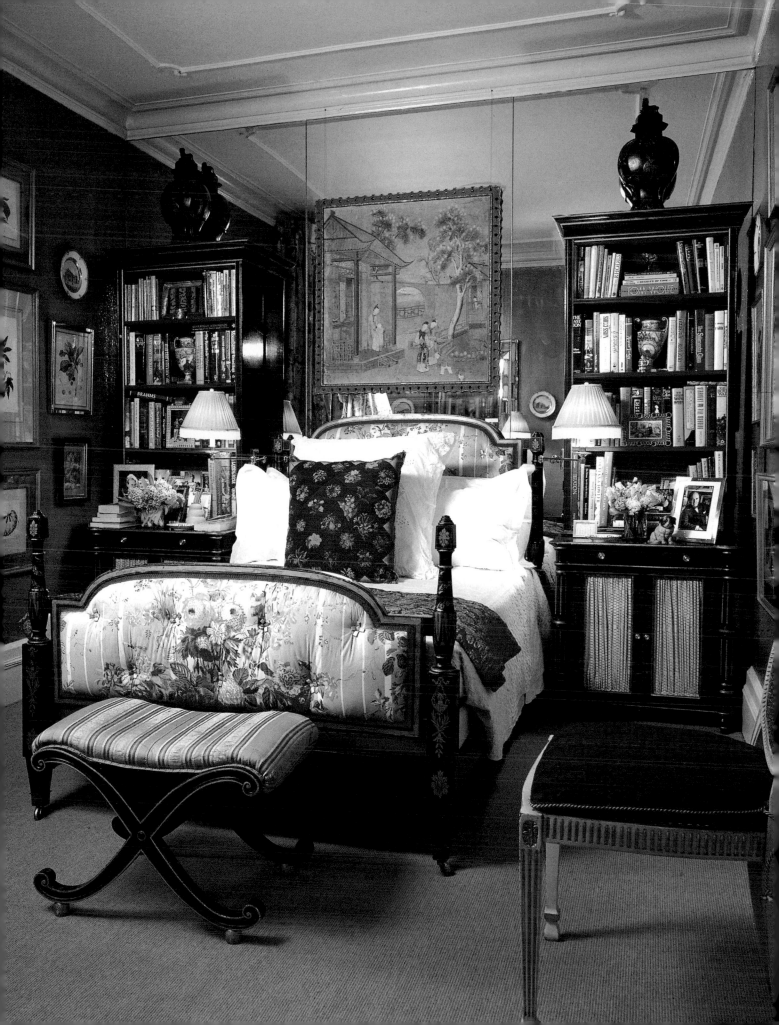

# UNDER THE EAVES

*With their quirky shapes and air of seclusion, attic bedrooms are intrinsically appealing. Sloping walls and exposed beams make a characterful basis – and stimulating challenge – for different decoration treatments, ranging from flower-sprigged wallpaper to plain white paint.*

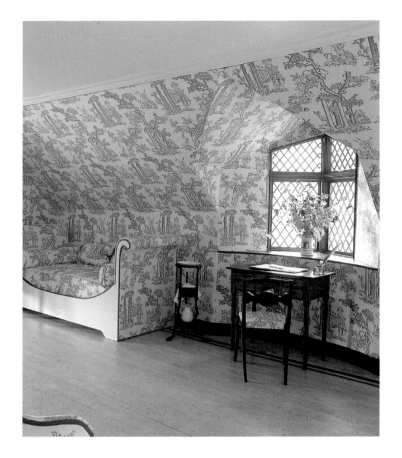

# Nostalgic imagery

Evocatively situated beneath the eaves, and decked out with
fabrics of exquisite charm, these two rooms encapsulate today's
nostalgic image of the attic bedroom. Geographically, they are
continents apart – the one shown on the left is in upstate New
York, while the room above is in Ireland – but architecturally and
decoratively they share many characteristics. The most obvious
structural similarities are in the sloping ceilings and the unusual
fenestration which, in the American example, is a half-height
window and, in the Irish room, is a triangular dormer. Both
interiors have plain wooden floors; and both have walls covered
with *toile*. The yellow room is in the home of Murray and Albert
Douglas, a school-house dating from 1894 which was converted
in the late Sixties. Its latest redecoration was carried out by
Murray Douglas with the help of her friend and decorator Nan
Hemingway. Lined with a fabric by Brunschwig, the bedroom is a
beautifully considered interior, where there is an overall
harmony but also an inspired piece of unpredictability in the
optically patterned rug. The blue room is in an early nineteenth-
century *cottage orné* in County Tipperary which has recently
undergone a major programme of restoration instigated by Sally
Aall. Called The Swiss Cottage, it was supposedly designed as a
trysting place for the Earl of Glengall and his mistress, a legend
borne out by its hidden-away setting and air of romance.

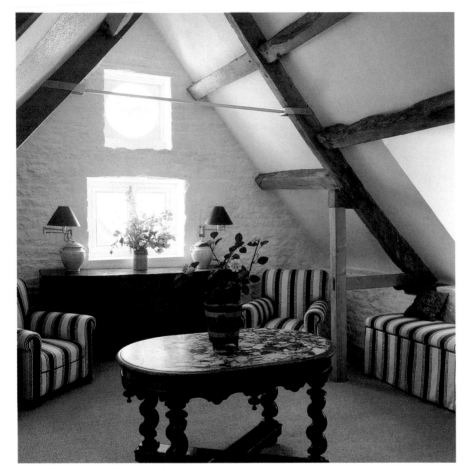

# White unity

White is a great architectural unifier and never looks out of place
in a country conversion. Here, the uneven texture of the brick
walls at either end of the room is perfectly integrated with the
smoother planes between the beams. Very few, if any, colours
would work as well as white in such a setting, especially on the
exposed brickwork. White also has a pristine quality which suits
a trim, uncluttered style of furnishing and enhances natural light.
This room was converted from a hayloft in a former coach-house
in the Cotswolds, where American decorator Robert Hering
carefully preserved the unpretentious character of the building
whilst turning it into an extremely comfortable home. The
conversion – in which he was aided on the architectural side
mainly by Peter Yiangou, working with Ugo Sap – involved
inserting new external windows and an internal opening above
the bed. This inside 'window' overlooks (and receives borrowed
light from) the sitting-room on the lower level.

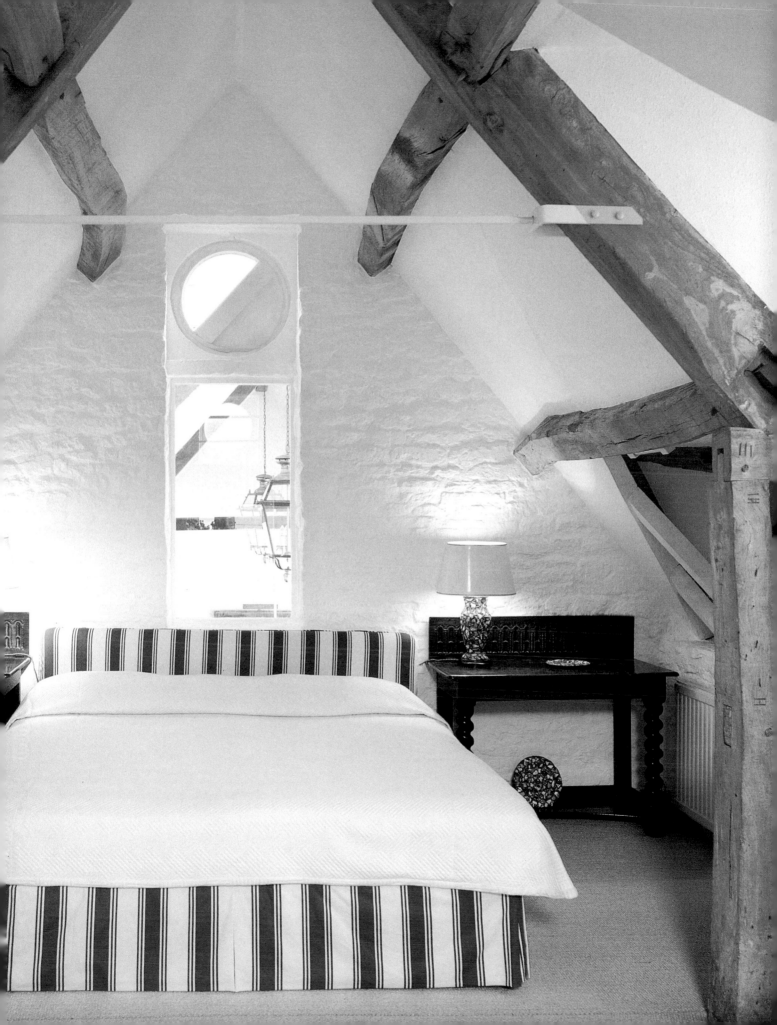

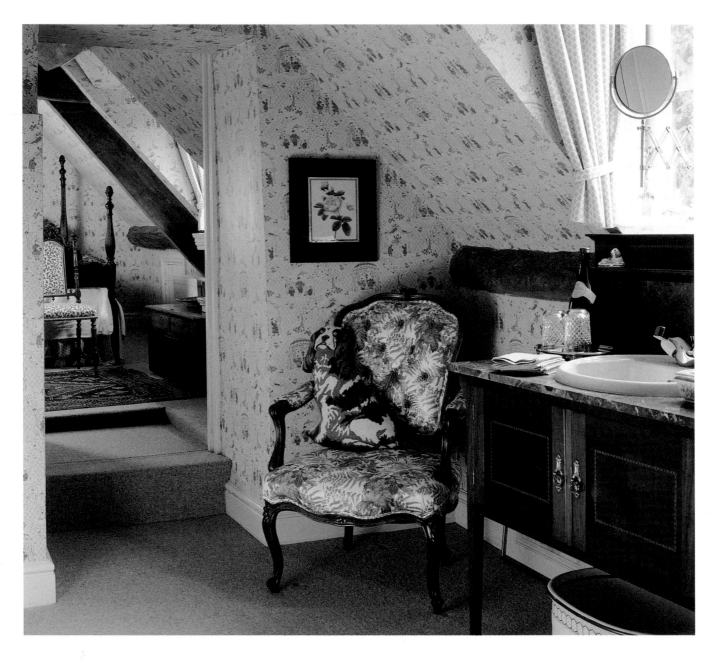

# Pleasing polarities

This room by Paul von Fullman is in a town in Wiltshire but its structure and character give the impression of a cottage deep in the countryside. Although the style of the furnishing is more sophisticated than the architecture, the effect is not ostentatious, and there is a pleasing polarity between the massiveness of the beams and the refinement of the furniture.

The twin beds, with their elegantly slender posts, are American; the two upright, Victorian children's chairs are English. In the adjoining bathroom, which is decorated with the same blue-and-white Chinoiserie wallpaper, an Edwardian marble-topped washstand has been adapted and plumbed to take a modern basin.

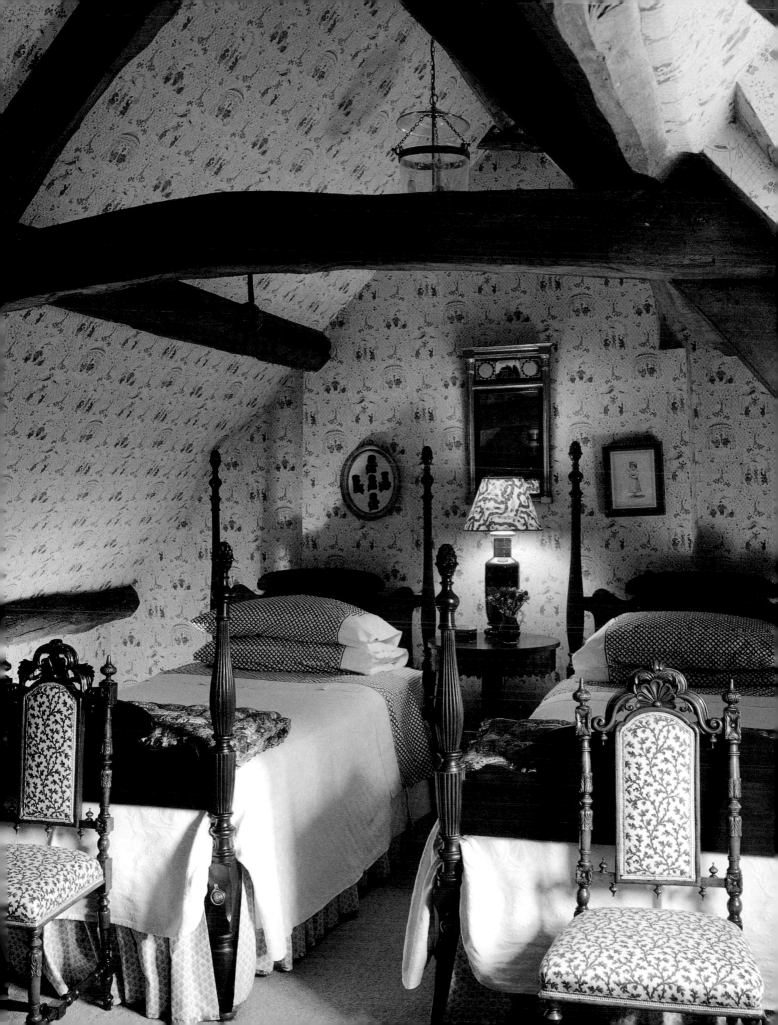

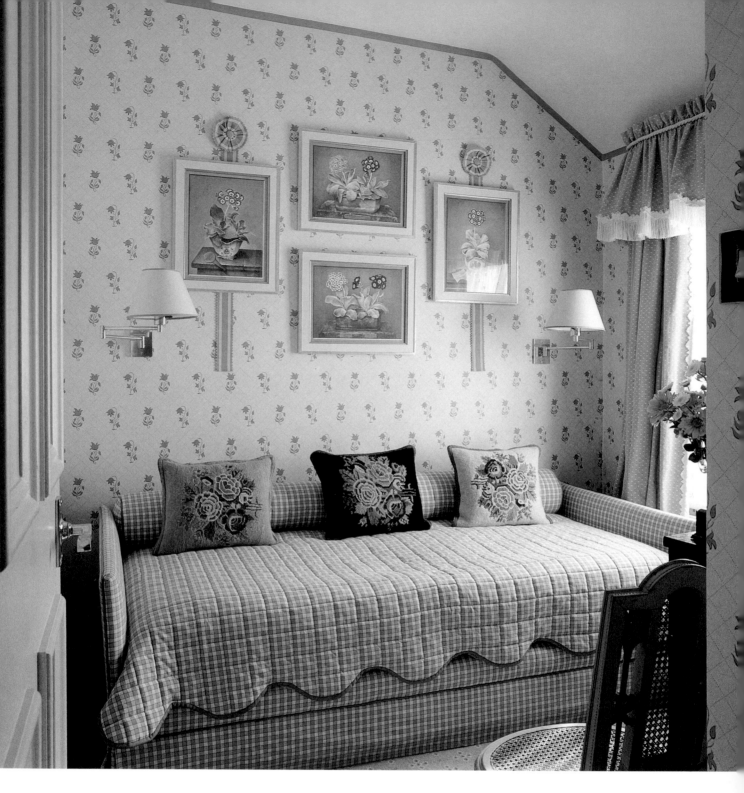

# A celestial colour scheme

The room shown opposite is a lyrical composition in blue and ivory: two peerlessly complementary colours which are employed here in many and varied ways. The wallpaper is prettily sprigged; the fabrics have polka-dots, checks and stripes; and the canework bedhead and stool have a painted trellis. Even the frame of the mirror above the sofa is creamy-white to harmonize with the scheme. The decoration and furnishing are utterly feminine and have a nostalgic charm which is also apparent in the adjoining dressing-room (above), with its upholstered bed and attractively scalloped quilt. The scheme was devised by Liz Ward for her London mews home as a scaled-down echo of the family's manor-house in Oxfordshire. She was assisted in the decoration of the mews-house interior by Elizabeth Neilson.

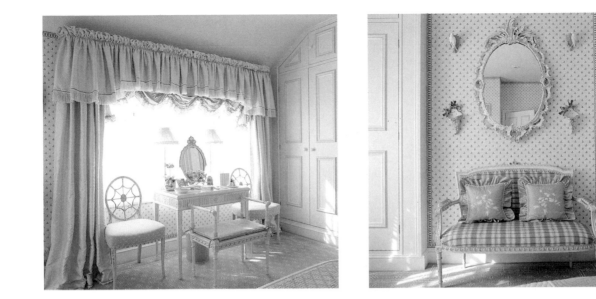

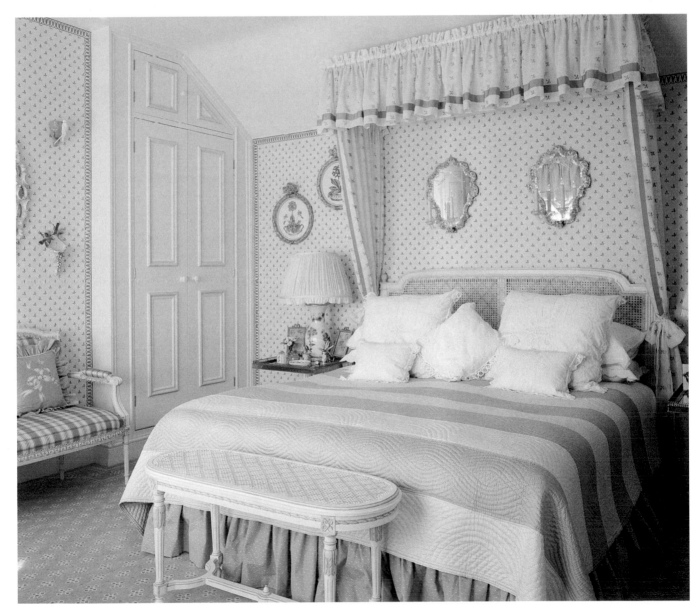

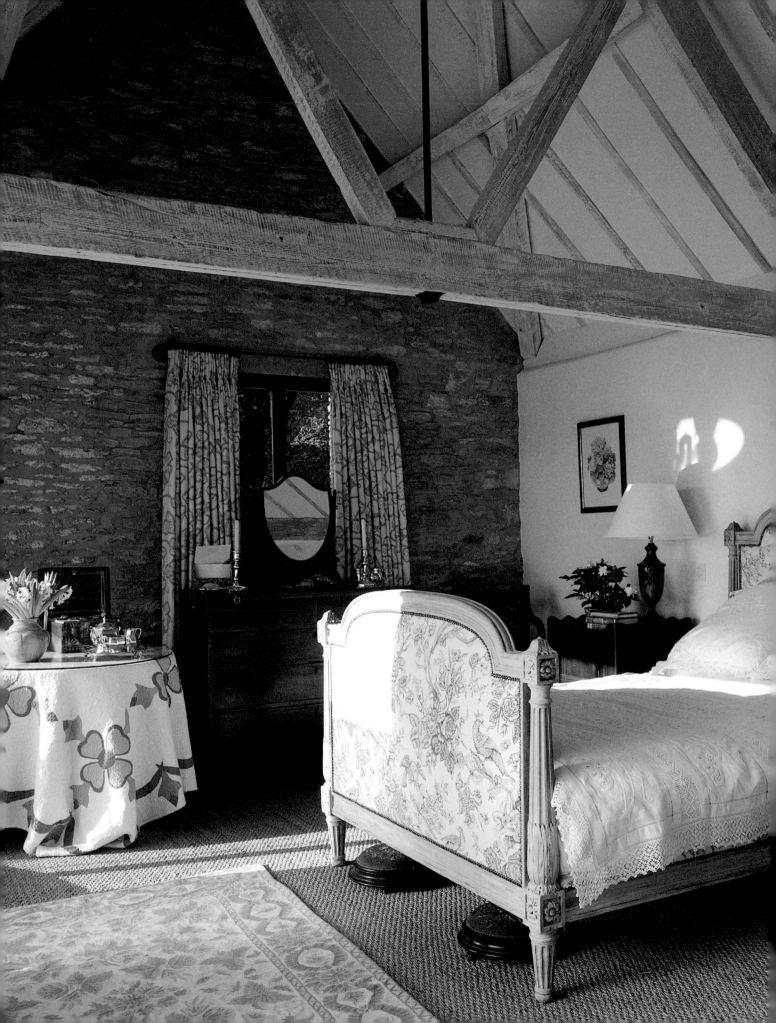

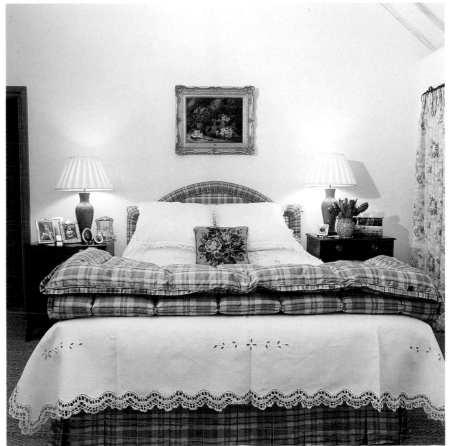

# Contrast and balance

Unless handled with care, contrast can be a disquieting feature in interior design, but in the country bedroom shown on the left, the disparity between the exposed stonework and the upholstered bed achieves a happy equilibrium between hard and soft. Equally, the contrast between the mellow, honeyed tones of the stone and the white of the plaster seems perfectly natural and in no way harsh – partly, perhaps, because there is a midway colour link in the limed finish of the beams. White also proves to be a satisfying choice in another, smaller bedroom (above) in the same building. The appeal of this room lies in its apparent simplicity, but this is simplicity of a very sophisticated and imaginative kind, incorporating finesse and comfort within deliberately plain surroundings. Both rooms are in a converted Cotswold barn where the interior was reorganized by architect Peter Yiangou, and the decoration was carried out by Henrietta Holroyd.

# A dramatic interplay

When Pieter Brand remodelled the loft of a 1901 Arts and Crafts studio in London for the international stage designer and director, Stefanos Lazaridis, he accomplished a feat of engineering as well as decorating. He had to cut into the framework of the roof, insert dormer windows and a new floor, all without causing structural mayhem; and he was also mindful of the need to introduce a feeling of comfort without eclipsing the intrinsic drama and light of the huge, triangular space he was confronted with. He left the wood bracing and metal straps exposed and undecorated, their basic functionalism generating an intriguing interplay with the carved intricacy of the Indian pilasters. The furnishing is a further mixture of Eastern and Western cultures, ranging from oriental rugs to Georgian chests-of-drawers. A secretaire provides a practical place for writing in an area lit by one of the dormers. Tongue-and-groove boarding is a warm, unpretentious finish to the window surrounds and between the rafters.

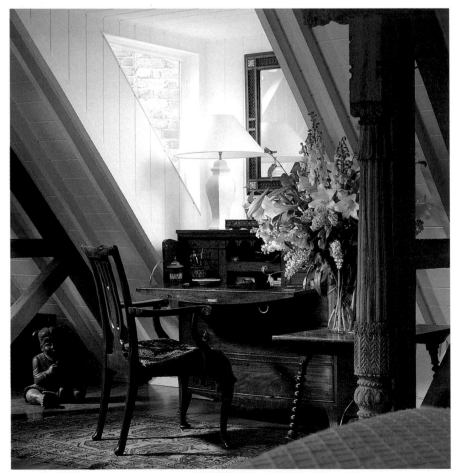

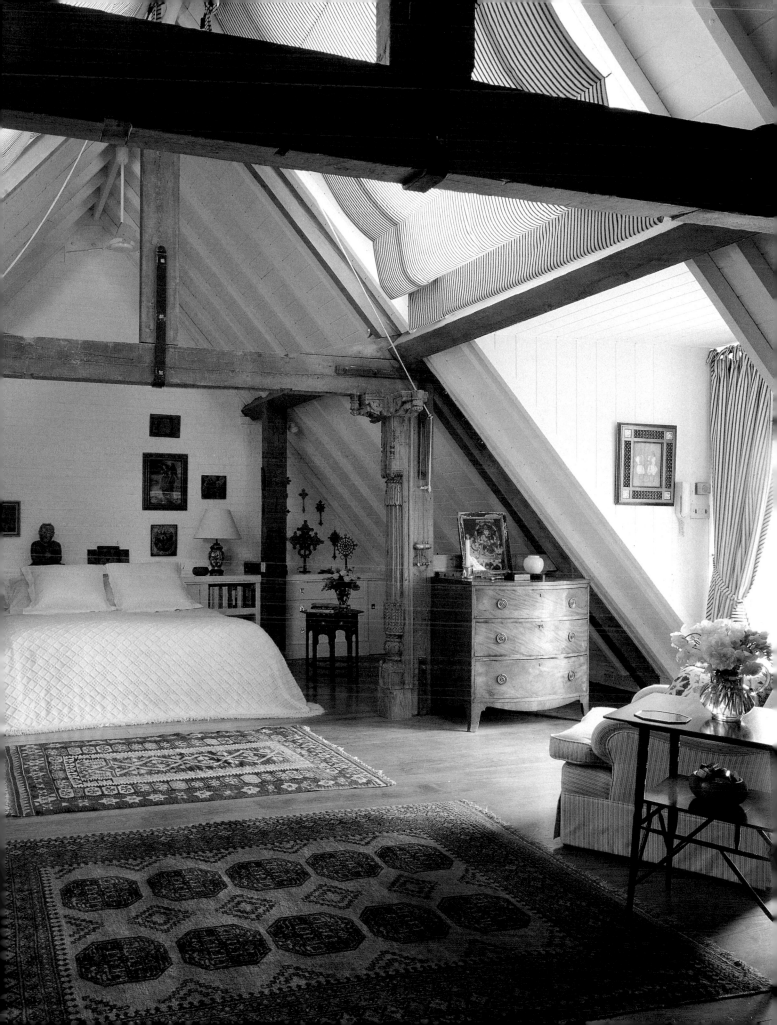

# A stylish simplicity

When decorating an attic bedroom, there is a strong temptation
to paper the walls with small, flowery patterns in an attempt to
recreate an idealized Edwardian cosiness, but a simpler look, as
seen in these contrasting schemes, can be altogether more
stylish. The light, unfussy room shown above is in a flat at the top
of a mid-Victorian mansion in West London, re-planned with the
help of architect Nicholas Johnson, while Hugh Henry assisted

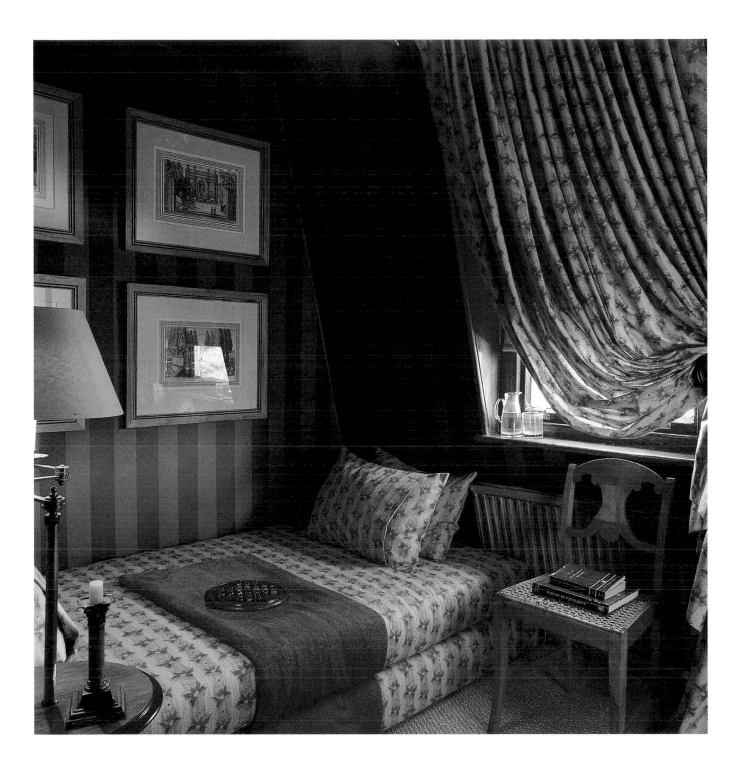

the owner with the decoration. Pattern has not been totally
excluded, but it is restrained and disciplined both in form and
quantity. The same stripe is used for the bedhead and blind,
while a bolder stripe is seen in the African blanket. Stripes also
play a part in the decoration of the diminutive guest-room
illustrated on this page, designed by Mimmi O'Connell, but here
they cover the walls and ceiling in two tones of forceful green.
Although the rooms have very different weights of colour, they
both display a clear, assured approach to design.

# A PLACE
# TO SIT

*The greatest bedroom luxury of all is space, lots of it, enough to make a twenty-four-hours-a-day retreat, complete with really comfortable seating—not just a single chair but a sofa or chaise-longue—and maybe a writing-desk and an open fire.*

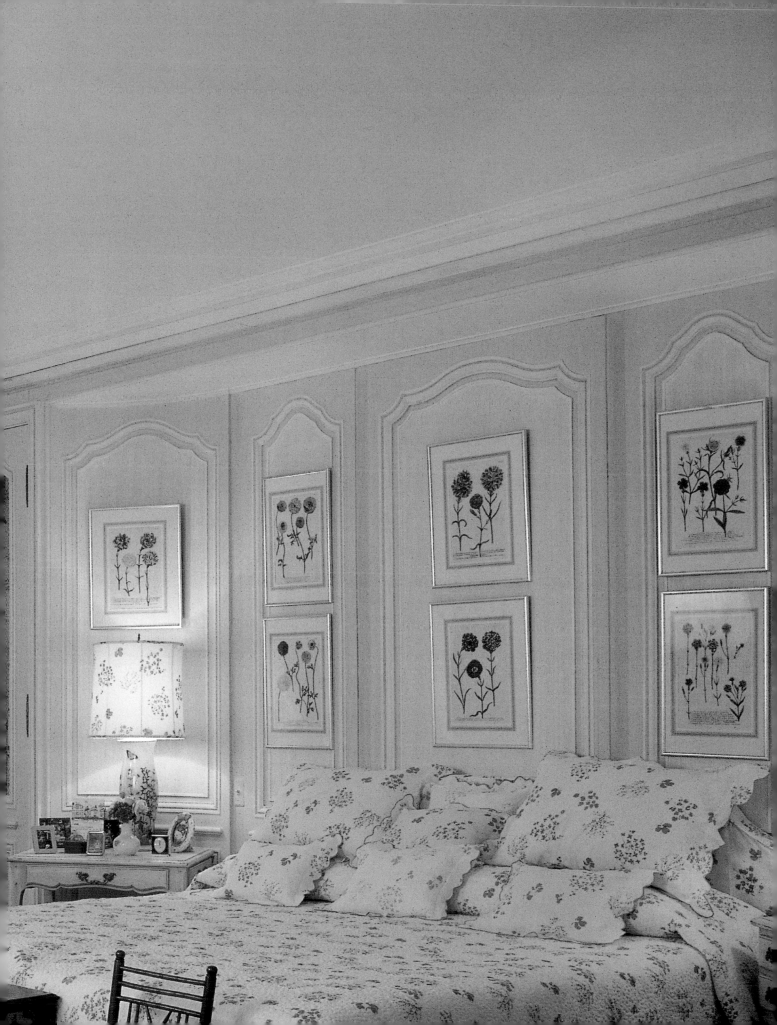

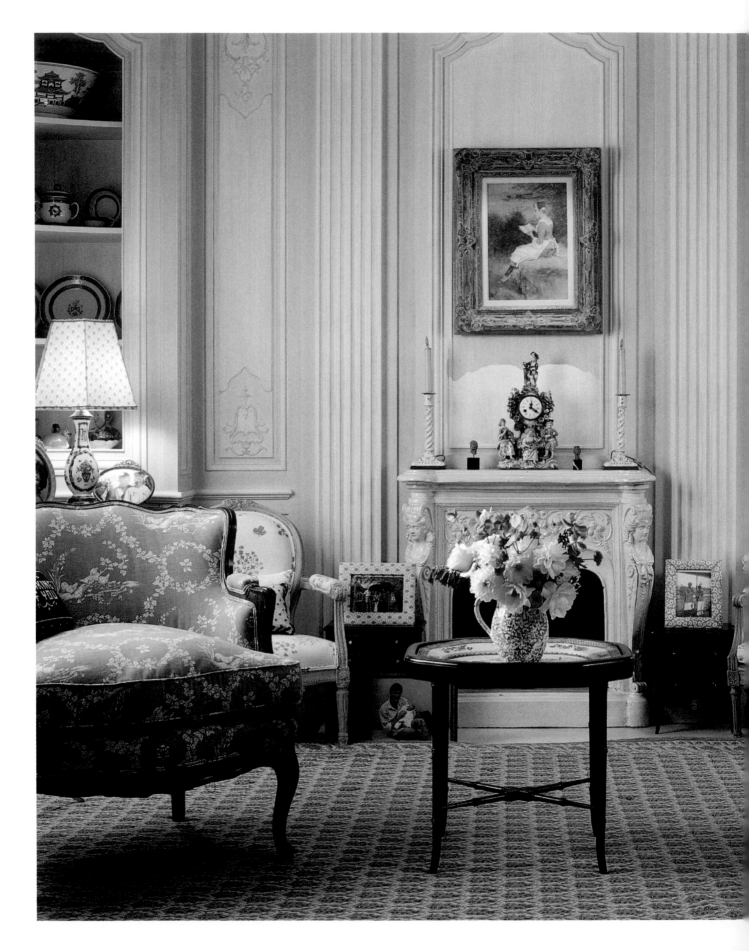

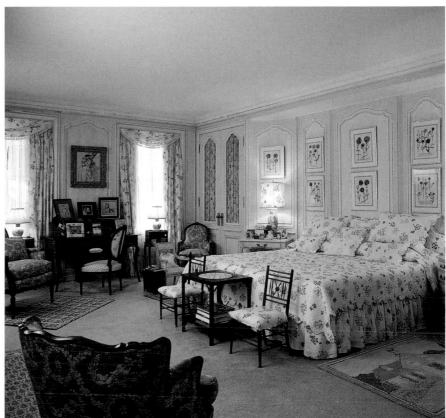

# Botanical themes

A blue-and-white colour scheme accentuates a ravishing display of architectural mouldings whilst forming the prettiest of backgrounds for eighteenth-century German botanical prints and a collection of Chinese export and European porcelain. The room is in a pre-war apartment in New York which still boasts its original features, including the attractively carved chimneypiece. The only alterations Robin Duke made to the room when she and her husband Ambassador Angier Biddle Duke bought the flat were to remove the doors from the alcoves to either side of the fireplace (where the ceramics are now displayed) and to substitute shirred fabric for the solid panels on the fronts of the cupboards. This lightens the effect and coordinates with the linen used for the curtains and bedcover. French-style armchairs with low, curved backs and deep seat-cushions are covered in a complementary blue-and-white print.

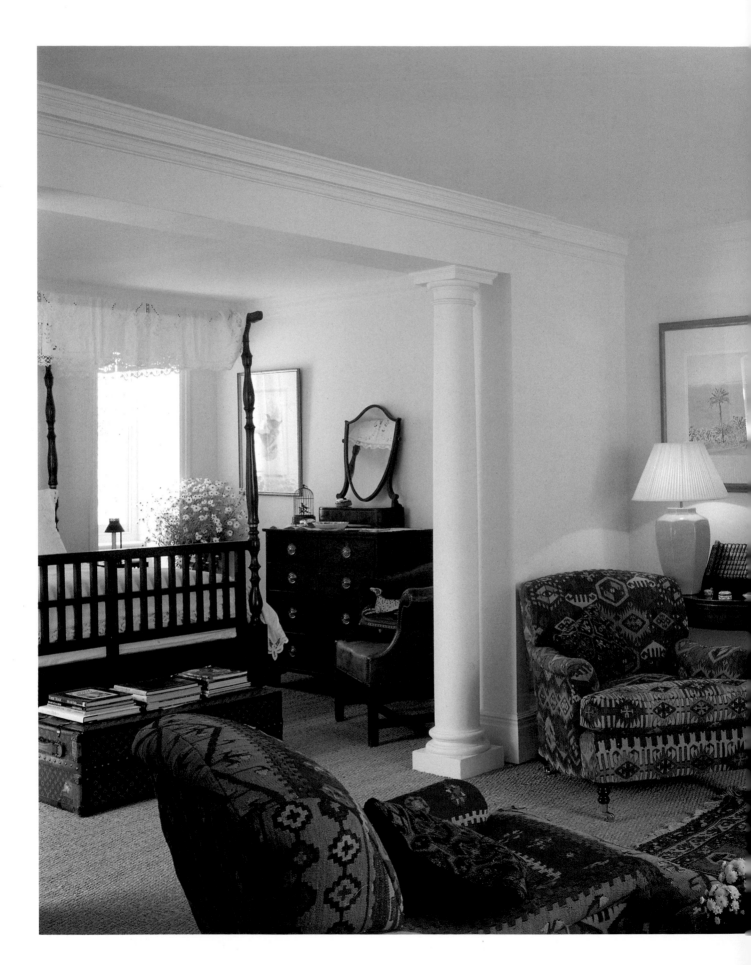

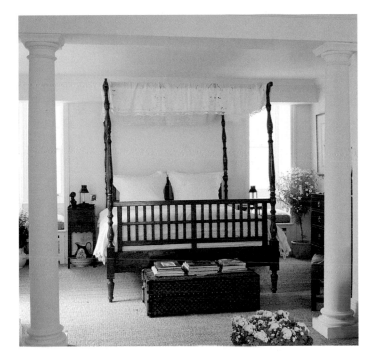

# Three-piece suite

This trio of interconnected spaces in a converted mews house forms a luxurious, twenty-four-hour living-area. A sitting-room with an open fireplace, a bedroom with a canopied four-poster and a bathroom with a recessed bath are integrated by plain white walls and an infusion of colonial influences. The Dutch-style bed has a diaphanous canopy made from an old, light cotton bedcover, while the floor is covered with seagrass and kelim rugs. The dark tones of the wood and the warm colours of the kelims – which are also used for upholstery – are comfortable and enriching. The decoration scheme was devised by Kerry Woodward Fisher for a property development by Fisher Land. Anthony Paine advised on the architectural side.

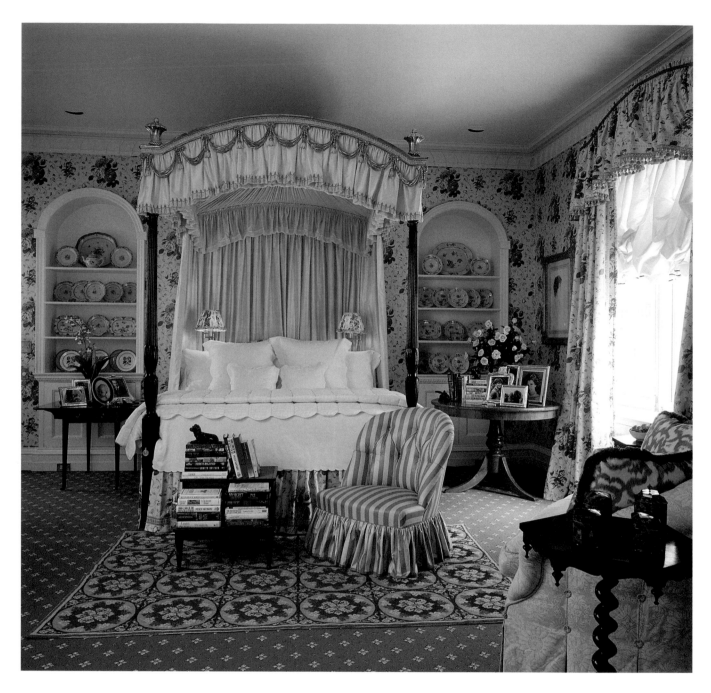

# A porcelain delicacy

Inspired by a collection of *famille rose* and Chinese export porcelain – part of which is seen in the arch-headed alcoves – the decoration of this interconnecting bedroom and sitting-room treads a well-judged path between grandeur and informality. Although the scheme incorporates exceptional pieces of antique furniture – not least the Regency bed and eighteenth-century Italian embossed leather screen – there is nothing museum-like or stultified about it. Infused with pretty patterns and colours, the two rooms exude an overriding sense of lightheartedness and intimacy. The spaces are linked by a broad opening, allowing a long axial vista from the bed to the fireplace whilst enhancing the spread of natural light from the large windows. The latter have elegant pelmets with arched contours similar to the tester of the four-poster bed. The abundance of daylight was one of the main reasons why decorator Hethea Nye and her husband were first drawn to the flat, but a considerable amount of restructuring of the internal layout was needed to suit their lifestyle and fine furniture. Hethea Nye was assisted in the project, particularly on the architectural aspects, by her partner Ralph Harvard.

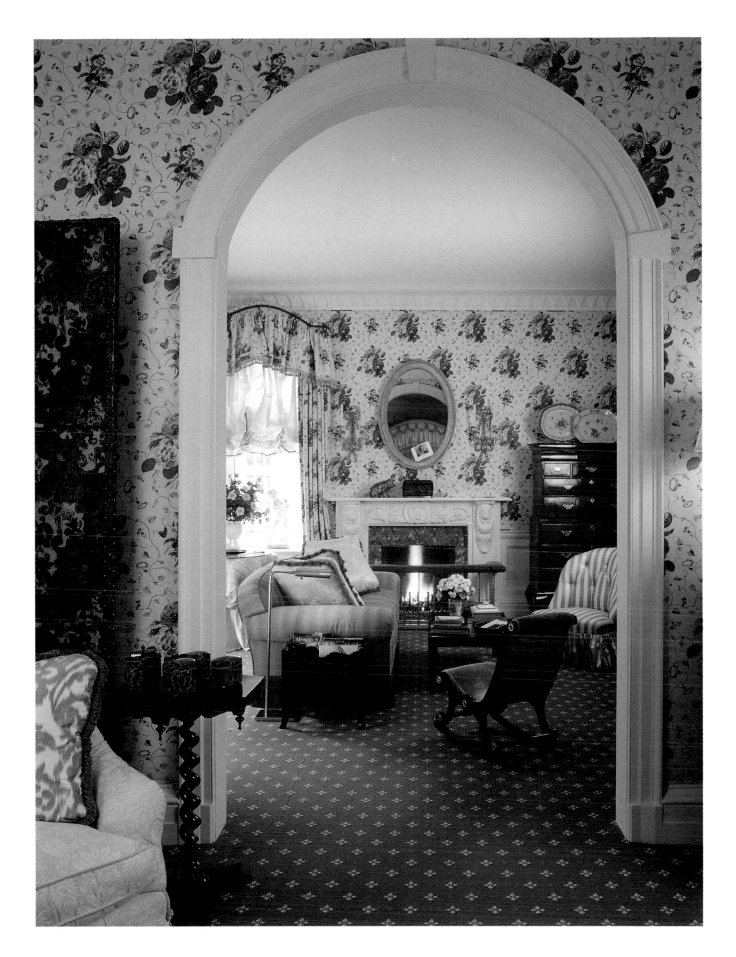

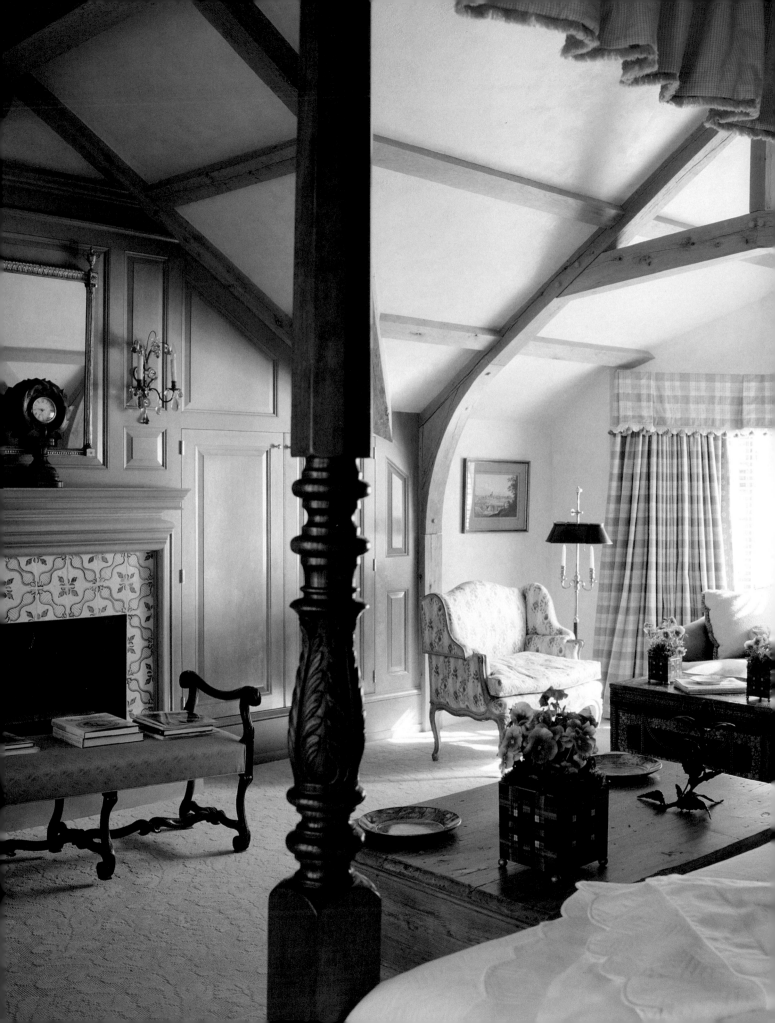

# Visual excitement

Rising to the challenge of planning rules which stipulated a steeply pitched roof for this recently-built house in the Colorado mountains, architect Mark Ferguson and designer Bunny Williams have made a spectacularly successful bedroom which is full of visual excitement and, by admirable artifice and invention, they have given it an uncanny feeling of maturity. Unplaned oak beams (hollowed out to reduce their weight ) have been stained to give a pale aged effect, and the poplar panelling has been painted and sanded to appear older and weathered. The room's rugged architectural finishes are skilfully matched by casual comfort, especially in the sitting-area where a large sofa, arrayed with cushions, is placed in the window bay.

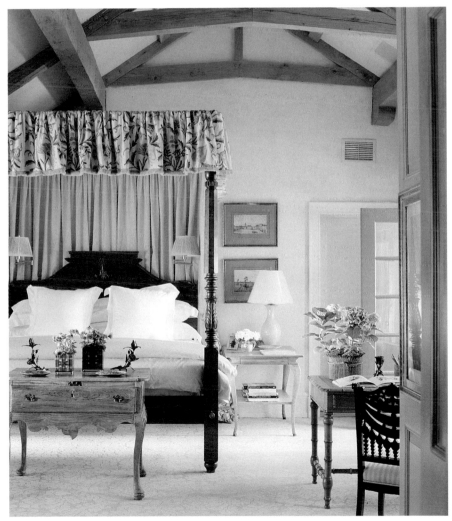

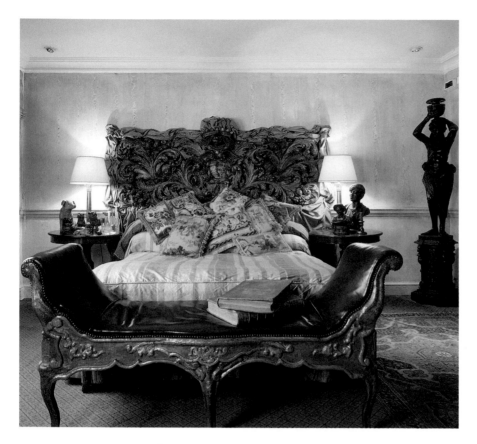

# Witty and flamboyant

This room is obviously the home of someone with individual taste
and a sense of humour. Although all the components are of
unusual quality and interest, they bear little relationship to one
another in period or provenance, and they are far from bland in
character, but the daring juxtaposition has amply paid off.
Antiques dealer Keith Skeel makes the point that, 'It's easy to
over-refine style and end up with a room that is ultimately safe
and boring.' This bedroom with integral sitting-area in his flat in
London is anything but boring and safe: Staffordshire dogs sit
amongst leather-bound books; a sixteenth-century armorial
carving forms a grand bedhead; heads and figures pop up on
tables and on the tall chest; above the painted wooden
chimneypiece is an Irish Regency mirror; and an early
eighteenth-century gilded Recamier day-bed is unconventionally
upholstered in leather. The panelled background to this eclectic
ensemble has a limed oak finish.

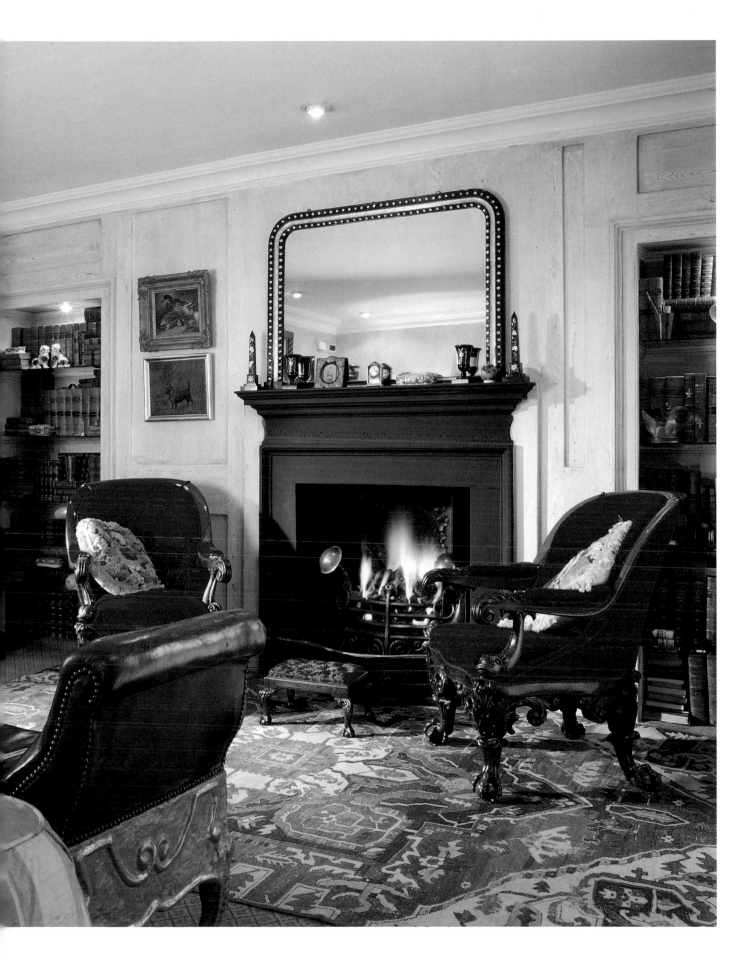

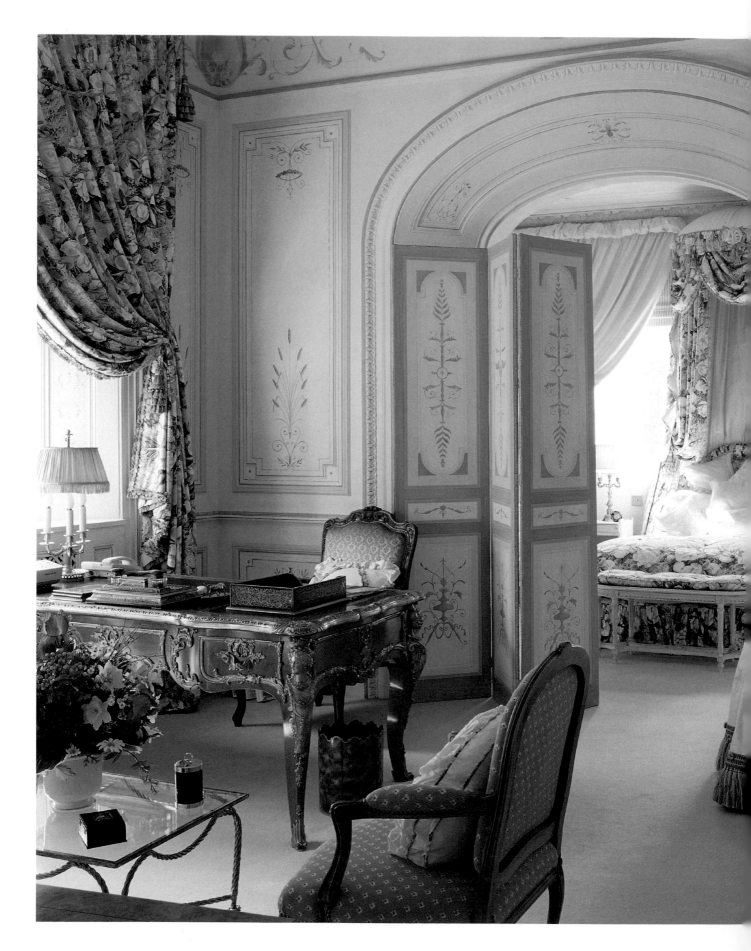

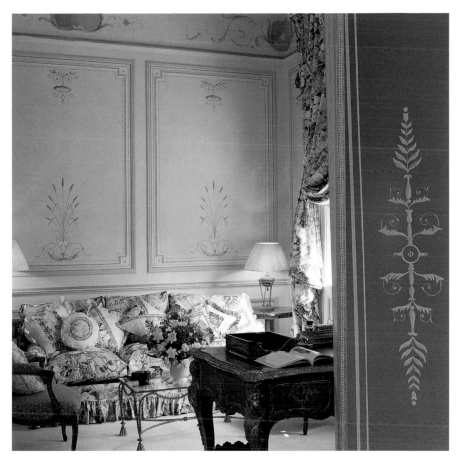

# Painted detail

Grandly proportioned and delicately painted, this guest-suite is in a laterally converted flat in Knightsbridge. Once the home of Ava Gardner, the Victorian interior has seen many changes in its lifetime, having at one stage been drastically 'modernized' – the elegantly high ceilings were lowered and original mouldings removed – then, more recently, it was sympathetically restored and redecorated as seen here. The sitting-area and bedroom are connected by a wide archway and complementary colour scheme in shades of cream, yellow and green. The buttermilk walls have painted detail by William Grantham, whose arabesques and cartouches reflect the designs on the reversible screen by Mark Aldbrook. The curtain treatments in both parts of the room are elaborate, their lavish use of textiles being appropriate to the scale of the windows and a conscious reference to the full-blown fashion of the late nineteenth-century. Next to the window in the sitting-area, and placed at right-angles to it, is a handsome antique French writing-table with ormolu mounts. The New York designer, Rosemary Gilman, and the London-based Swiss designer, Christiane Kahrmann, advised on the curtains throughout the apartment.

# Artistic and original

The more you look at the curtain treatment in this room, the
more you realize how imaginatively the fabrics have been used.
The main curtains flout the usual convention of having the
patterned fabric facing the room while the plain fabric – the
lining – faces the window. Here, a pink-and-green *toile* (the same
as on the walls) forms the lining and is only revealed in
tantalising glimpses when the curtains are flipped back. The
under-curtains are made of a delicate unlined check, doubled
over at the heading to create a more solid band of pattern which
is reflected in the vertical trim of the main curtains. This
layering of textiles adds to the visual warmth and comfort of the
bedroom, as do the plumply upholstered armchairs and the
patterned carpet. The room is in the home of Patrick Frey, head
of the renowned French furnishing fabric firm Pierre Frey – so
perhaps it is not entirely surprising that it exhibits such artistry
and originality in its synthesis of materials.

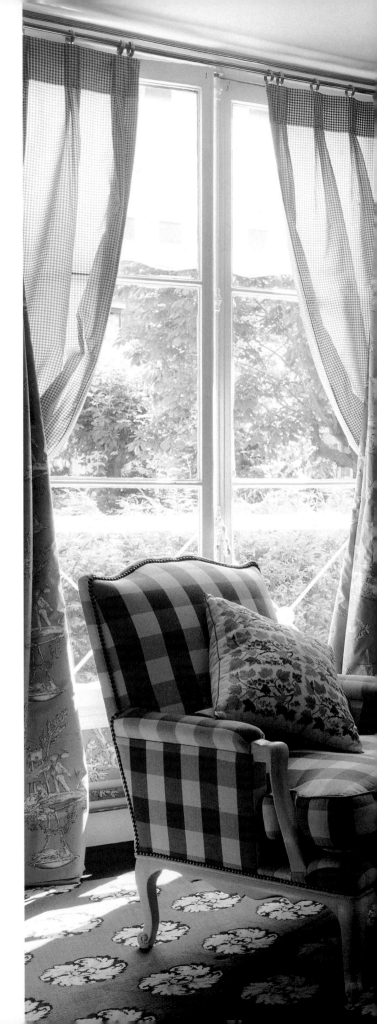

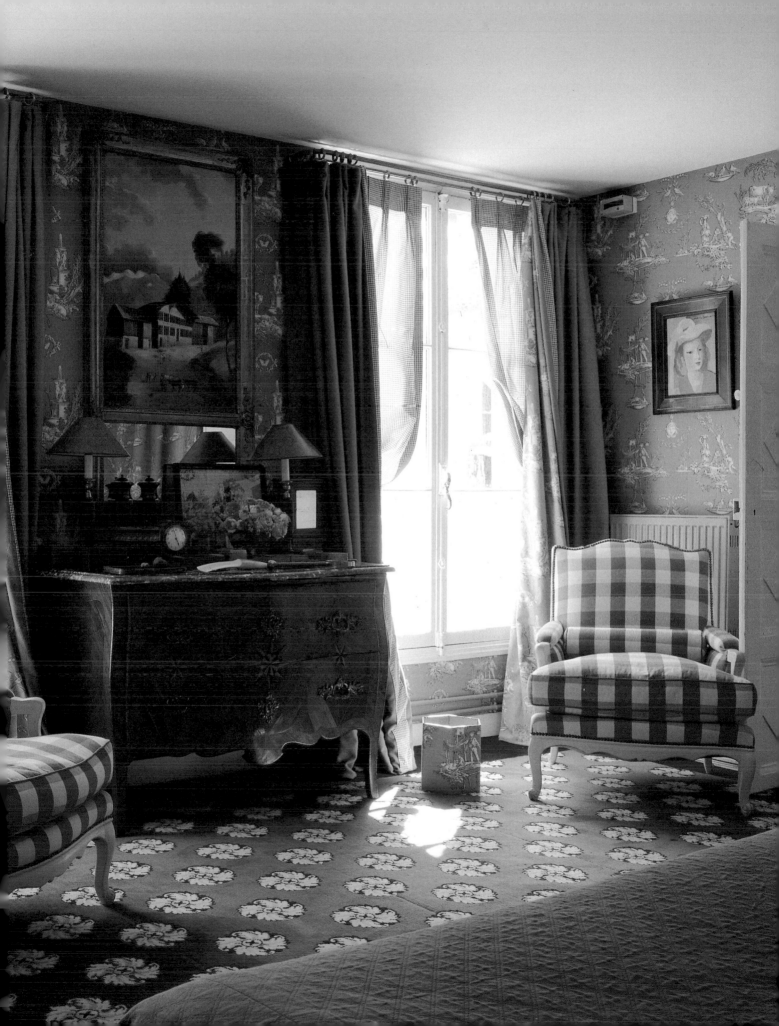

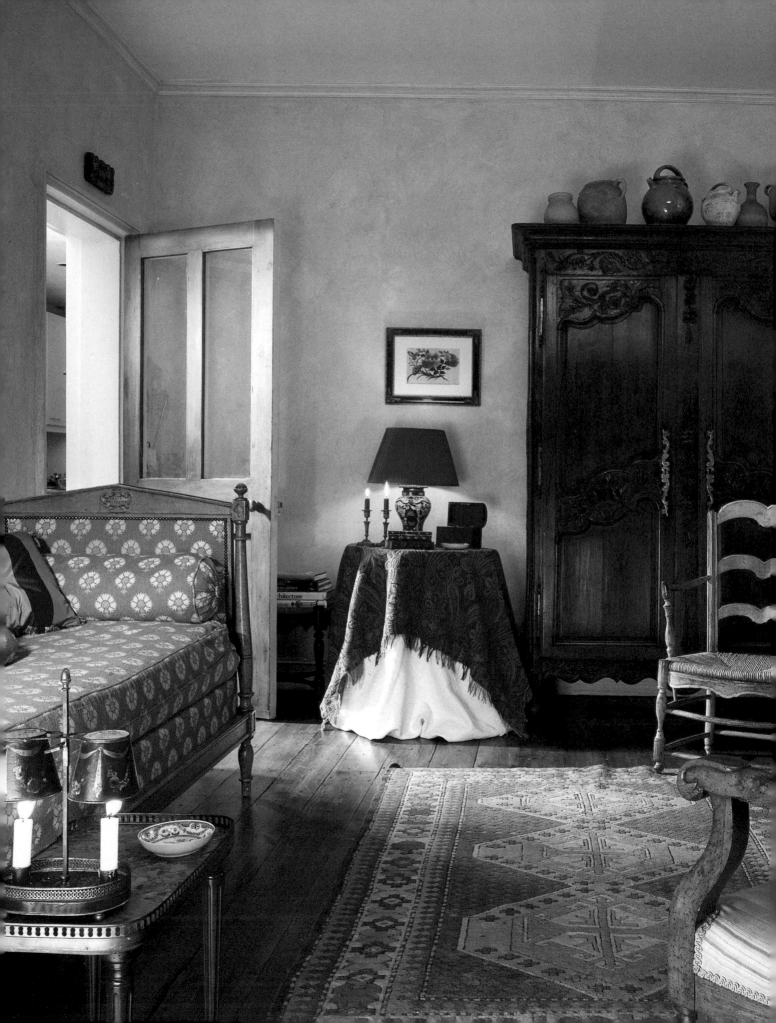

# Shades of Provence

Although this bedroom in a basement flat in London is not particularly large, Lauriance Rogier has managed to include all the elements of a sitting-room  so that it can also be used comfortably during the day.  With its open fireplace, fireside chairs, cherrywood secretaire and magnificent armoire, it takes on a wider role than a typical bedroom.  Looking like a couch, the French Directoire bed is the perfect answer in this situation. Using her specialist skills in paint effects, Lauriance Rogier has given ordinary plaster walls the characteristically irregular appearance of the inside of an old Mediterranean farmhouse.

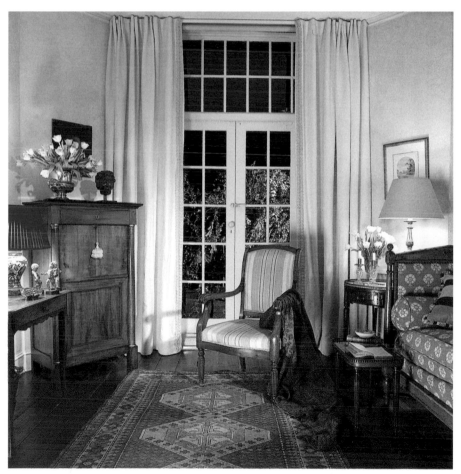

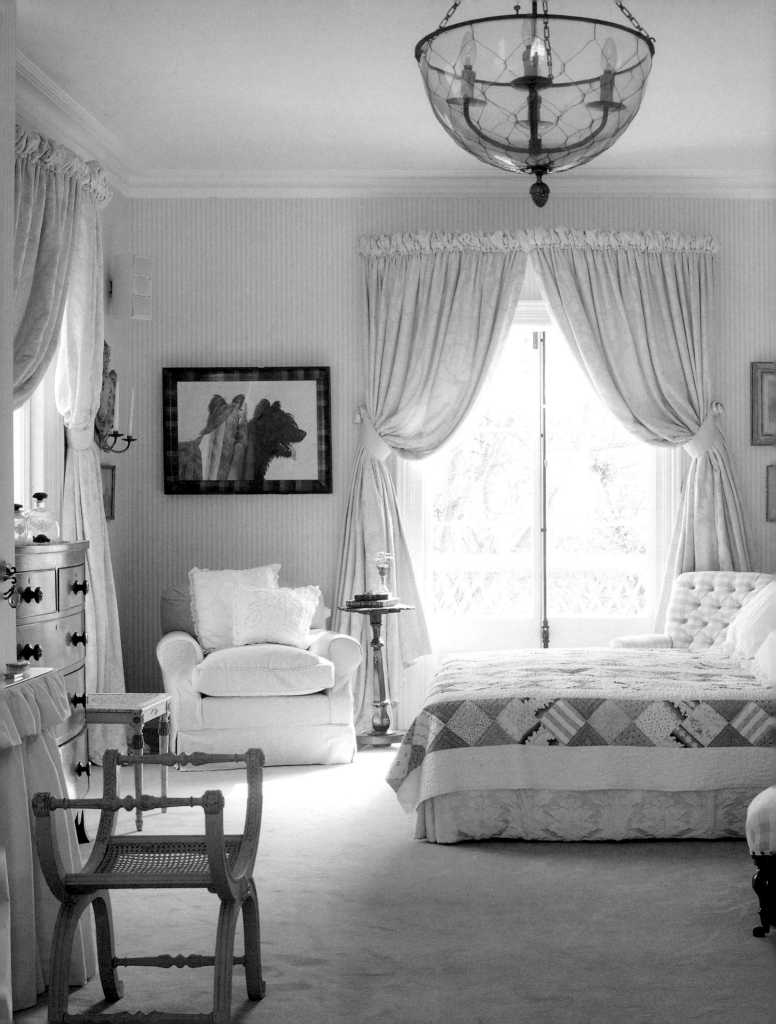

# A shadowy palette

The decoration problem encountered in this room was not the age-old one of how to maximise limited natural light but, unusually, of how to cope with a great flood of light. The room has five long windows, each leading onto a balcony, and while interior decorator Marion Lichtig certainly did not want to play down such an unusual and valuable feature, she was conscious of the need to moderate it. Her solution was to use a spectrum of pale, shadowy tints: creamy beiges for the main surfaces, with an infusion of dusty lilac for the check-upholstered chairs. The patchwork bedcover brings together a criss-cross of delicate, powdery colours, while the dressing-table is an equally delicate confection of softly gathered curtains.

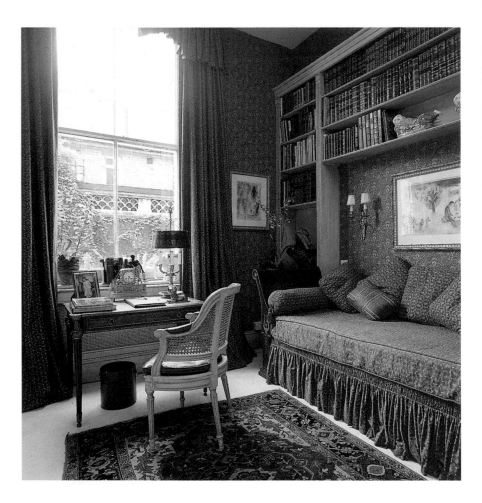

# For sleep and study

Comparatively modest in size, these two interiors play dual roles as bedrooms and sitting-room/studies, complete with generous bookshelves and a place for writing. Both rooms have beds which can be used for day-time seating and, in the context, look more appropriate than divans. These are placed within recesses created by the shelving, giving a suggestion of enclosure and cosiness, augmented by wall lights and pictures.

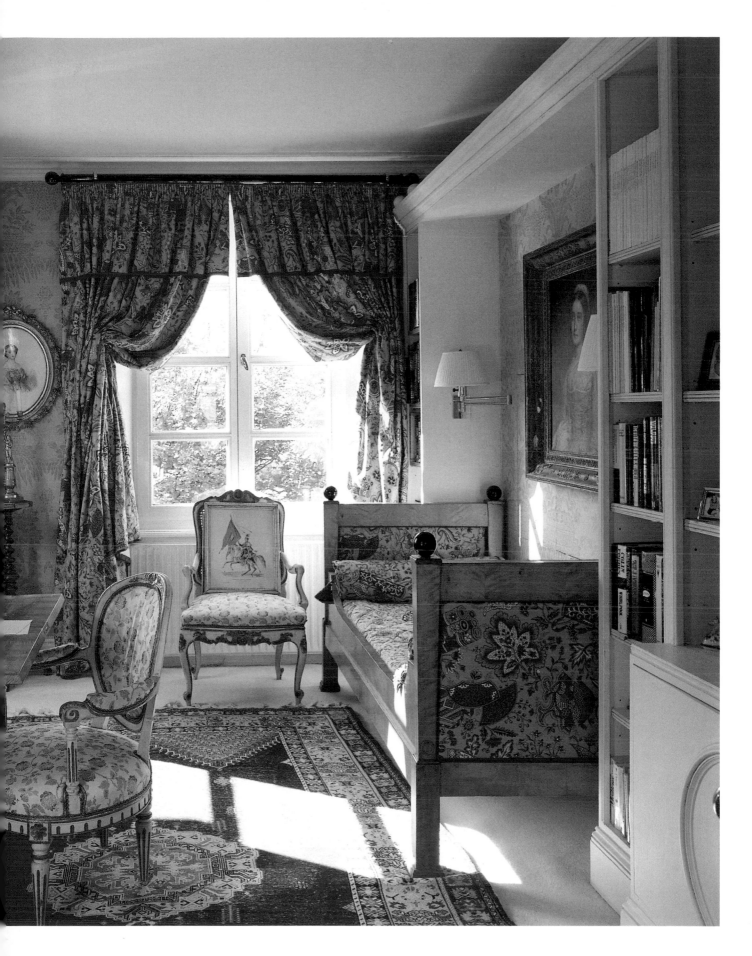

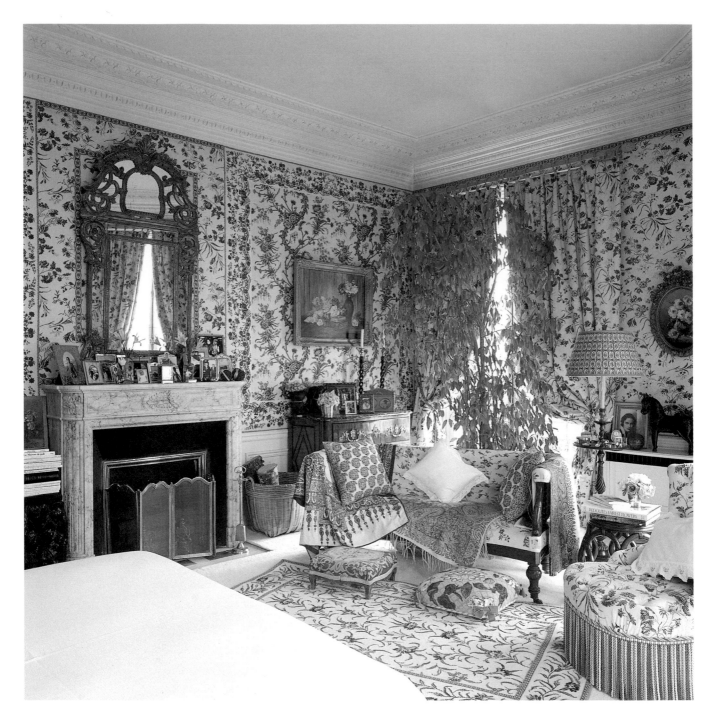

# An informal relationship

Eight different but related fabrics have been brought together in this light, delicate scheme, with additional decorative effects achieved on the fireplace wall and behind the bed by cutting and stitching some of the materials to form panels and borders. The sofa in the sitting-area is strewn with similarly coloured antique paisley shawls and cushions which add to the room's graceful informality. Footstools and a flowery rug give an overlay of pattern to the plain carpet.

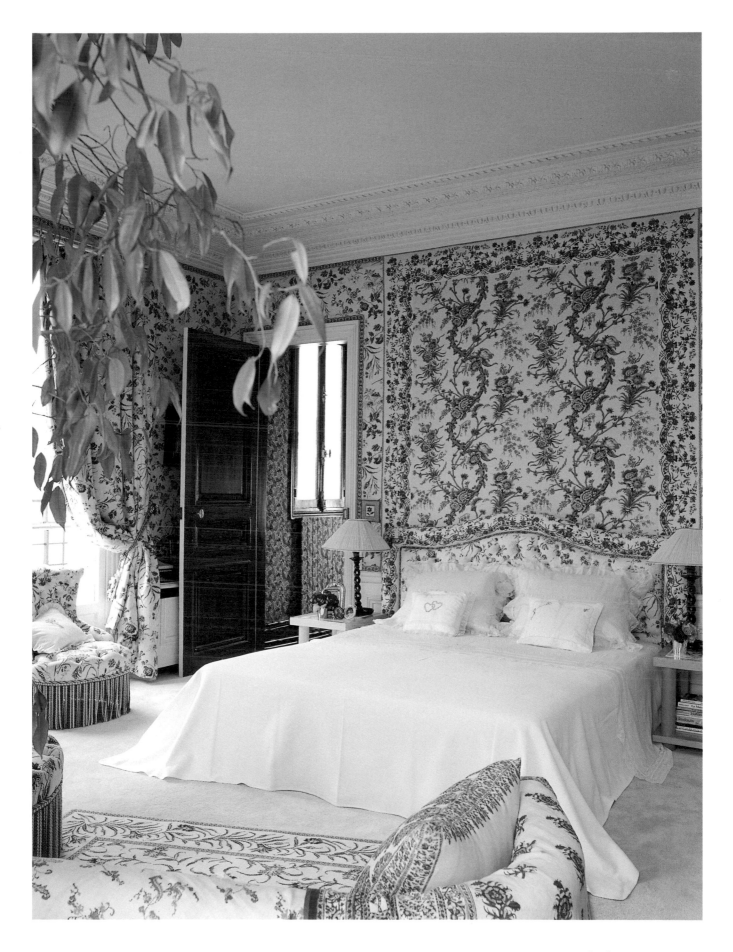

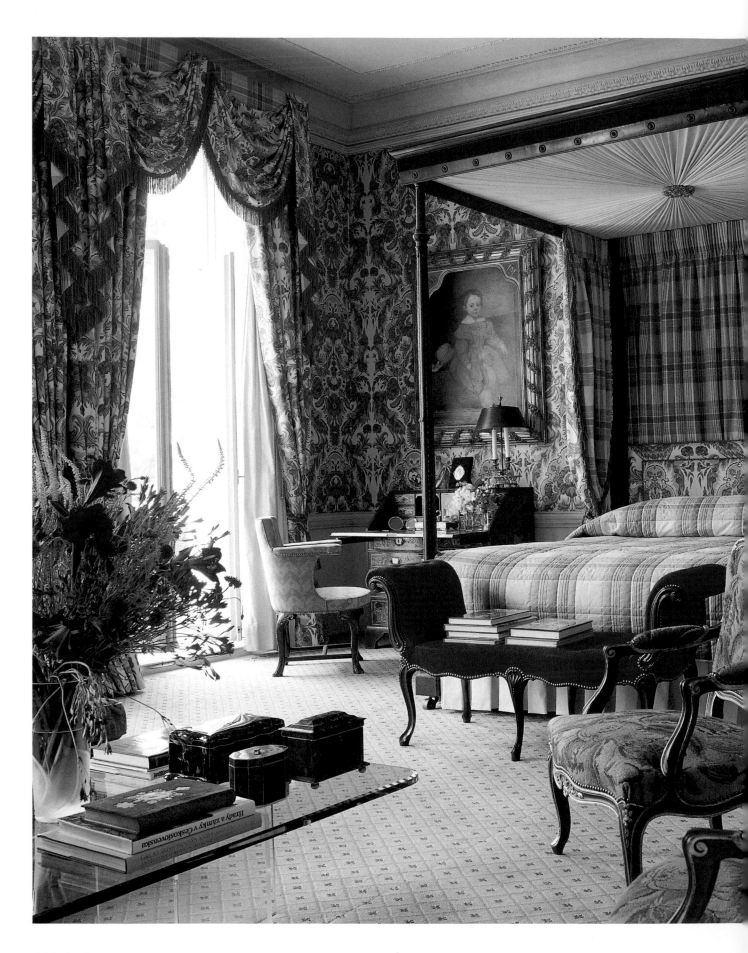

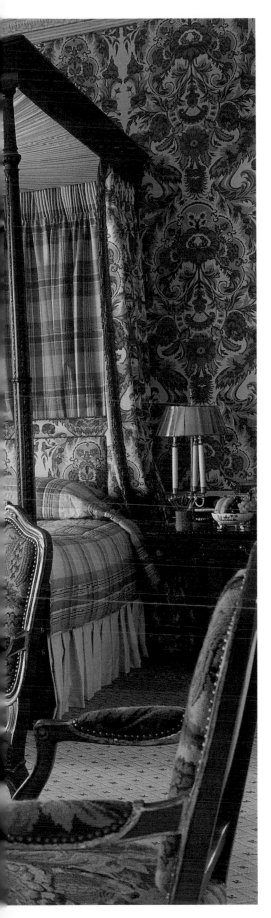

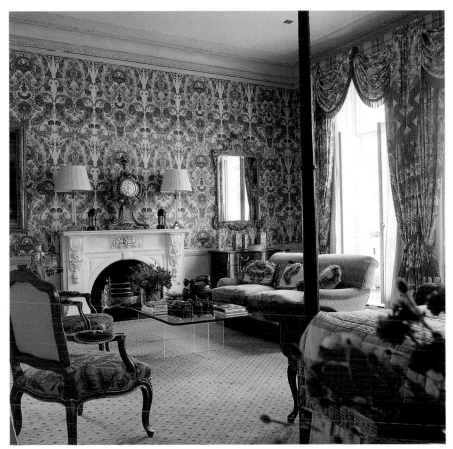

# Anything but grey

The richly-hued colour scheme which vitalizes this bedroom was chosen to counter the frequent greyness of the London sky which the American owners of the flat find dispiriting. Their decorator, Louisa Pipe, picked a striking floral fabric in blue, red and beige with a design large enough to suit the room's impressive size. This fabric is contrasted with a large checked pattern which lines the bed hangings and is quilted for the bedcover. The bed itself is a handsome Georgian four-poster placed directly opposite the marble chimneypiece which is the focal-point of the sitting-area.

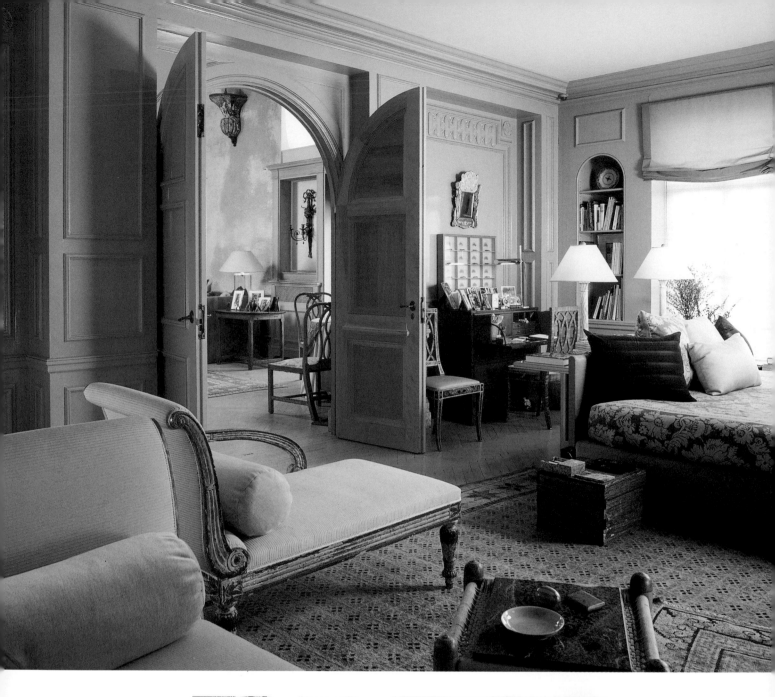

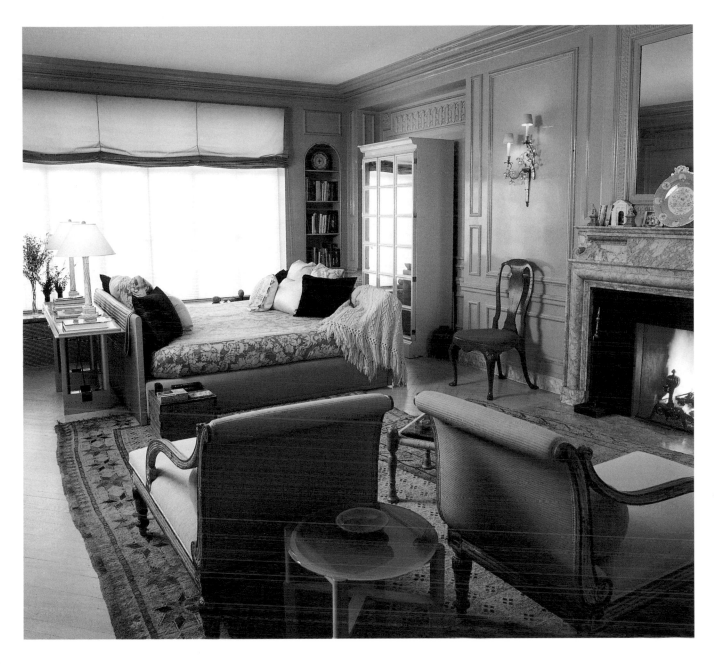

# Precise and articulate

John Saladino is what other designers appreciatively call 'a designer's designer', whose professionalism and articulate views are founded on a deep understanding of historical design and an elegant, original approach to solving problems of contemporary living and aesthetics. His authoritative, disciplined hand is apparent in the master bedroom of his flat in a Twenties building in New York. Set out in the manner of

a sitting-room, it is impeccably composed and restful, combining light harmonious colouring and a very precise arrangement of furniture. The bed is placed away from the walls and has a tailored, upholstery-like cover rather than a throw-over bedspread; two chaises-longues are positioned at right-angles to one another on the patterned rug by the original Twenties marble chimneypiece.

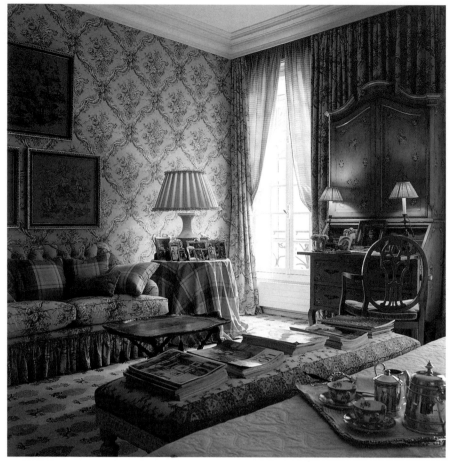

# A warm infusion

Philippe and Sylvie Sermadiras' bedroom in Paris glows with that particular kind of visual warmth which derives from the prolific use of a single fabric. In this instance, it is a wonderful, large-scale chintz in yellow and pink. Embracing the walls, bed and sofa, it is a totally splendid background for an idiosyncratic mix of furniture, ranging from a nineteenth-century screen to a modern American bureau painted in the eighteenth-century French manner. Sylvie Sermadiras is an eclectic who dislikes rooms with furniture all in the same style, but nevertheless there is an underlying affinity between many of the pieces seen here, mainly because they are painted. To maintain a simple outline to the room, there are no pelmets – merely a continuous cornice across the window wall. The secondary curtains are unlined checked silk which matches the lining of the bed canopy. The shape of the corona has been skilfully cut to follow the pattern of the chintz.

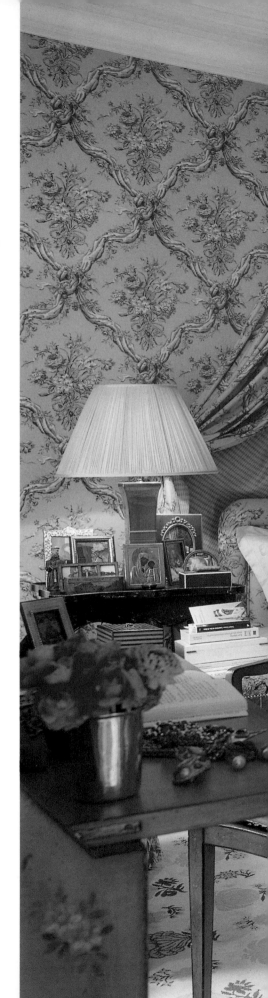

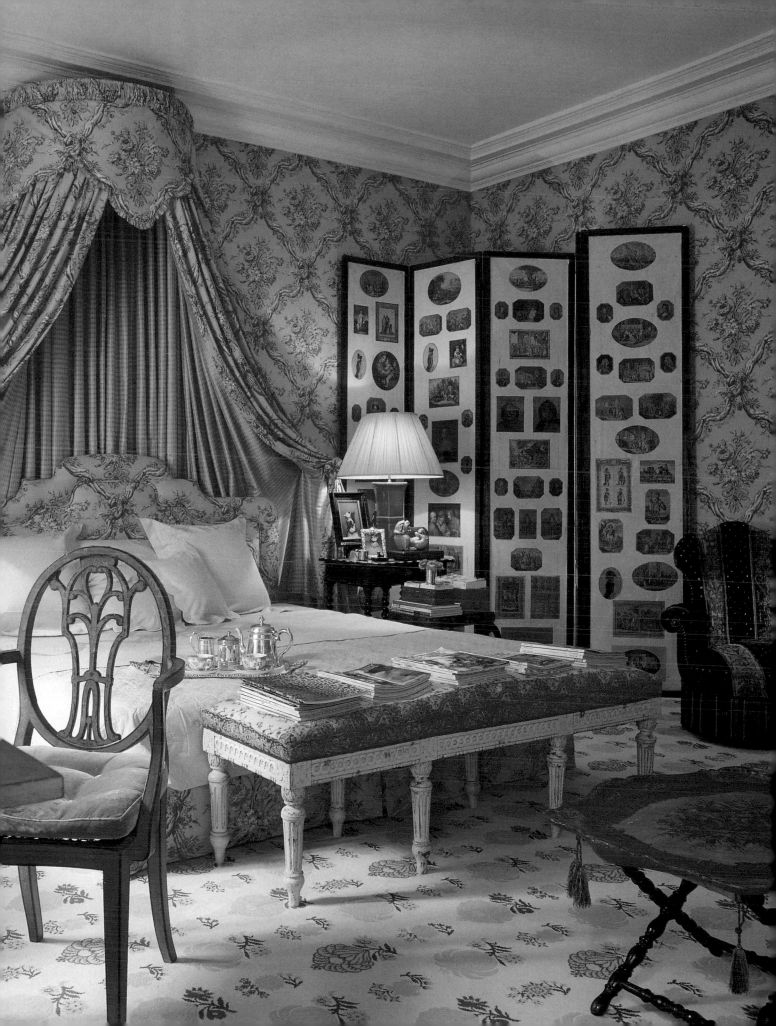

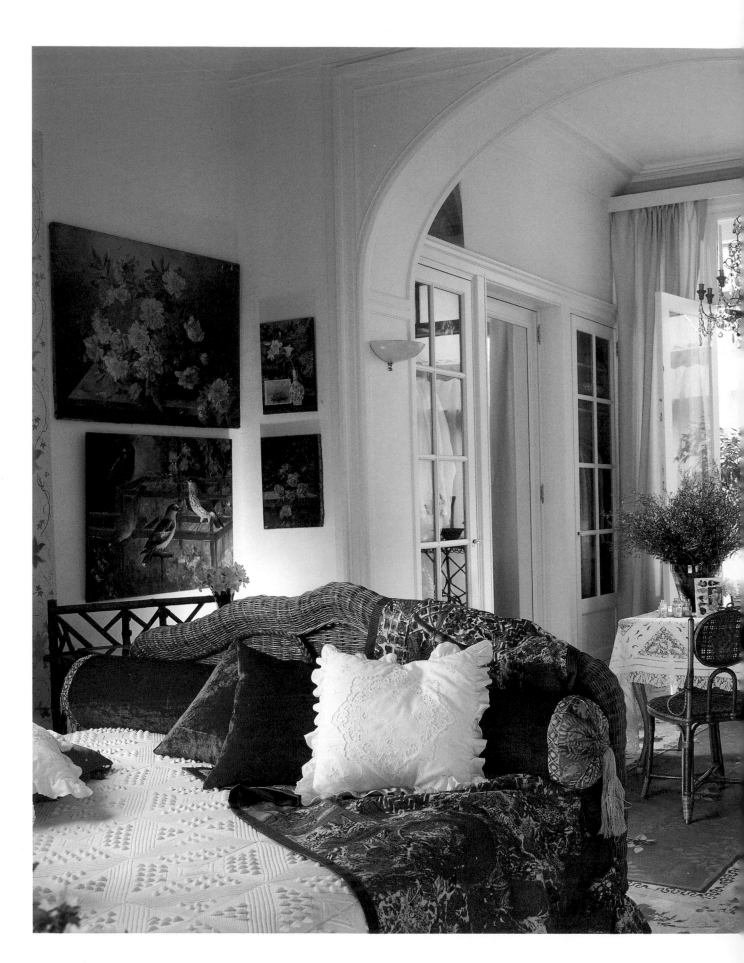

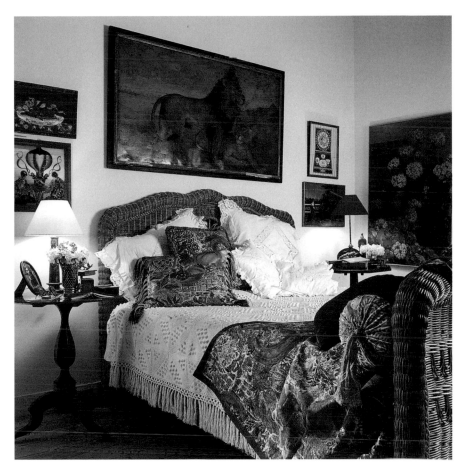

# Leading into
# a conservatory

Isabelle de Borchgrave combines a hectic family life with her
work as a fabric designer. Her love and understanding of textiles
are as much a part of her domestic environment as they are of
her professional studio, as is clearly evident in these views of the
bedroom in her house in Brussels. The tripartite room comprises
a sleeping-area with a cane bed from the Philippines; a dressing-
area with cupboards and a breakfast table; and, beyond, a small
conservatory/sitting-room curtained with fine white wool. The
spirit of the decoration and furnishing is one of naturalness and
continental nostalgia.

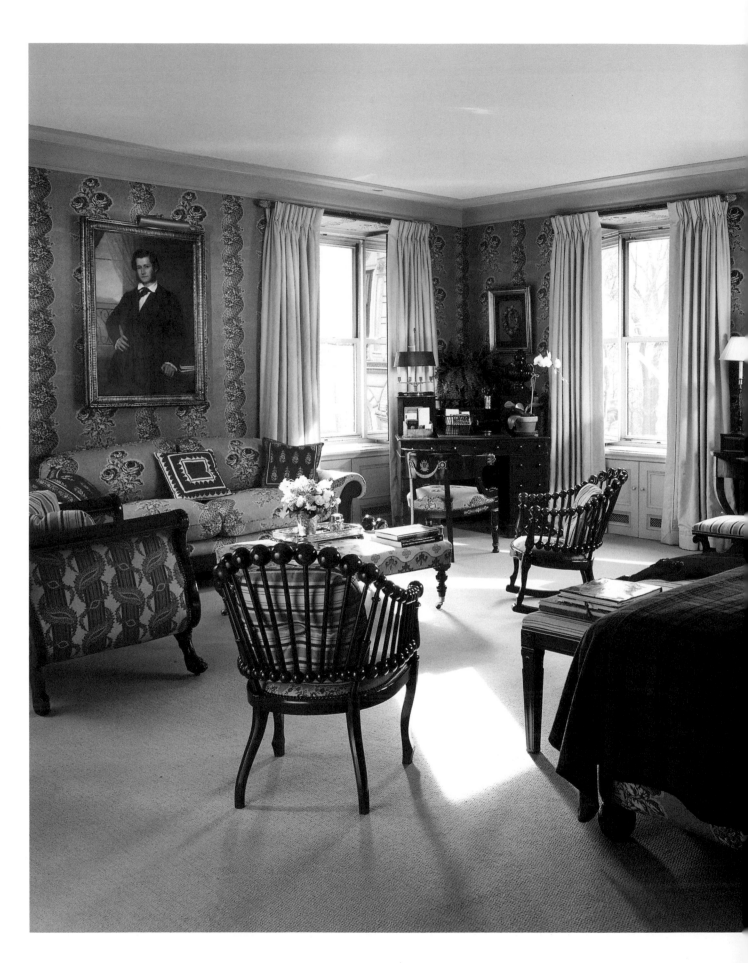

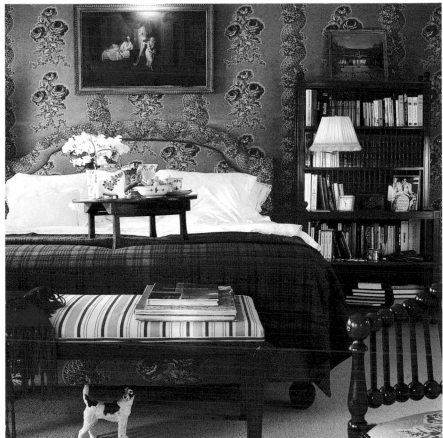

# The agreeably lived-in look

New York-based decorator Genevieve Faure is a great believer in rooms looking lived-in. 'I sometimes think that after I have finished overseeing all the details, I should go and live in my clients' houses for a year or so. Let some things accumulate, move some others around. A house isn't really finished until you've done that.' The main bedroom in her own apartment on Fifth Avenue underlines the notion. In a most agreeable way it looks as though people really enjoy living there, surrounded by furniture and objects chosen for the pleasure they give rather than merely to fill up the space. There is a sense of gentle, constant evolution as things are added and subtracted within the room's warm-toned framework, which is created by a beautiful fabric with a spiralling flower design. The quirky bobble-back chairs are nineteenth-century American; the bookcases to either side of the bed were designed by Genevieve Faure.

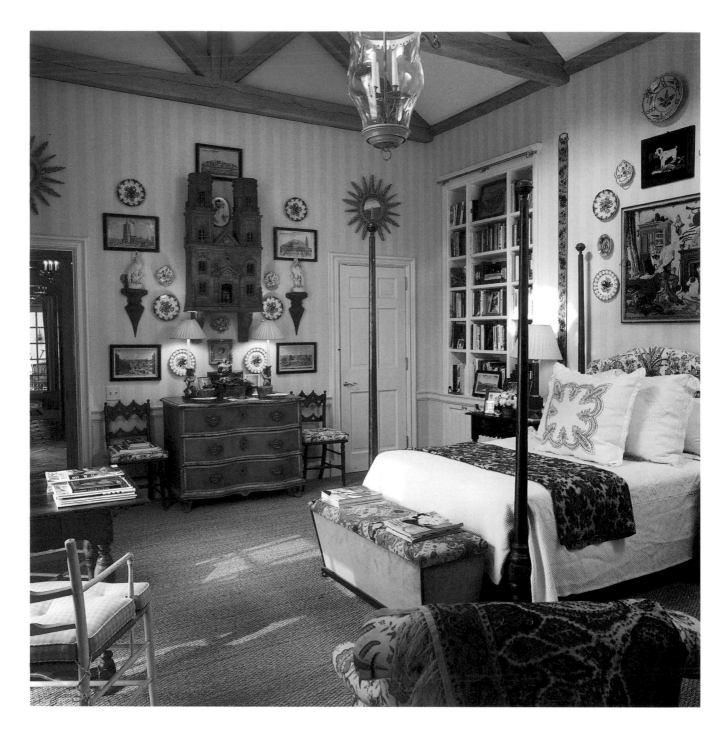

# Thinking three-dimensionally

In a room of this height, it is essential to think three-dimensionally and introduce strong vertical lines in the furnishing as well as in the grouping of pictures. If all the 'weight' is concentrated too low down, the effect is off-balance and bleak. Here, David Easton has brilliantly manipulated the soaring space in the main bedroom of his house in New York State – and he has also shown that a country look, with exposed beams and rafters, need not be inelegant or folksy. The room has very tall windows (with high-level staging for a pair of blue-and-white pots) and bookcases of similar proportions. The painted Italian mirror above the chimneypiece in the seating area rises almost to the beam and reflects the equally lofty arrangement of decorative objects on the opposite wall. Cleverly, the posts of the antique French steel bed inject verticality in the middle of the room without interrupting the feeling of space.

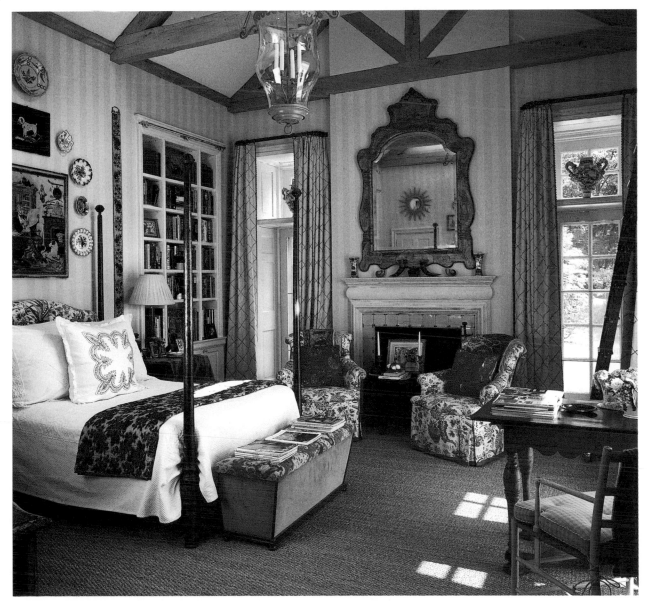

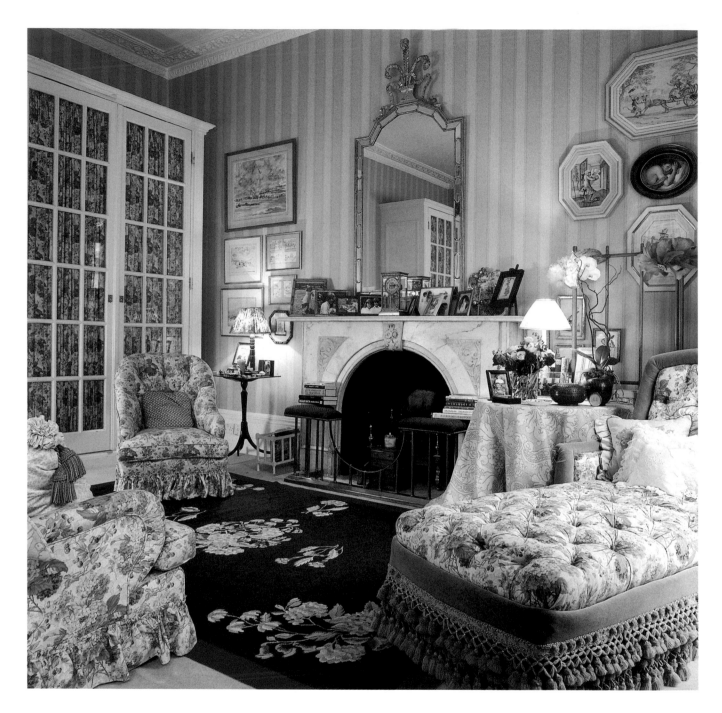

# Soft and sequestered

Not many bedrooms in town houses boast such majestic proportions as these. Nor do many other houses in London convey such feelings of pampering, rest and seclusion. The size of the room is relatively simple to account for – the bedroom was converted from what was formerly a grand drawing-room - but the soft, sequestered ambience is more enigmatic to explain. Until, that is, you learn that the room is in the home of interior designer Nina Campbell, who is famously adept at using chintz, gorgeous trimmings and lots of interesting little objects to conjure a deeply cosseting milieu. The high glass-fronted cupboards already existed when Nina Campbell converted the house, but these have been turned into wardrobes with gathered fabric backing the doors. The sitting-area, with skirted armchairs, a deep-buttoned chaise-longue and floral rug, is centred on a substantial marble fireplace.

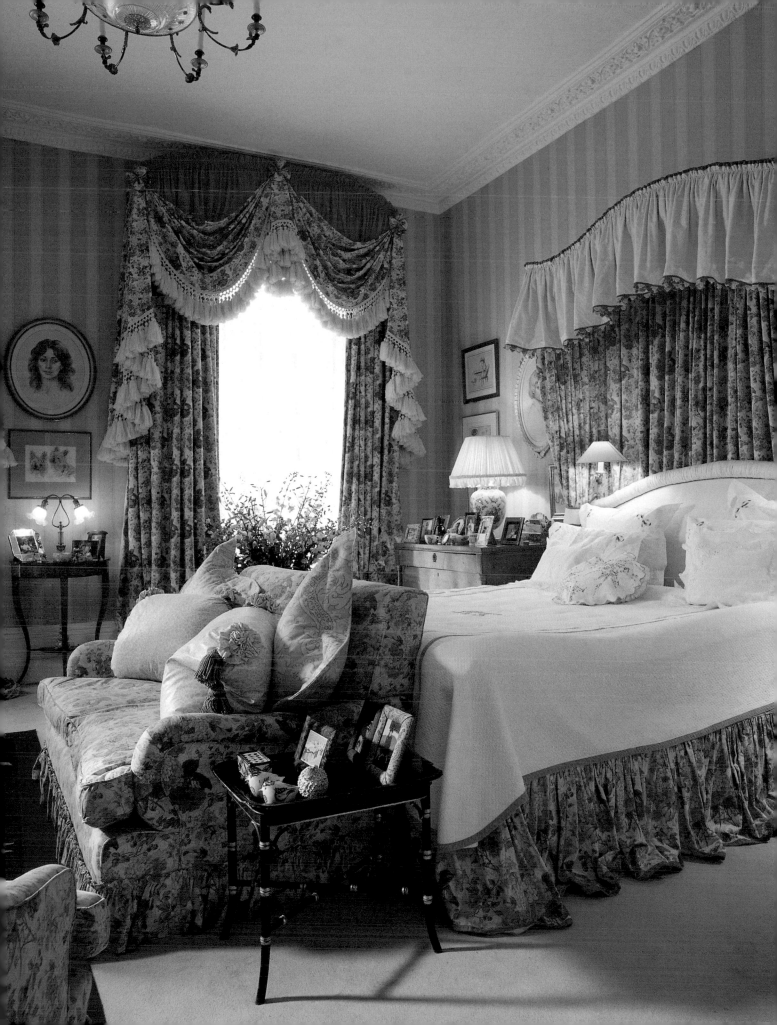

# AWAY FROM IT ALL

*Palm-fringed tropical islands
and remote alpine valleys are
the stuff of escapist dreams.
Such exotic locations are
magically refreshing to the eye
and spirit, and their very special
styles of interior decoration are
evocative and inspiring.*

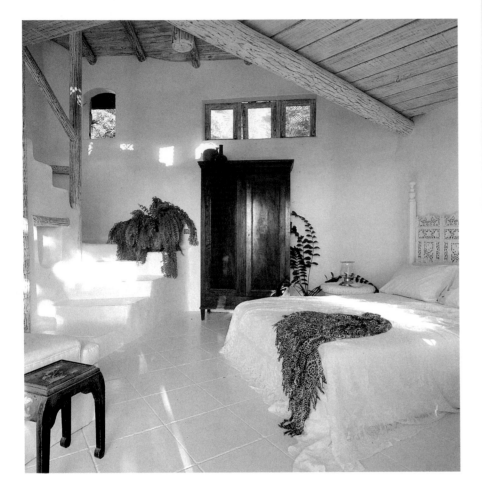

# Facing the view

When the outlook is as spectacular as the one from Marc Johnson's house on St Lucia in the Caribbean, it would be madness to detract from it with fussy interior decoration. Hence this ultra-simple but highly considered scheme (right) where walls and furnishings are all in shades of soft white. The bed, with a skeletal bamboo frame supporting a mosquito net, is raised on a platform to take full advantage of the view. At the foot of the bed, a masonry sofa is painted white and covered with cushions. The guest bedroom (above) is similarly simple in its decoration, though here the floor is tiled rather than of limed wood. The design of the house, which was built in 1985, was a collaboration between Marc Johnson, architect Ian Morrison and interior designer Judy Johnson.

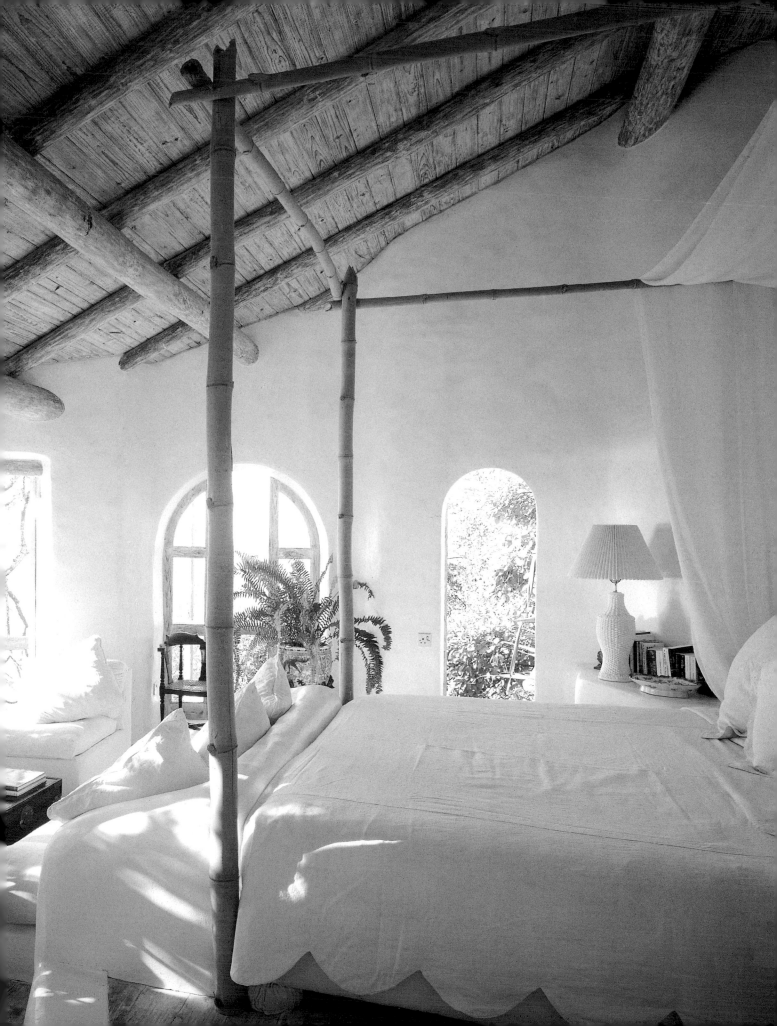

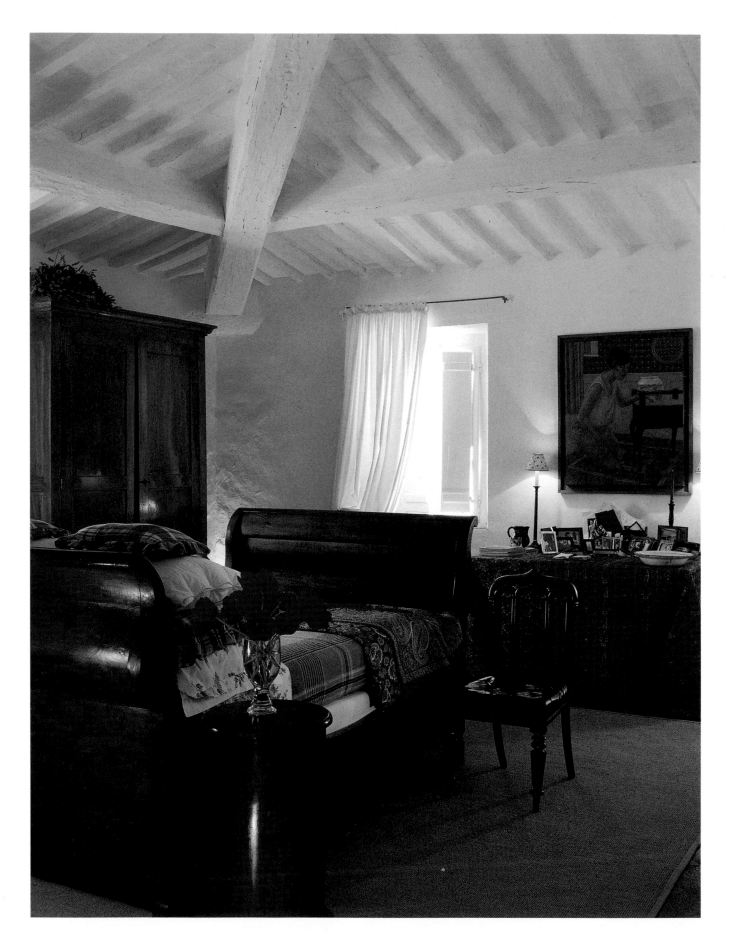

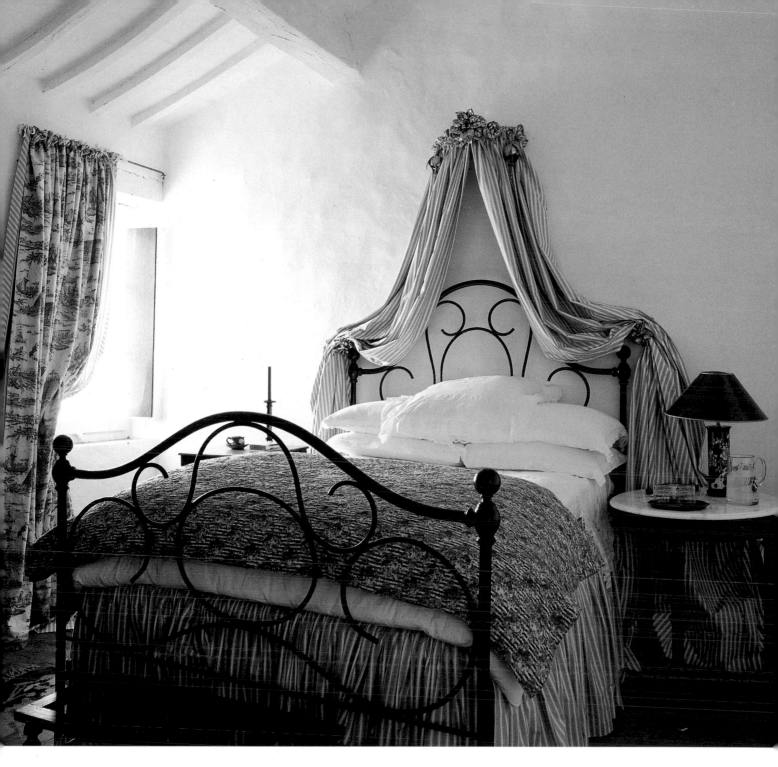

# The Tuscan ideal

An ancient farmhouse in Tuscany, surrounded by olive groves and cypress trees, has long been the British ideal for a holiday home. With whitewashed walls and exposed beams, these two bedrooms designed by Mimmi O'Connell are the epitome of the romantic, escapist dream. What makes them especially alluring is that they declare their unassuming origins and recall their pastoral past, yet they have an air of present-day comfort and chic. The combining of antique Italian country furniture with luxurious textiles (opposite) looks smart but appropriate, while an iron bed (above) festooned with green-and-white fabric suspended from a gilded corona is equally successful. In the former room, the curtains are plain, unlined linen; in the latter, the antique *toile* is hung asymmetrically to overcome the position of the window.

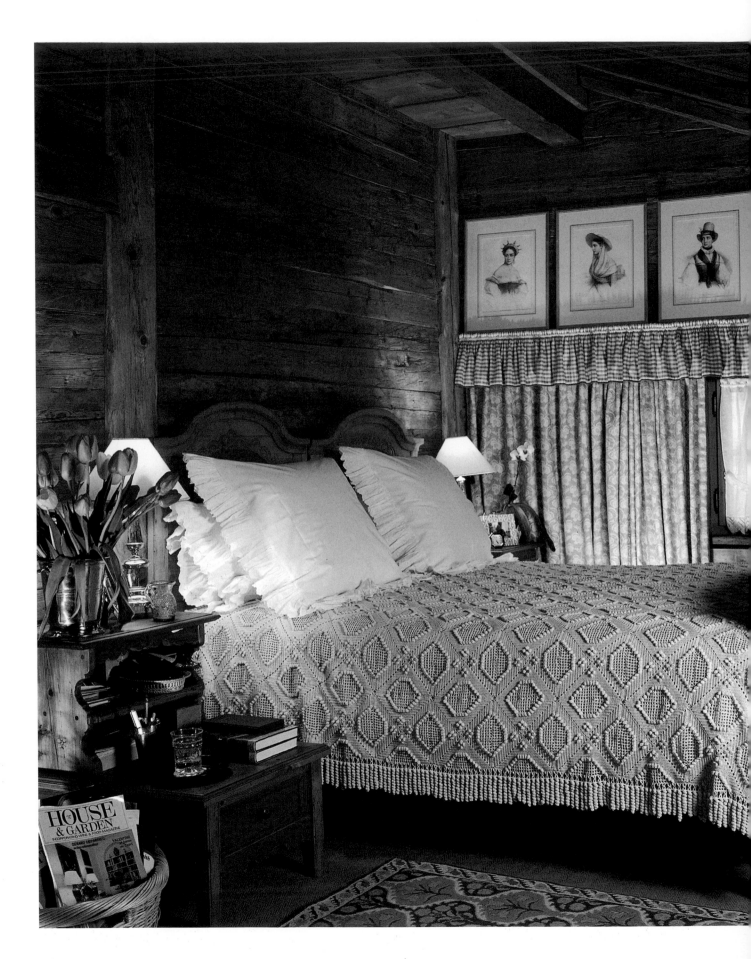

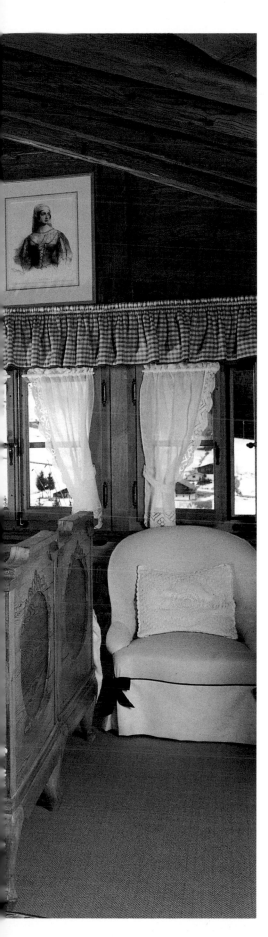

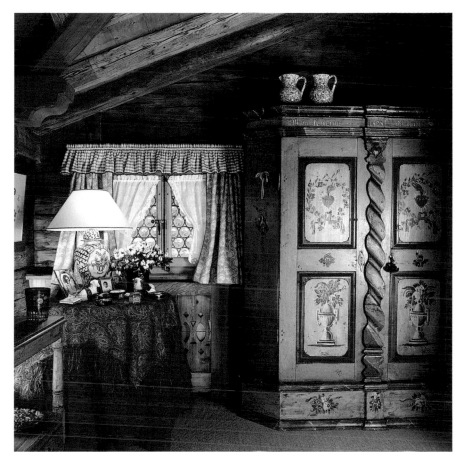

# Regional reminders

Rough wooden walls, bare rafters and low windows are
reminders of the regional character and eighteenth-century
origins of this Swiss farmhouse. With its cosy textures and
efficient heating, the interior is a snug refuge after a day's skiing.
The radiator cover beneath the window is made from panels
rescued from an Austrian chalet where they were part of an
elaborate balcony. Also from Austria is the remarkable hand-
painted armoire with floral embellishments and a barley-twist
column disguising the door edge.

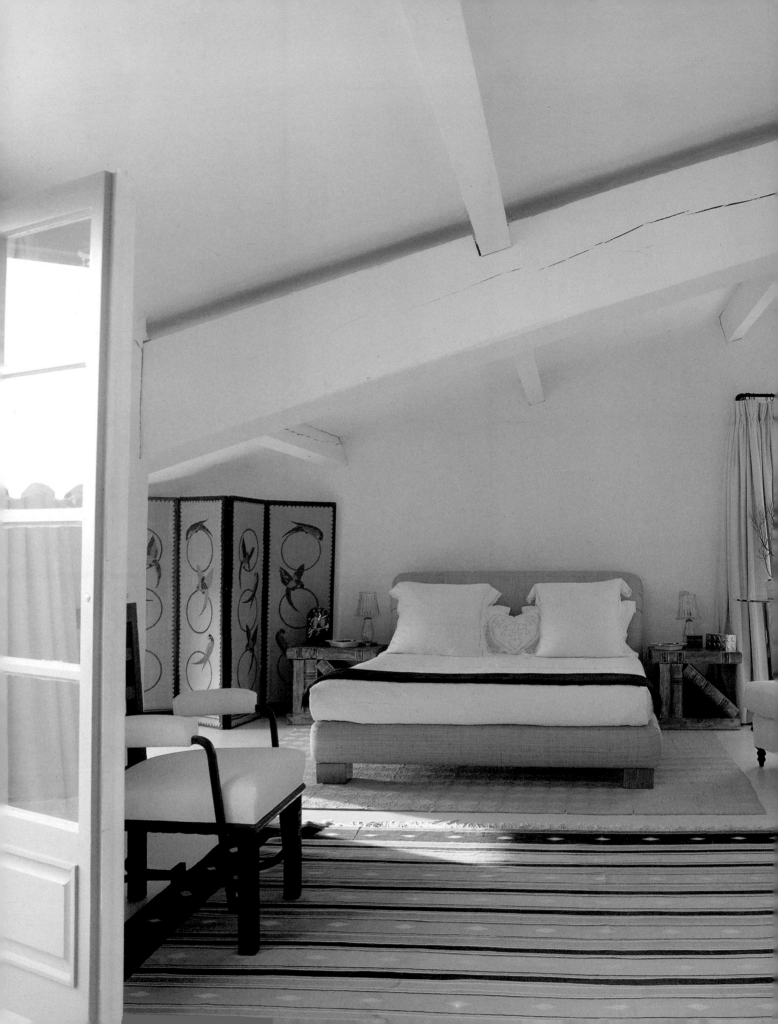

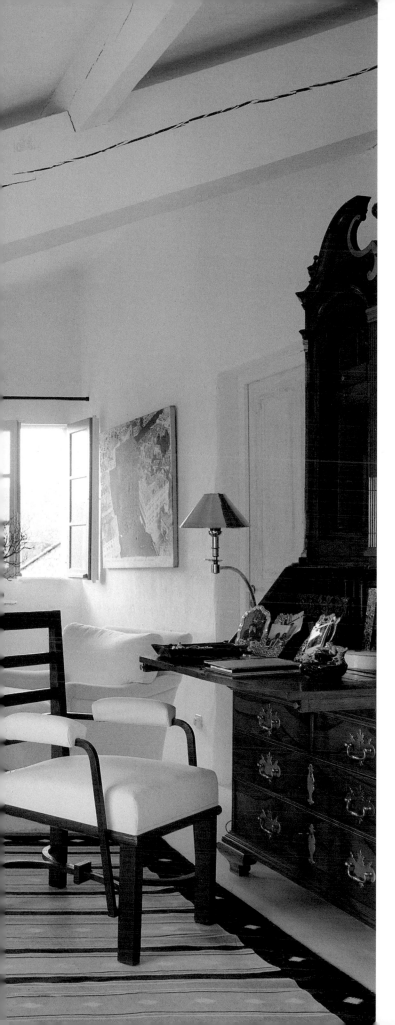

# Corsican eyrie

Alberto Pinto is usually associated with an opulent, theatrical style of decoration, but for his holiday house on Corsica he has adopted the contrary standpoint of simpleness. 'Very elaborate decoration is irritating in the heat,' he says, 'whereas in cities it feels right to create grand, full rooms.' His Corsican bedroom is a big, open eyrie at the top of an old farmhouse, dominated by a gigantically beamed, sloping ceiling and endowed with a small balcony. The only truly important piece of furniture in the room is an eighteenth-century bureau with ornate swan necked pediment. Otherwise, everything is light and reticent, with old and new pieces mixed in a contemporary manner. In the adjoining dressing-room, storage is an original, witty arrangement of basic, pigeon-holed shelving with woven baskets, each with a luggage label for identification.

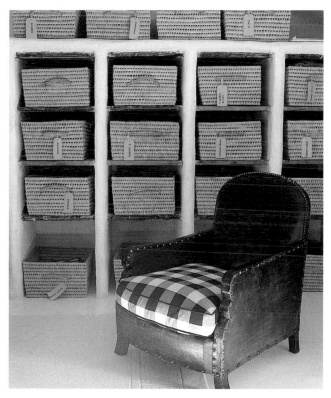

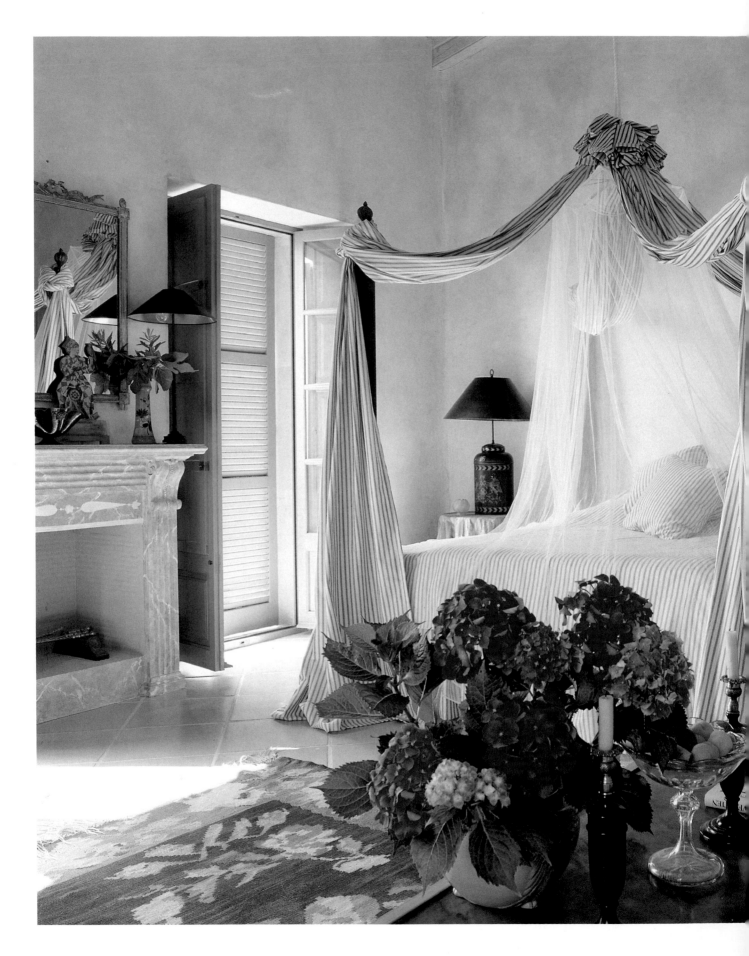

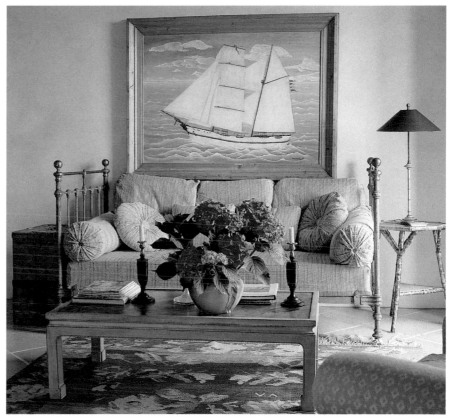

# For long hot holidays

In a room designed for hot Mediterranean summers, Ursula
Hubener has kept the furnishing and architectural finishes cool
and simple. The rough-plastered walls have been painted with a
cloudy, dream-like effect in diffuse shades of pale blue, grey and
green, inspired by the naive Uraguayan painting of a sailing ship.
The four-poster bed is dramatically draped with ticking gathered
up to a central point and roped to the ceiling.

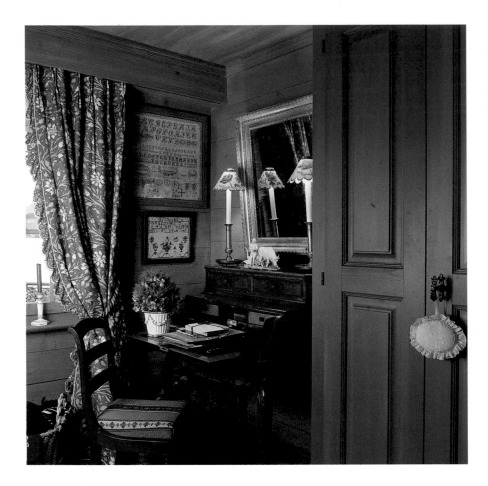

# Intriguing contrasts

Unlike most alpine interiors, where the pine boarding is left in its
natural finish, the timber in this chalet in Switzerland has been
stained a strong cobalt blue. The narrow timber cornice, which
extends across the window wall to conceal the curtain track, has
also been stained – as has the pierced casing for the radiator – to
produce a total integration. A medley of fabrics, all with blue as
the mainstay, is cheerful and welcoming. The Empire mahogany
bed, walnut writing-desk and gilt-framed mirror make intriguing
stylistic and colour contrasts with the rugged walls and ceiling.

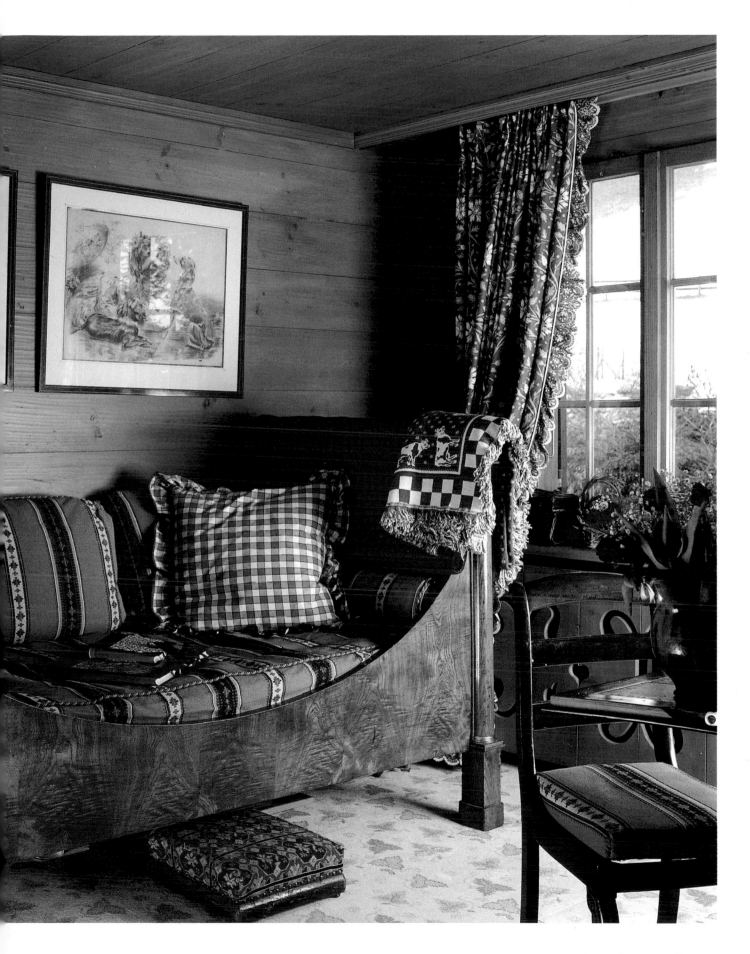

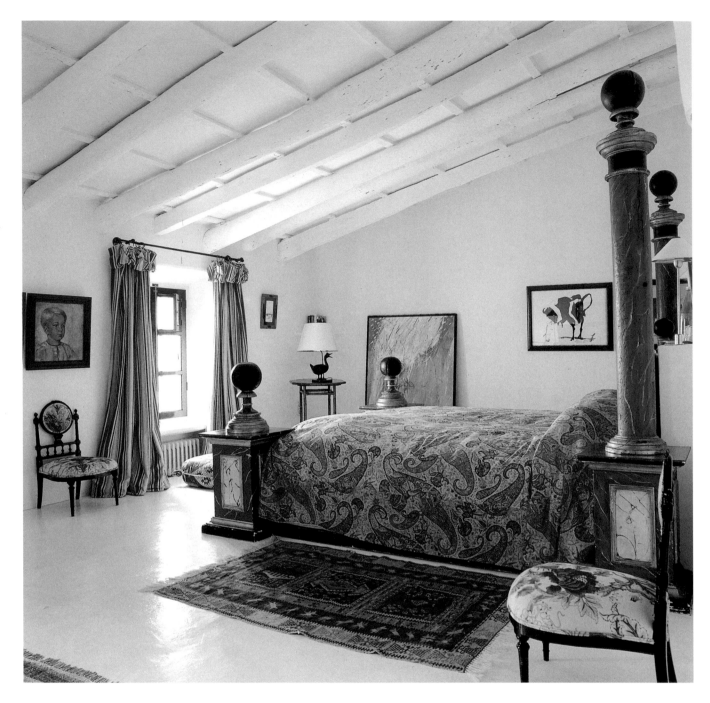

# An all-white transformation

What was once a grain store on the first floor of an old farmhouse in Majorca is now a spectacular bedroom with open-plan sitting-area and bathroom. The transformation, made by Nona von Haeften with decoration advice from Holger Stewen, leaves exposed much of the original structure whilst sympathetically incorporating cupboards, shelves and bathroom fittings. The entire space has been painted white to give continuity and to maximize the sense of light and space. White is appropriate in a big, rustic space such as this and provides an unbeatable background for colourful rugs and textiles. A pair of Italian marbled columns inspired Nona von Haeften to design the monumental bed.

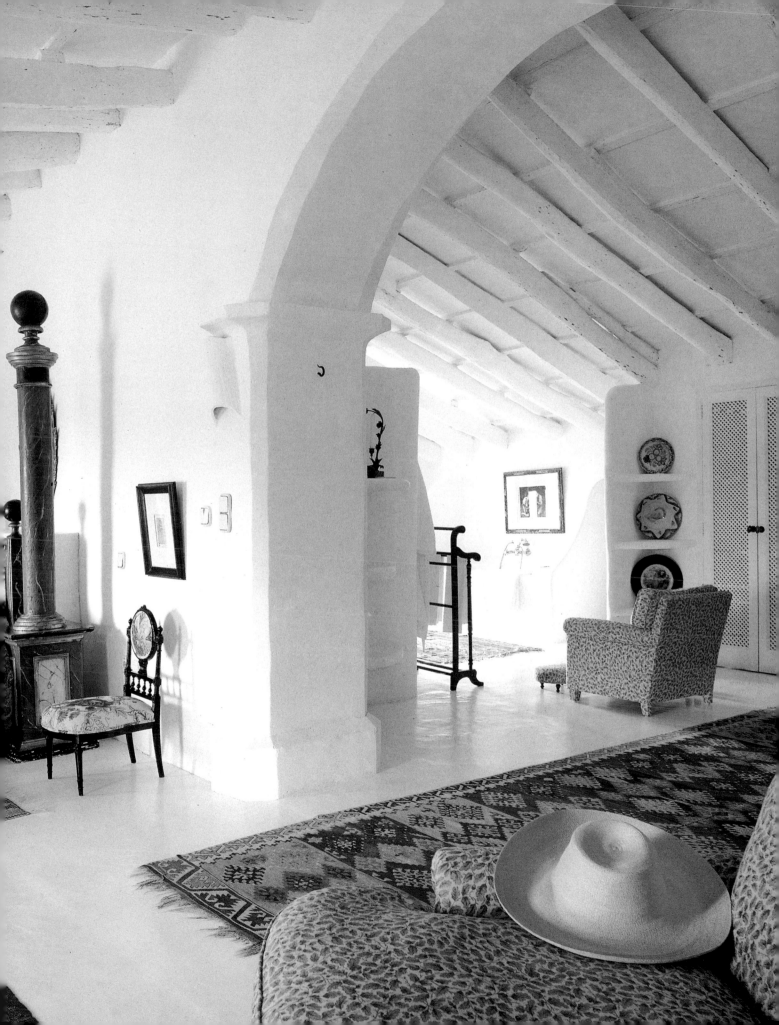

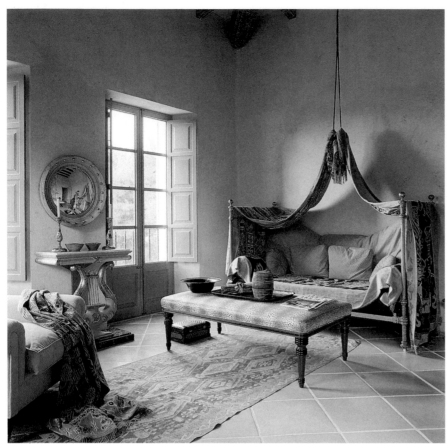

# Island serenity

With their exposed roof timbers and plain plastered walls, these two rooms in Majorca typify the enduring appeal of the island's vernacular architecture. The one shown above is in fact in a new building but, structurally, it conveys the same rustic honesty and timelessness as that seen on the right. From a furnishing point of view, both schemes are sympathetic to the rural spirit of the settings but, in addition, there are nicely unexpected touches of sophisitication. In what Ursula Hubener calls her 'Bedouin' bedroom, she has draped the little metal campaign bed with hand-woven, earth-toned textiles and piled it with cushions. It sits surprisingly happily with the gilded Regency mirror and lyre-based side-table. The rural serenity of the bedroom (right) designed by Princess Tatiana of Hesse is enhanced by the sparseness of the furniture and the use of white paint on all the structural surfaces, including the cement floor. The painting and vivid pink bedcover give an injection of clear colour and contemporary taste.

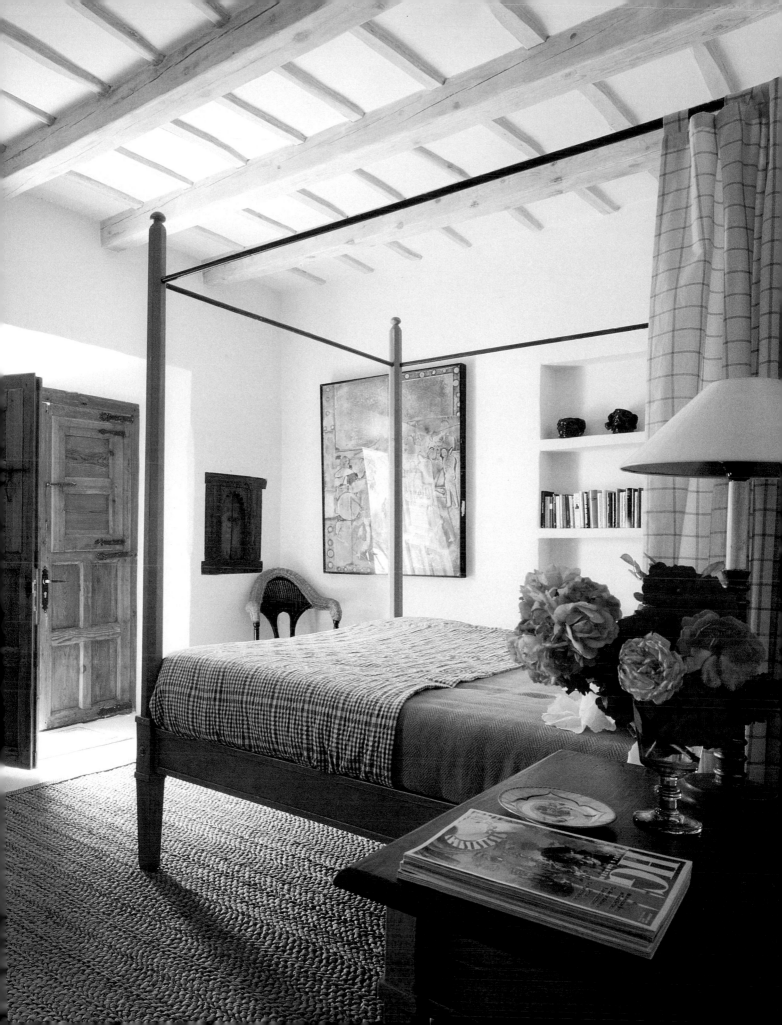

# COMFORTABLE
# AND
# COSSETING

*Even the smallest bedroom can be
given a sense of comfort and
indulgence. To achieve the effect,
concentrate on texture: use fabric on
the walls, padded headboards, quilted
covers, snow-white linen, lacy pillows.
Add warm colours, soft patterns and,
if there's space, an armchair.*

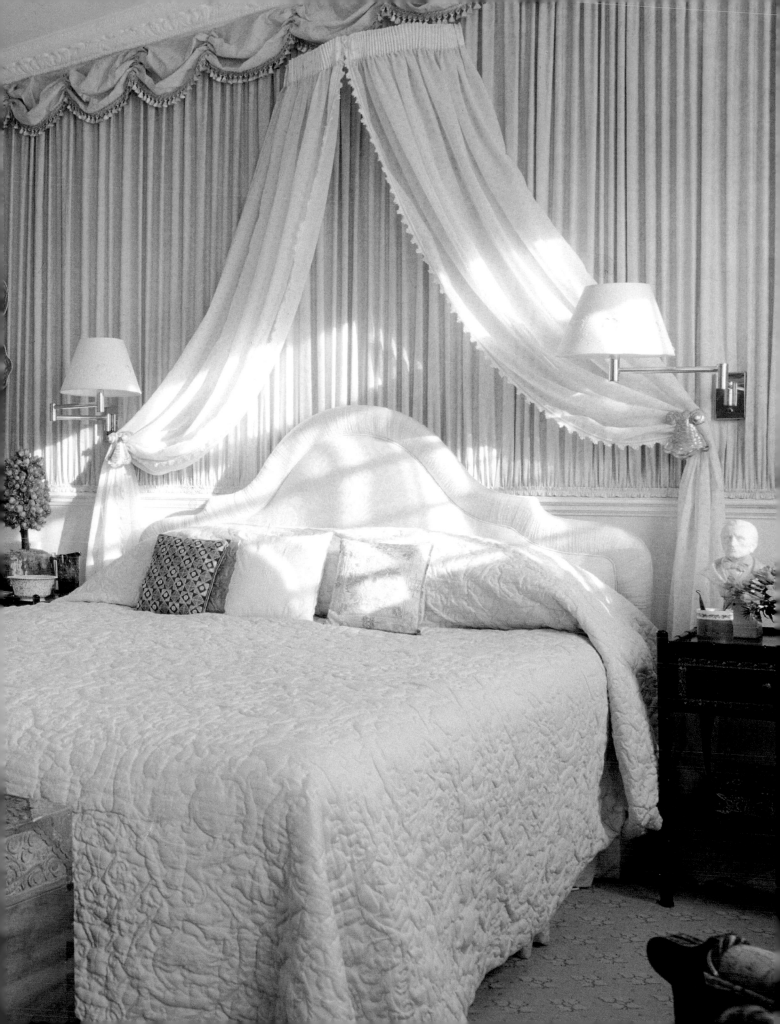

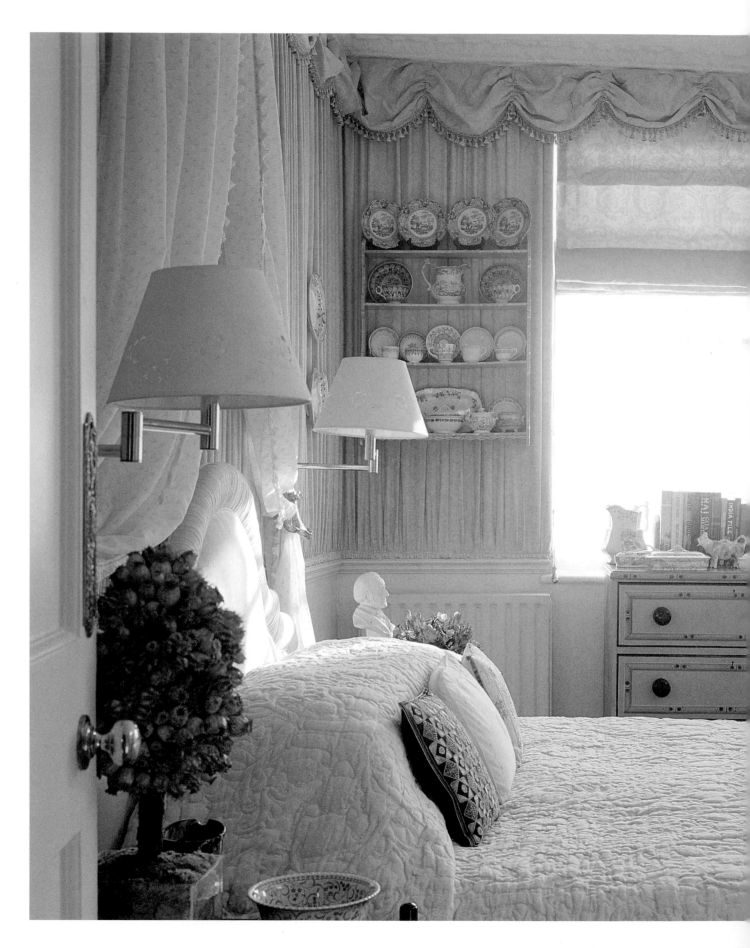

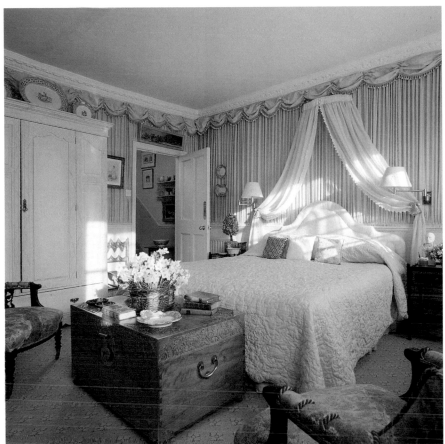

# Enveloping and flattering

Yellow is one of the happiest choices of colours for bedrooms. Light and restful, it has a sunny temperament even on dull days, and it makes a flattering background for furniture. In interior decorator Rosemary Hamilton's bedroom, the walls are covered in pleated fabric, finished at the cornice by a swagged pelmet. Enhanced by the quilted bedcover and upholstered bedhead, the effect is softly enveloping and protective. At the foot of the bed a camphorwood chest from the Far East doubles as a table.

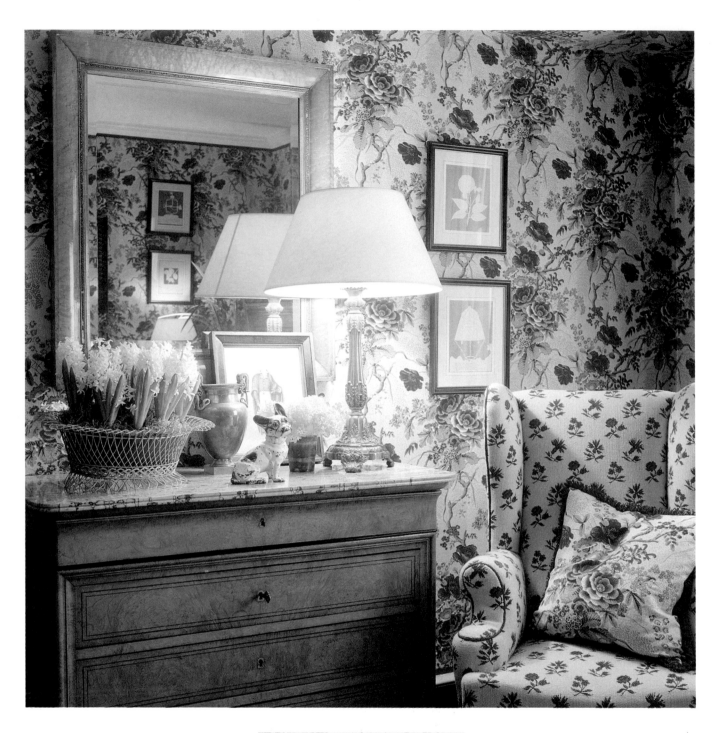

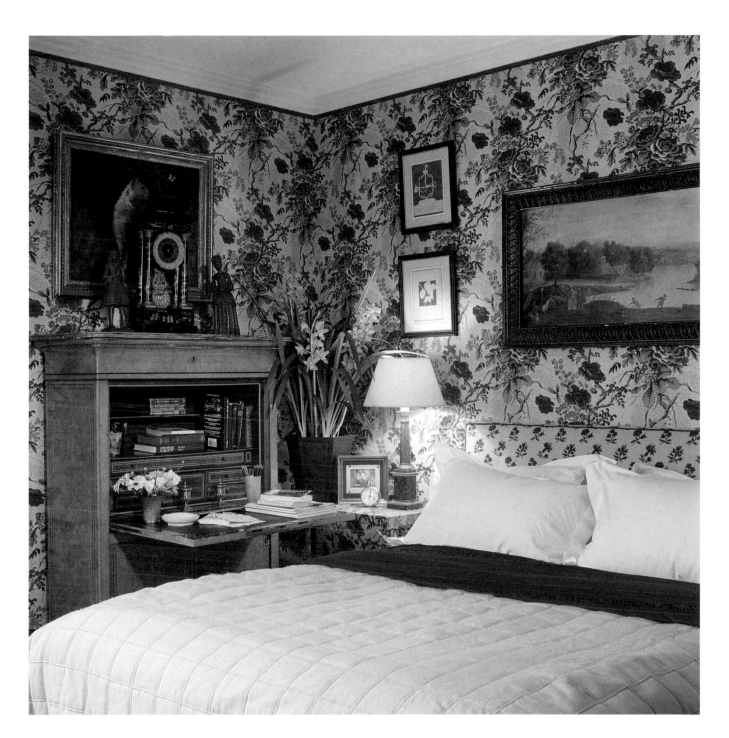

# Colour harmony

The smaller the flat, the more important it is to have a controlled and harmonious decoration scheme. In this bedroom designed by Roger Banks-Pye of Colefax and Fowler, the palette is concentrated on red and cream – but used in numerous different guises. The walls and cupboard doors (see opposite, below) are covered in a vibrant, poppy-motif chintz outlined with a narrow red border, while the bedhead and wing-back armchair have a more geometrically-arranged floral pattern, again edged with red. The warm colours and quilted bedcover are cosy, intimate foils to the handsomely severe set of Charles X furniture which includes a secretaire and commode in bird's eye maple.

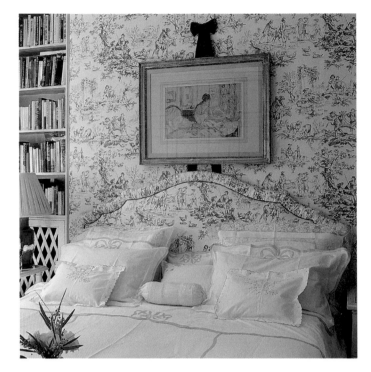

# A scenic background

Making a room look comfortable as well as fresh is a skilful balancing act. Anne Singer has successfully achieved that equilibrium in her London bedroom where blue-and-white *toile de Jouy* has sponsored a light, scenic background for books, pictures and mementos. Attention to detail is apparent throughout – for example, there is a neat blue edging to the walls, and the exquisitely fine bedlinen is decorated with blue appliqué bows – but much of the room's charm originates from its air of relaxation and from not looking over-precise.

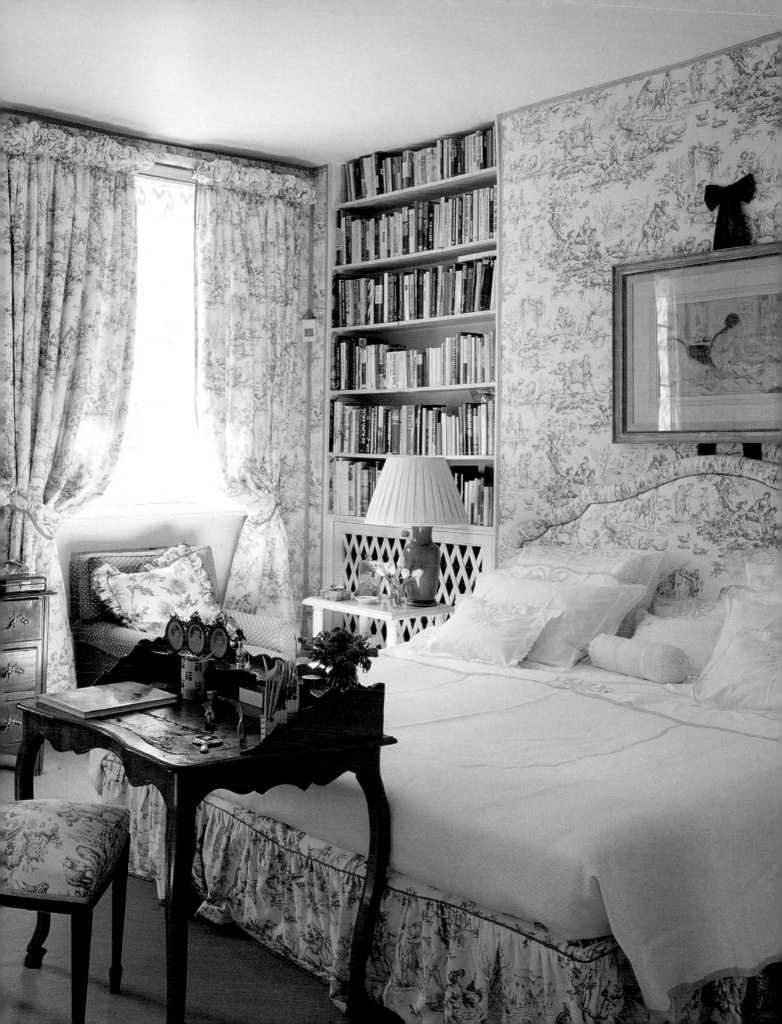

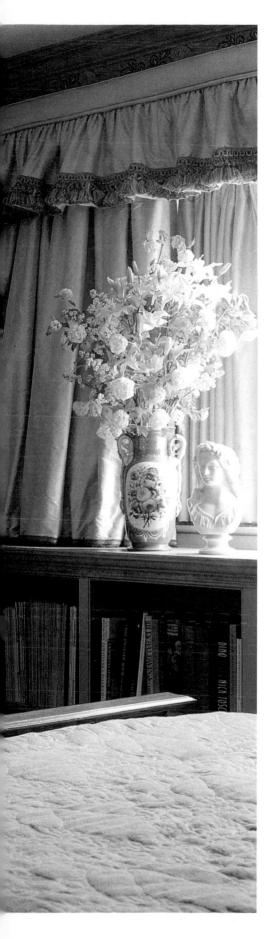

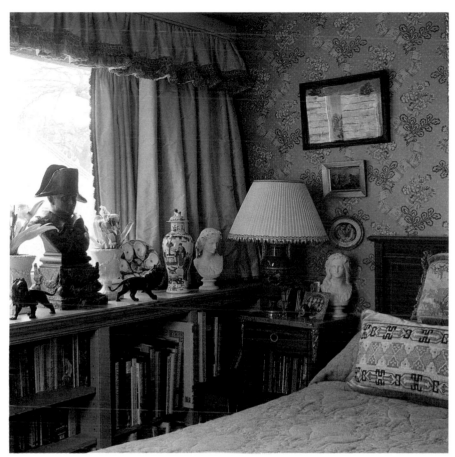

# Famous faces

There are a lot of people in Jonathan Hudson's small bedroom in his two-room flat overlooking the river Thames. Napoleon is there (on the bookcase beneath the window), and so is Madame du Barry (to the left of the French Empire chest-of-drawers), not to mention the Prince of Wales before he became George IV (in a painting just out of view), plus a host of less well-known figures depicted in portraits and sculptures. They are historical companions for the softly coloured wallpaper derived from an eighteenth-century design. The proportions of the window are not ideal but these have been overcome aesthetically (and practically) by the installation of the low bookcase and short curtains in apricot silk taffeta.

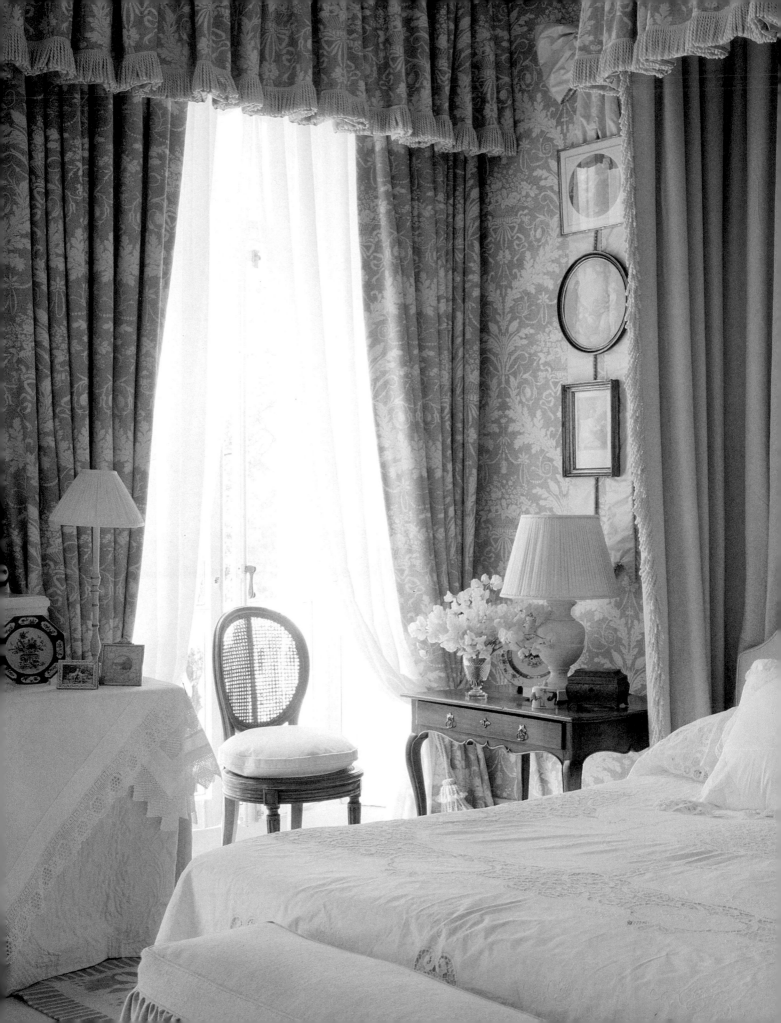

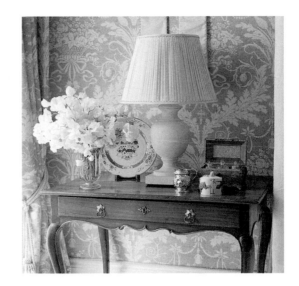

# Adaptable and feminine

Linen is one of the most adaptable of fabrics. Without appearing coarse or unsophisticated, it has an appealing naturalness and suits a wide range or situations and decoration styles. In this instance, a printed linen in delicate pink and cream is very feminine and luxurious yet avoids being fussy or twee. It has 'substance' but is nevertheless light. The print is used in tandem with a plain cream linen for the tester, dressing-table, stool and chairs. The interior decoration was devised by Grant White of O.F. Wilson.

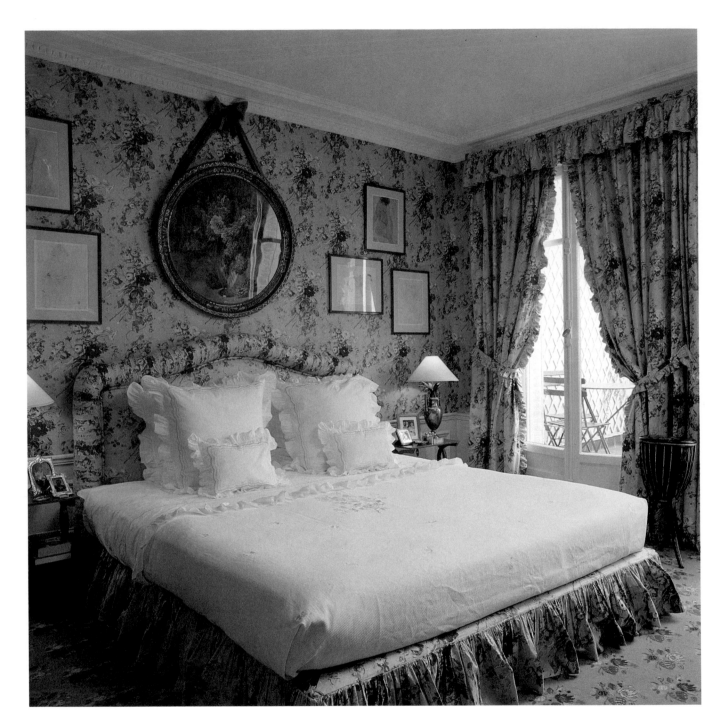

# Exquisitely tactile

Snugly ensconced within a small flat in Paris, this room designed
by Sabine Marchal has an exquisite build-up of textures revolving
round an elaborately patterned fabric recreated from an
nineteenth-century document design. With its matching valance

and upholstered headboard, the bed is totally integrated in the
scheme and is pivotal to the overall impression of tactile comfort
and intimacy. Yellow-trimmed linen and a floral carpet (based on
a nineteenth-century Russian original) enhance the femininity.
Against the fireplace wall are a small escritoire and an inlaid
secretaire dating from the 1760s.

# Year-round flowers

Tea roses on a tea-coloured background...if you want to summon up the spirit of a romantic nineteenth-century bedroom, this is the type of wallpaper to go for. The nostalgically-drawn summer flowers and soft colouring are a year-round joy. So, too, are the creamy curtains with their pleated edging, echoed by the trim on the pillows. There is a decorating theory that every room needs a touch of red to bring it to life and give 'value' to the other colours, and this room shows how a dash of scarlet can indeed have a sharpening influence without being aggressive. The bedroom is in the London home of Arnaud and Carla Bamberger, and is very much a distillation of their joint tastes and international backgrounds. Arnaud Bamberger is French; Carla was born in America; and both of them admire what they call the 'relaxed and comfortable English way of decorating, with a feeling of cosiness and warmth, and with nothing quite matching.'

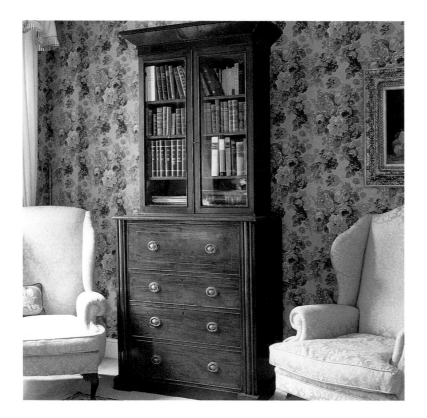

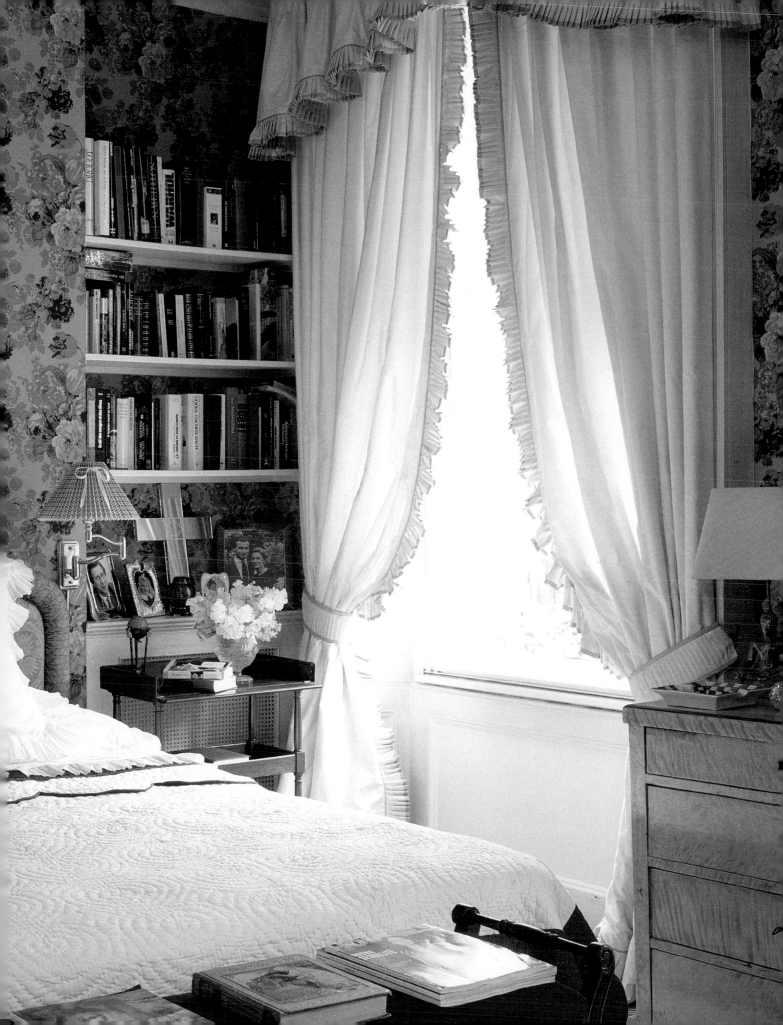

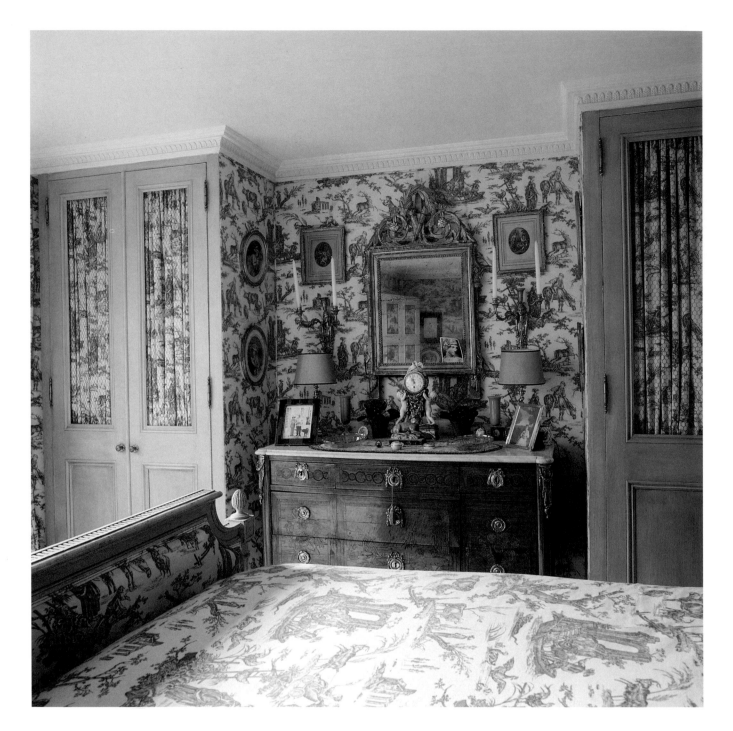

# Arcadian France

Making full play of a delightful red-and white *toile de Jouy*
printed with scenes of bucolic people and pastimes, the bedroom
in jewellery designer Elizabeth Gage's house in London invites
thoughts of an arcadian past in France.  Painted in a soft sage-

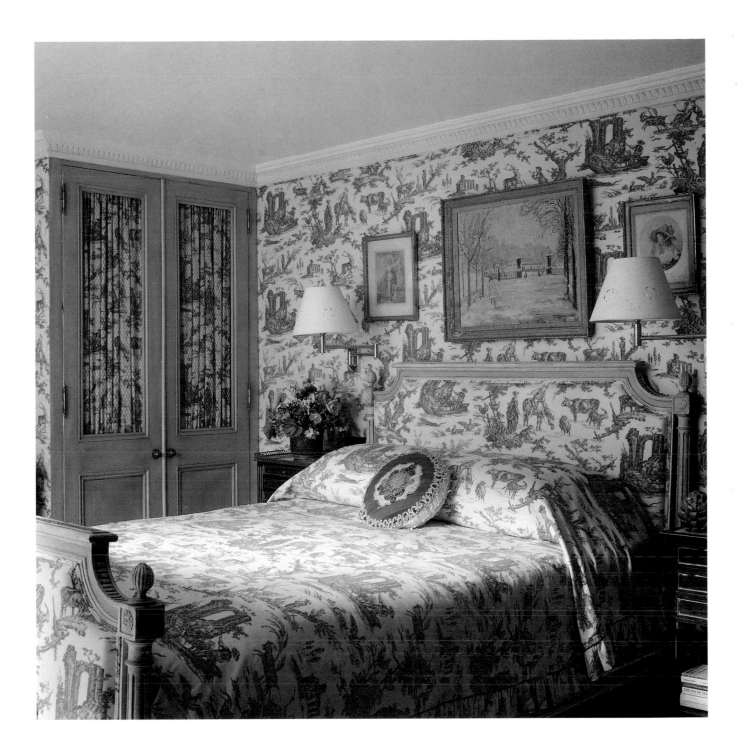

green, the cupboard doors incorporate the printed *toile* behind
chicken-wire panels, again suggesting a French country house
where comfort and tranquillity are paramount. The cupboards
neatly enclose a marble-topped chest-of-drawers and a
symmetrical arrangement of pictures, sconces and a mirror
which decorate the wall.

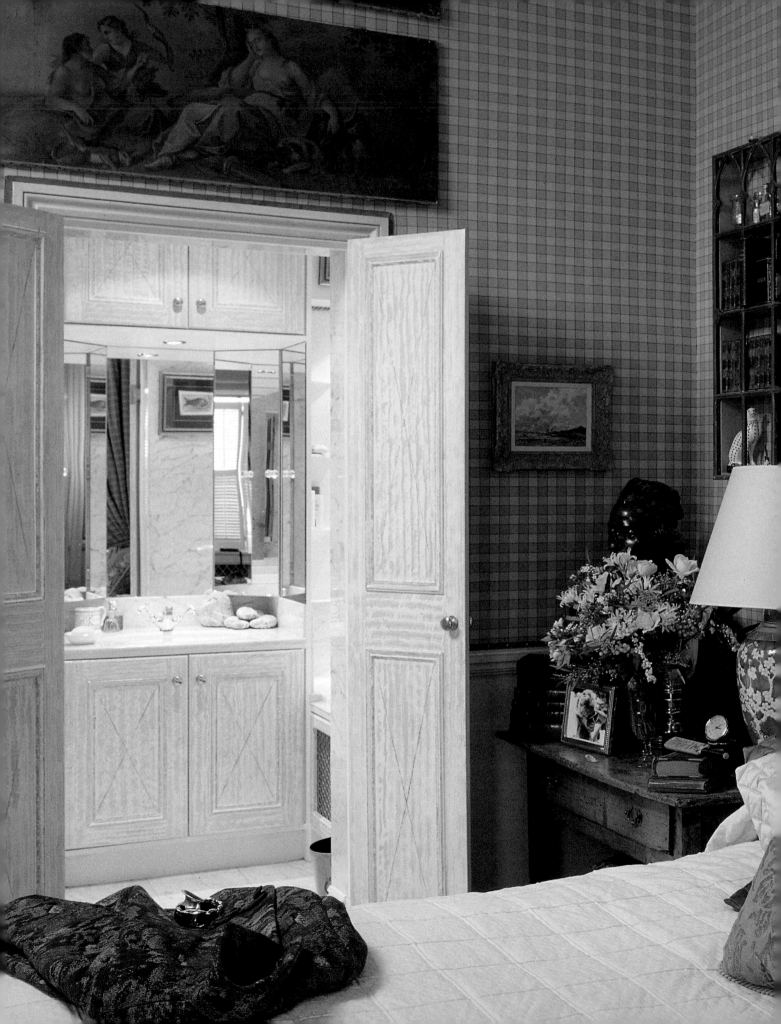

# WITH BATHROOM EN-SUITE

*Having an integrated bedroom and bathroom is more than a matter of logistics. The two rooms should relate to one another visually, so there is harmony and continuity of style. Similar colours, patterns and details all help to make the decoration connect.*

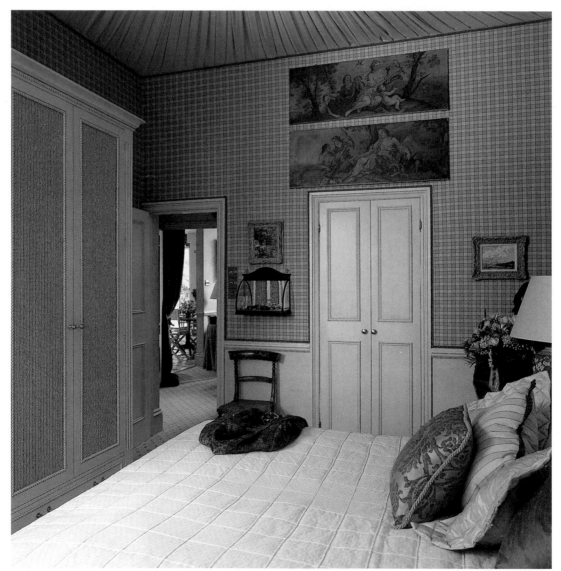

174 With bathroom en-suite

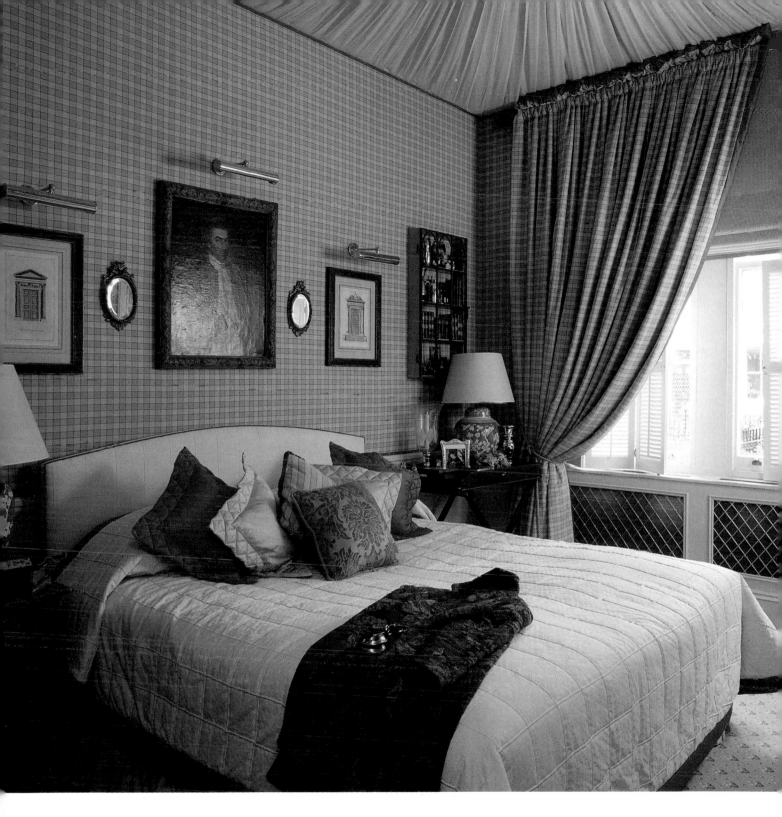

# Double purpose

The tented design for this bedroom in a London *pied à terre* was not devised simply to create an interesting effect – it has two other purposes. First, it improves the room's proportions which are too high for the floor area; secondly, it muffles sounds from above. In rooms with tented ceilings, the most satisfactory way to deal with the walls is usually to line them with fabric rather than to paint or paper them. Here, interior designer Carolyn Holmes has chosen a formal checked cotton, edged with petersham ribbon. In the bathroom, which opens off the room through double doors, the woodwork has been given a silver-layered paint finish by Terry Davies to complement the grey marble and mirrors.

**With bathroom en-suite 175**

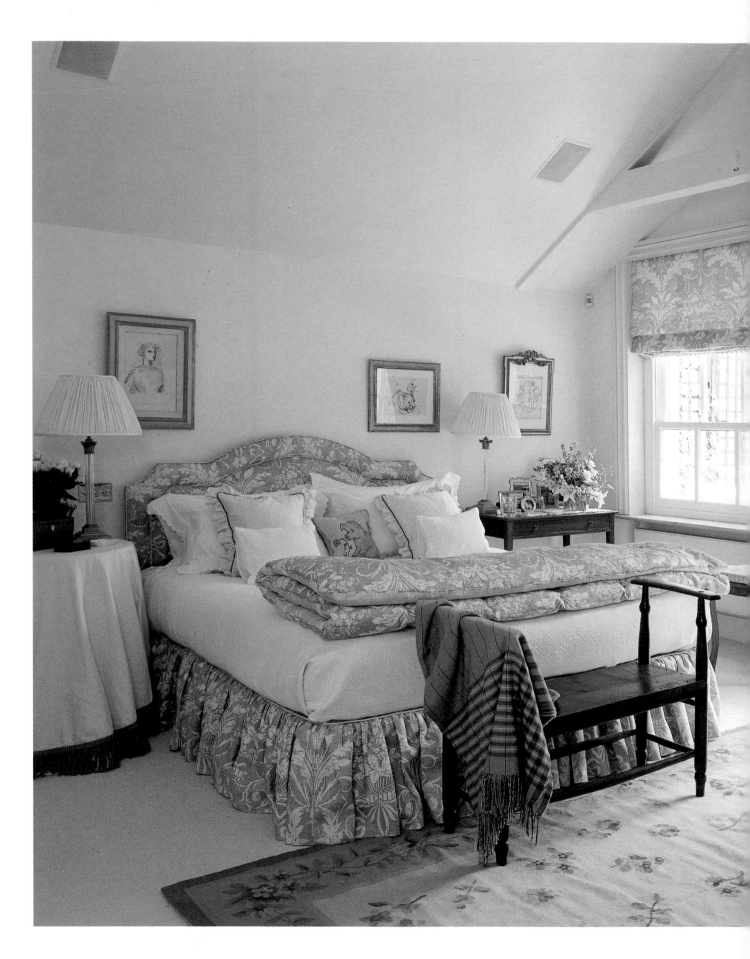

176 With bathroom en-suite

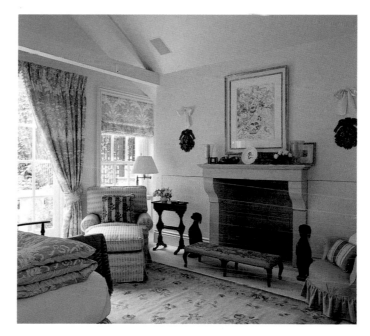

# Unexpected setting

It is hard to imagine that this bedroom, with its sloping ceiling and doors opening onto a garden, is in a new house right in the centre of London. Tim Simonds had clear ideas on how he wanted the interior decoration to look, and he asked Joanna Wood to interpret the brief. The result is particularly refreshing in this area of the house where there is an exceptional feeling of light, partly due to the architecture and partly to the blue-and-cream colour scheme. The twin basins in the bathroom are inset in an attractively designed cupboard which is practical as well as suitable to the room's traditional style.

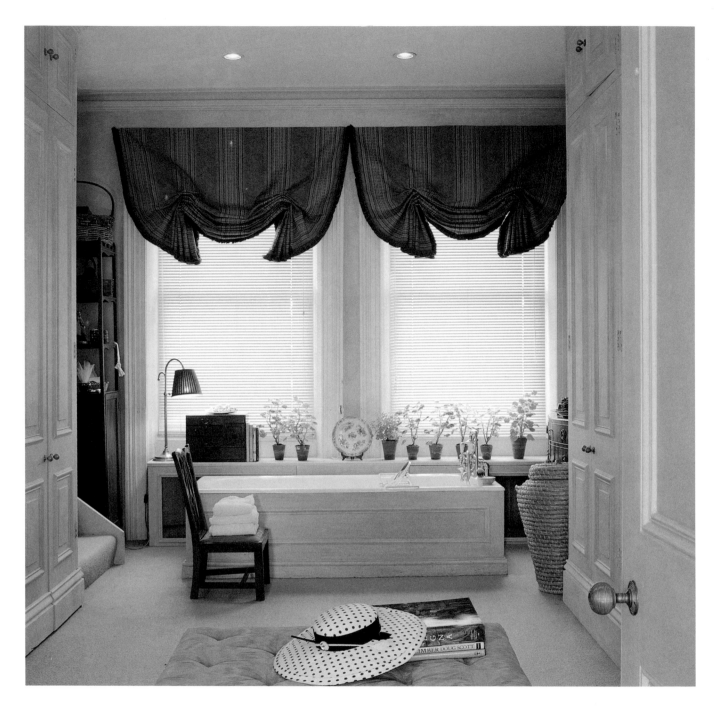

# Hints of Italy

This bedroom (opposite) in a house in South Kensington, decorated by Emily Todhunter for much travelled clients, has associations with many parts of the world. The bedcover is from Pakistan, the rug is from Khotin in Russia, the antique wallhanging is French, the furniture is English, but woven through these international elements is an underlying Italian ambience. This derives from the beautiful Italianate wall-finish in pale terracotta plaster by Adam Calkin, and from the curtain fabric which is a traditional Italian woven stripe. The curtain heading is unusual and simple: deep box pleats coincide with the stripes to create a neat, fitted effect. The same fabric is repeated at the large double windows in the bathroom, but here it is used in conjunction with Venetian blinds which give daytime privacy. On either side of the room are floor-to-ceiling cupboards with painted, panelled doors echoed in the design of the bath casing.

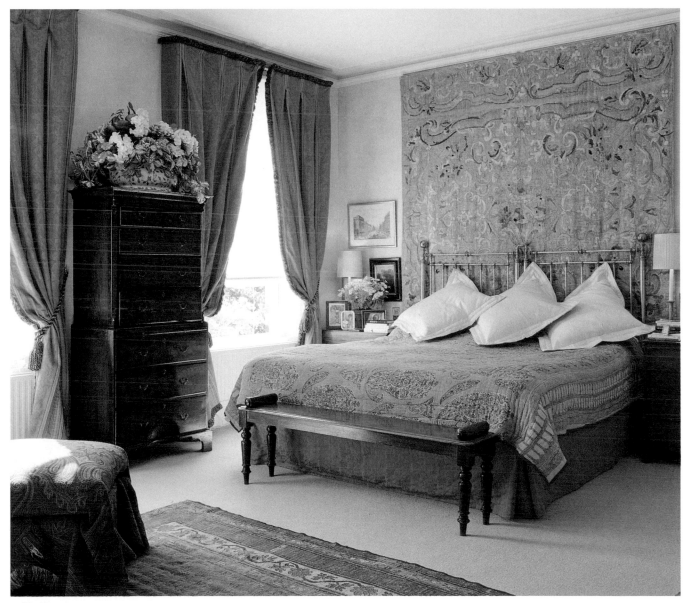

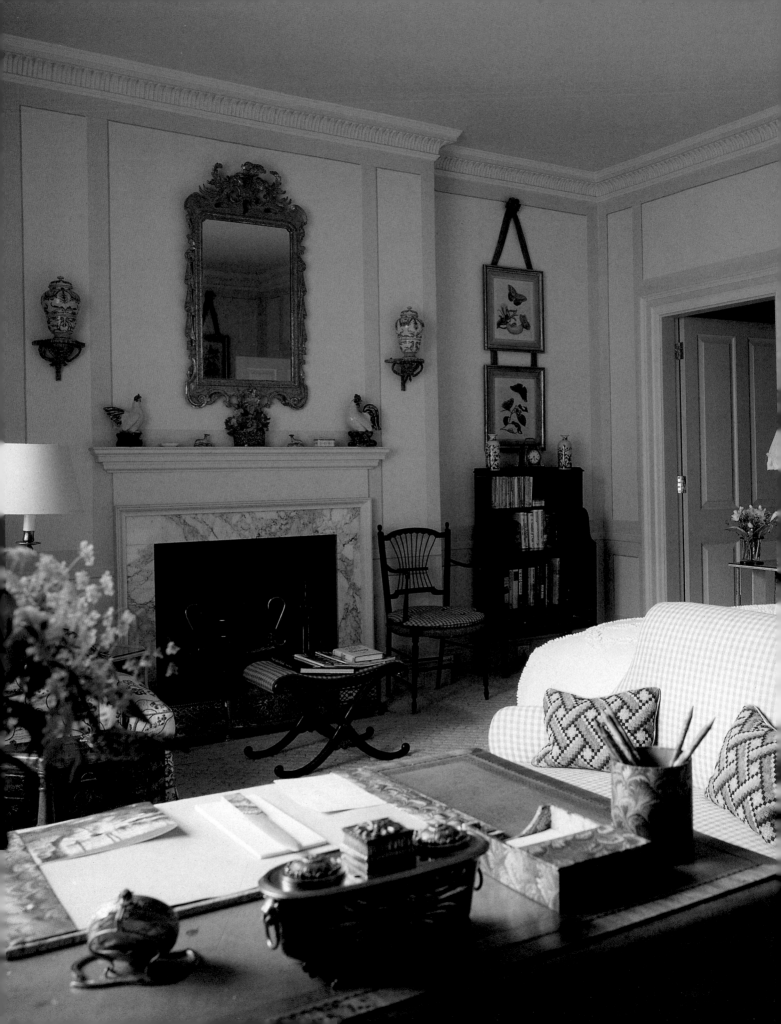

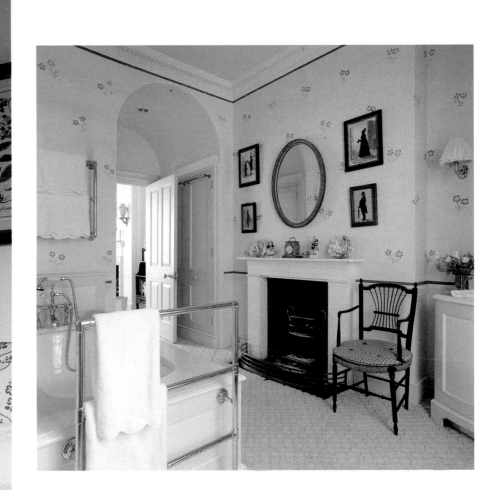

# Country-house colours

A reassuring quality of timelessness is inseparable from the classic English country-house style of decoration. In this guest bedroom decorated by Stanley Falconer of Colefax and Fowler, the effect has been achieved with seeming artlessness. Everything harmonizes and gives the impression of having come together by serendipitous chance rather than contrivance. The background for this uplifting assembly is *trompe l'oeil* panelling in a delicate shade of grey-blue, similar to that seen in the checked upholstery of the sofa and the trellis-design linen on the bedhead. The linen was copied from an old French pattern and inspired the hand-painted flowers on the walls of the bathroom where the country-house character is emphasised by the open fire and pretty armchair with gingham squab. The strategic placing of the towel-rail at the foot of the bath, away from the wall, is an efficient use of space and heating.

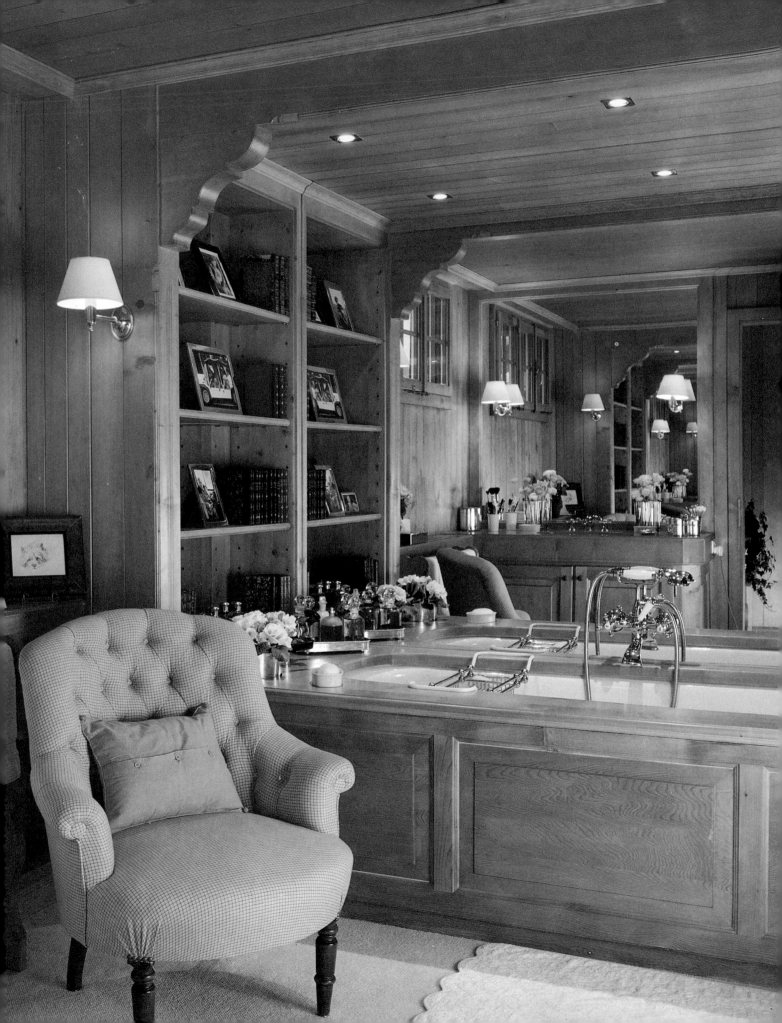

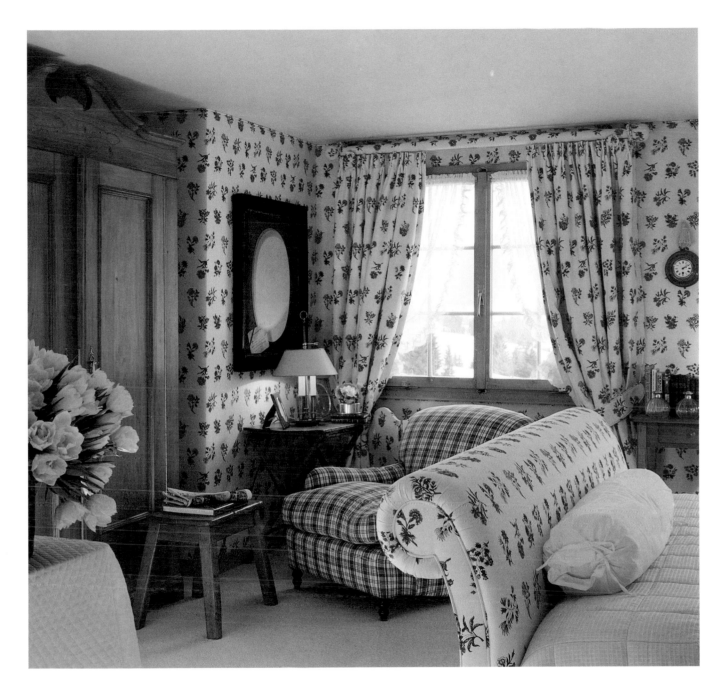

# Extending a tradition

The tawny tones of natural wood and the soft textures of fabrics are psychologically warming in a cold climate. To have a feeling of cosiness indoors, when the temperature outside is freezing, is almost primeval in its dichotomous pleasure. This bedroom and bathroom are in a chalet in Gstaad, refurbished with the advice of architect Marcel Neuhaus and interior designer Lars Bolander. The rooms reflect the mountain custom of using timber, but the tradition has been assimilated within a wider, more refined style of decoration. The floral fabric used for the bedroom walls, curtains and bed upholstery was chosen by the owners and is a cheerful partner for the check suggested by Lars Bolander for the armchair. Both rooms, though perfectly attuned to the Alps, would look equally well in many other settings.

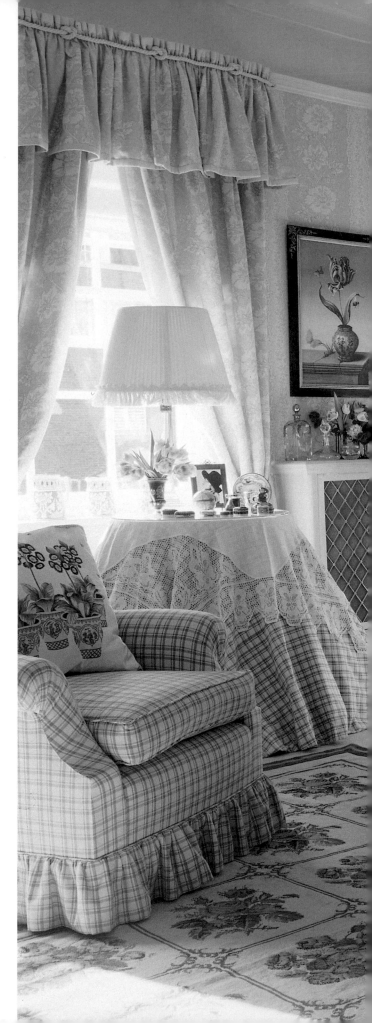

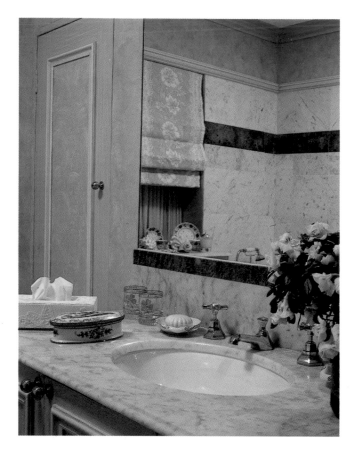

# Spring green

Mint-and-cream is an unusual colour combination but it works exceptionally well in a bedroom where prettiness and a soft, springlike freshness are the aims. Here, it is seen in a delectable wallpaper which has lacy stripes alternating with stylized flowers. The same pattern is used for the curtains and cream-edged pelmets which are decorated simply and effectively with knotted rope. The stepped design of the cupboard is a practical solution to a problem often encountered in old houses, where the distance between the window and the adjacent corner is too short for a full-depth cupboard. The stepped-back arrangement leaves the window unobstructed and does not interfere with the curtains. To create a tidy horizontal alignment, the height of the cupboards and wallpapering was determined by the height of the windows. In the adjoining bathroom, the walls are finished with marble, mirror and a mint-green paint effect by John Brown to tie in with the unusual bedroom wallpaper. The interior designer was Cecilia Neal of Meltons.

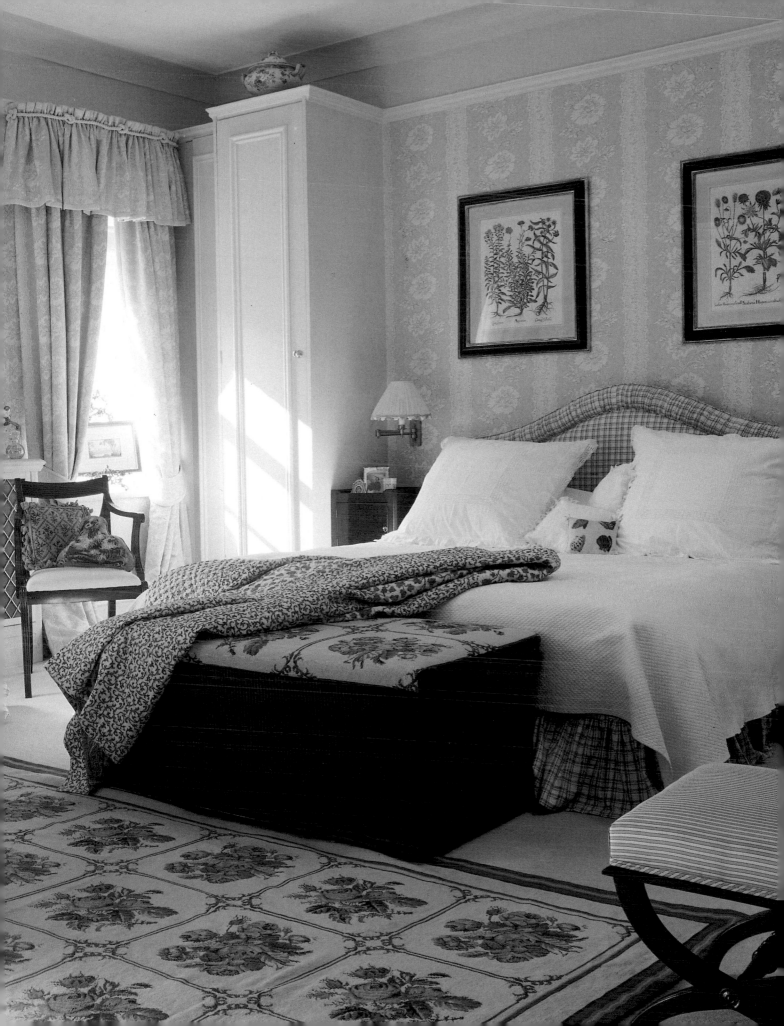

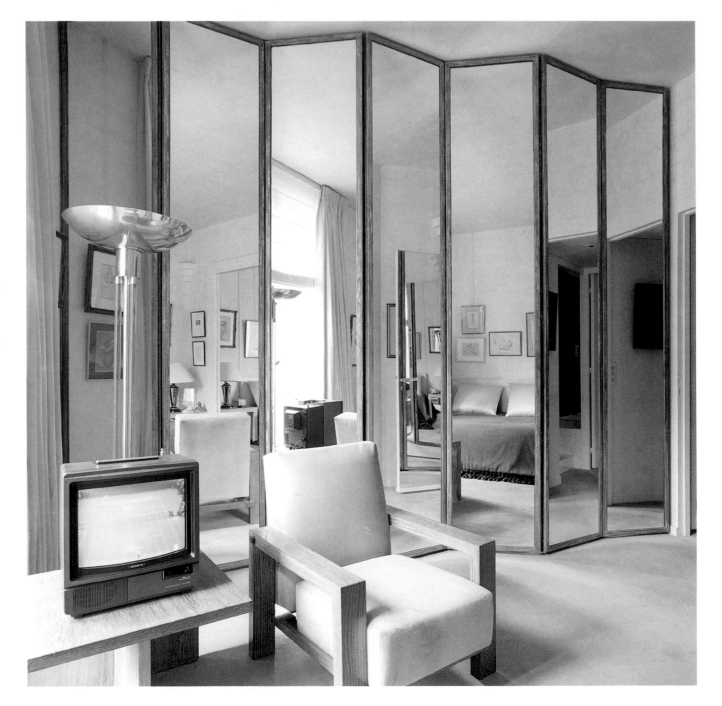

186 With bathroom en-suite

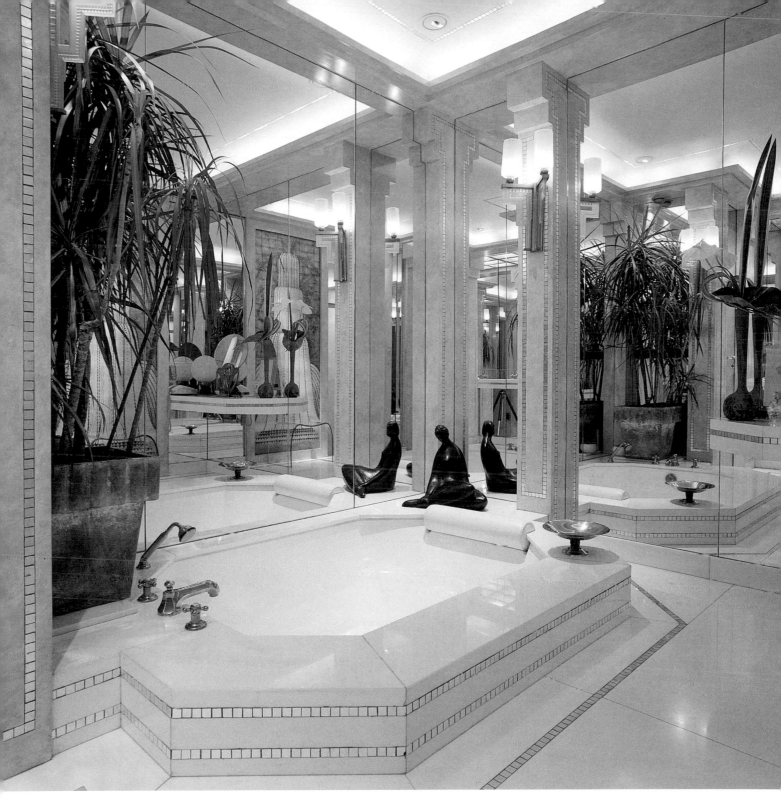

# Back to the Thirties

This bedroom and bathroom in Paris were designed by Frédéric Méchiche for a couple whose style preference is the Thirties. He, too, likes this period and has indulged in all kinds of decorative illusions to the people and fashions of the time: the bedroom, for instance, is 'sober and simple', inspired partly by the designer Jean-Michel Frank. The walls are covered with paper resembling parchment, and the colour of the cashmere bedcover is suitably subdued. Opposite the bed is a bank of cupboards designed to look like a screen of mirror, with silver-painted wooden surrounds. Leading off the bedroom is a sumptuous Thirties-style bathroom lined with mirror and white marble inset with silver mosaic.

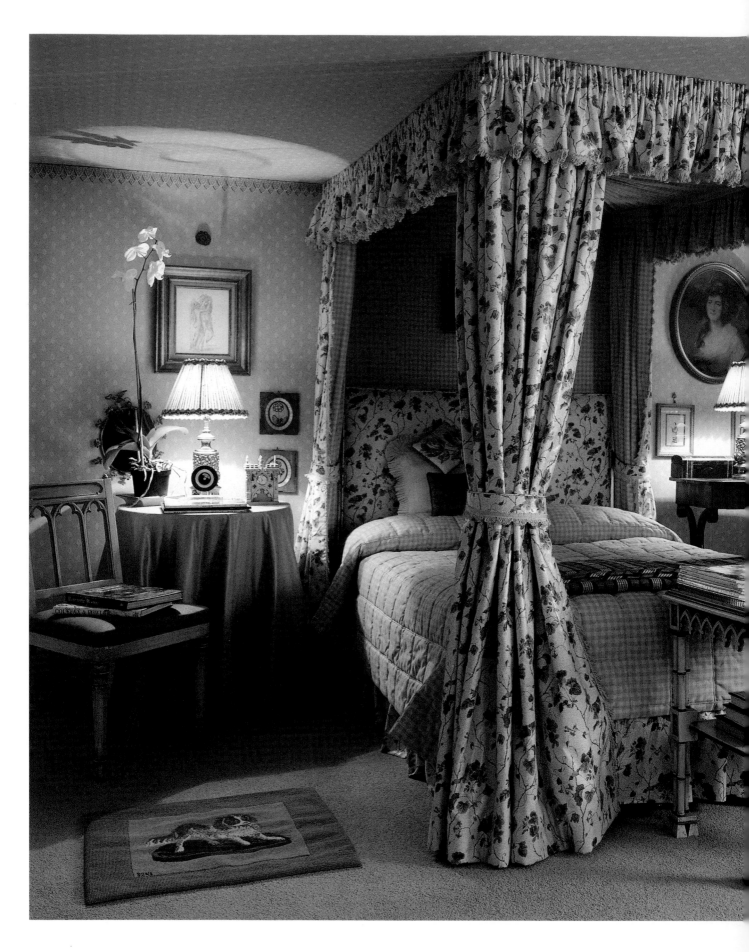

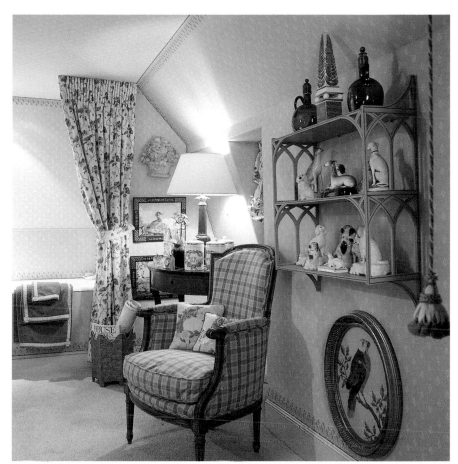

# Gothic intricacy

Gothic is the link between the bedroom and bathroom seen here. Designed by Louisa Pipe, the rooms are at the top of a converted town house and combine the charms of quirky architecture and intricate decoration. The beige-and-cream wallpaper is continued over the bedroom ceiling and has a gothic border in the same colourway. One wall – illustrated on page 216 – has specially designed cupboards with partially glazed, pointed-arched doors, and the hanging shelves in the bathroom also reiterate the gothic theme. Reaching to the top of the room, the bed copes decoratively with the low ceiling and gives a convincing impression of being a real four-poster. In fact, it is a divan placed within a framework of poles hung with curtains.

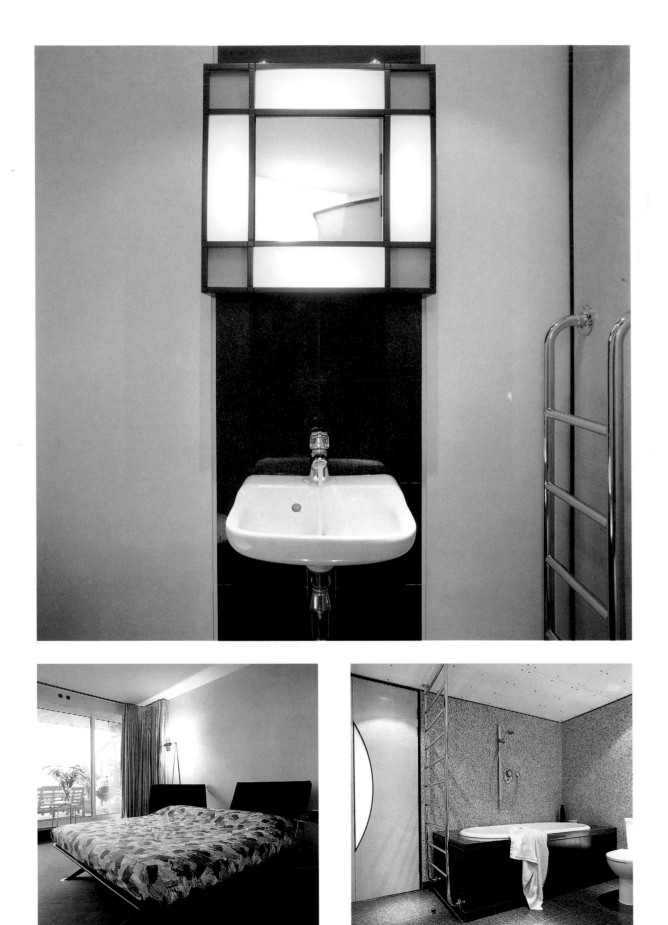

**190 With bathroom en-suite**

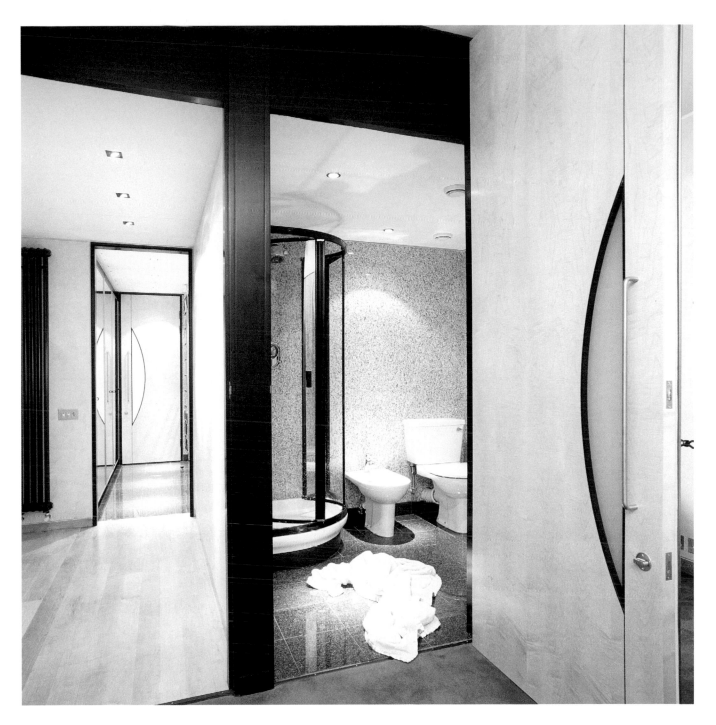

# Minimal and calm

'Less is more' is the rule in the modern Chelsea Harbour flat redesigned by Tim Bushe for Michael Piercy. The owner's brief specified minimalism, with no pictures to interfere with the clarity of line, and no clutter to detract from the calming ambience. The colour scheme is poised between the cool shades of grey seen in the bedroom fabrics and bathroom granite, and the warmer, sienna tints used for the bedroom wall finish and sycamore doors. The bathroom, though strictly architectural, has concessions to comfort with a ceiling-high radiator, deep bath and separate shower-room.

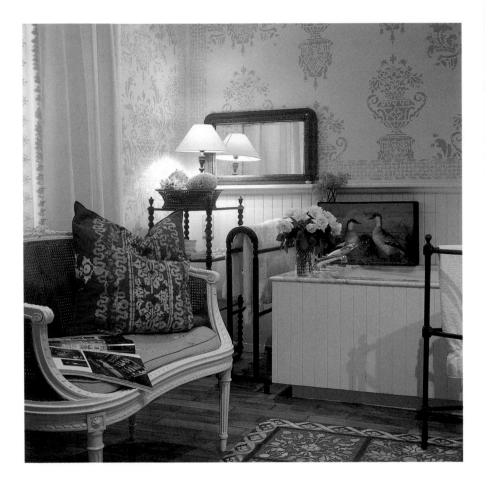

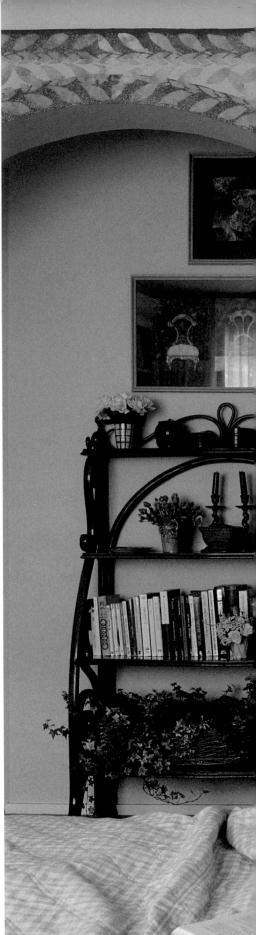

# Simpler and prettier

The bedroom and bathroom designed by Isabelle de Borchgrave for a seaside house in Belgium are united by colouring and stencilling. Both are essentially yellow rooms with a dash of pink, but the stencilling in the bedroom is used purely as an outline for the walls and archway leading to the bathroom. In the latter room, the stencilling is more exuberant – a bold design of urns and flowers which is repeated over the entire wall surface above the boarded dado. Interestingly, the bathroom used to be a much more glamorous affair, with steps up to the bath and lots of marble, but that was too glitzy for Isabelle de Borchgrave and her clients, so she replaced it with this more artistic scheme which has an unassuming, almost naive, charm.

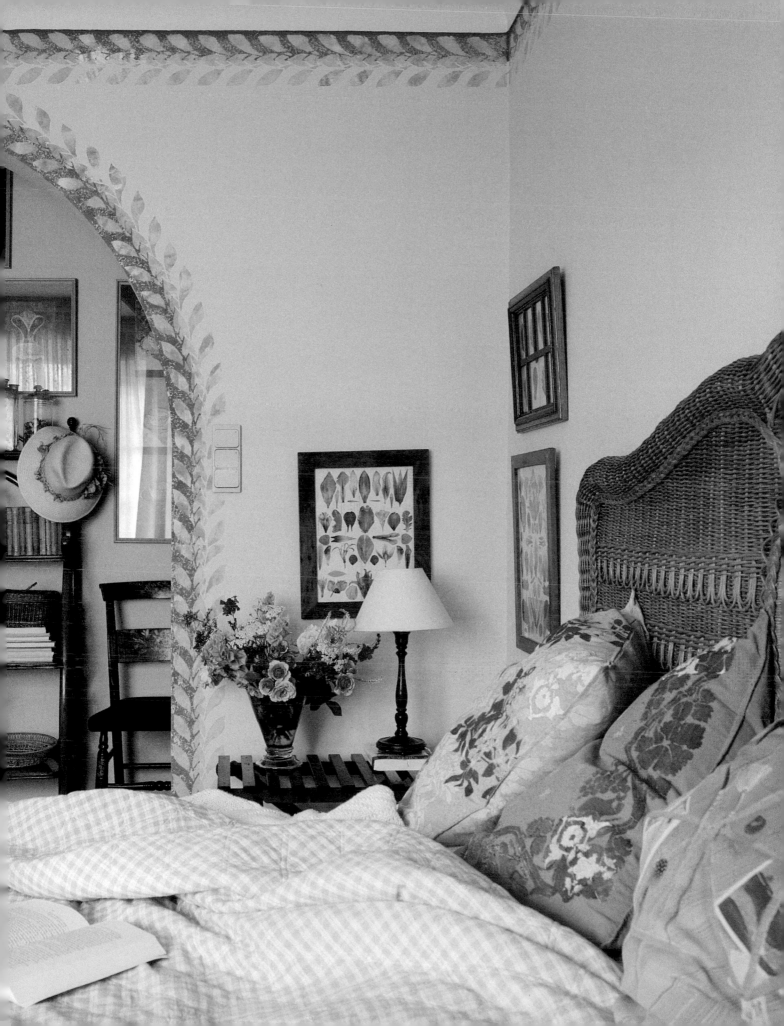

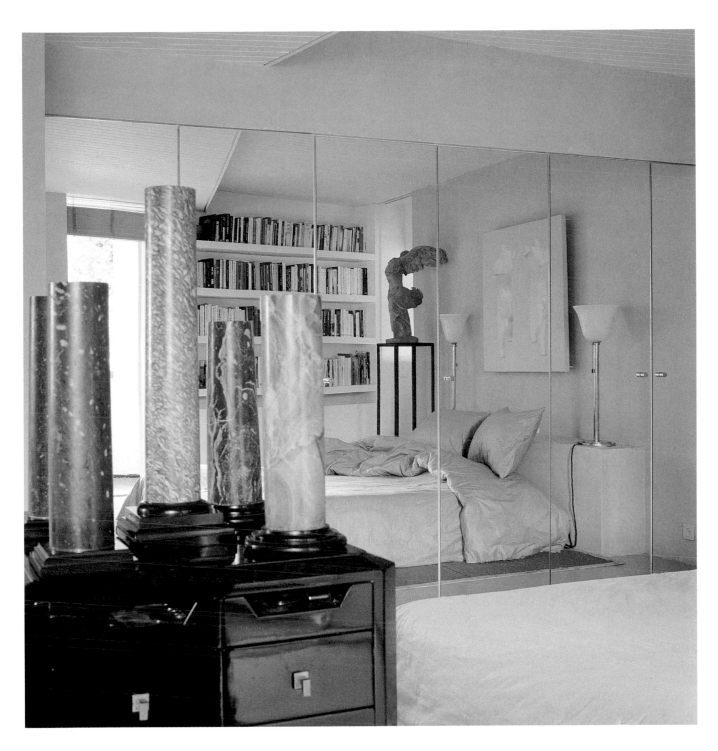

# A contemporary entity

Marc Corbiau is an architect whose home in the centre of Brussels is a true reflection of his design philosophy. He believes in simplicity and that 'each angle, window, door, wall, piece of furniture and object should co-relate and form part of the whole as one cohesive entity'. His bedroom is a luminously serene space with one wall faced with mirror to reflect and balance the light which floods in from the floor-length windows overlooking the garden. A Thirties black laquer table displaying marble classical columns is positioned in the centre of the floor space as a further means of giving balance to the room's proportions. Like the bedroom, the bathroom has an almost tangible feeling of tranquillity, thanks to the monochrome scheme, accented only by a green sculpture by César Bailleux and a sculptural plant.

# Primary panache

This bedroom and bathroom are in a flat in London which, in the Fifties, belonged to Cecil Beaton and was notable for its avant-garde colouring and furnishing. A few years ago, it became the home of interior decorator Nicholas Haslam. Sympathetic to Beaton's panache, Nicholas Haslam redecorated it in a manner which reflected that exciting phase. He painted the walls blood-red and played up the primary vividness with lots of white: white ceiling, white curtains and, most effectively, white-and-gold doors and architraves. He kept the 'fitted' bathroom and enhanced it with a mahogany casing for the bath. He hung the walls with architectural drawings and he added a sofa to give the room the semblance of a small sitting-room. The sofa is covered in a leopard-print fabric which forms a visual link with the fur fabric in the bedroom. In Beaton's day, this room was furnished with a four-poster but, sadly, it was no longer there when Nicholas Haslam took over the flat – hence the divan. However, at least this has allowed space for the painting, thought to be by a pupil of Jacques-Louis David.

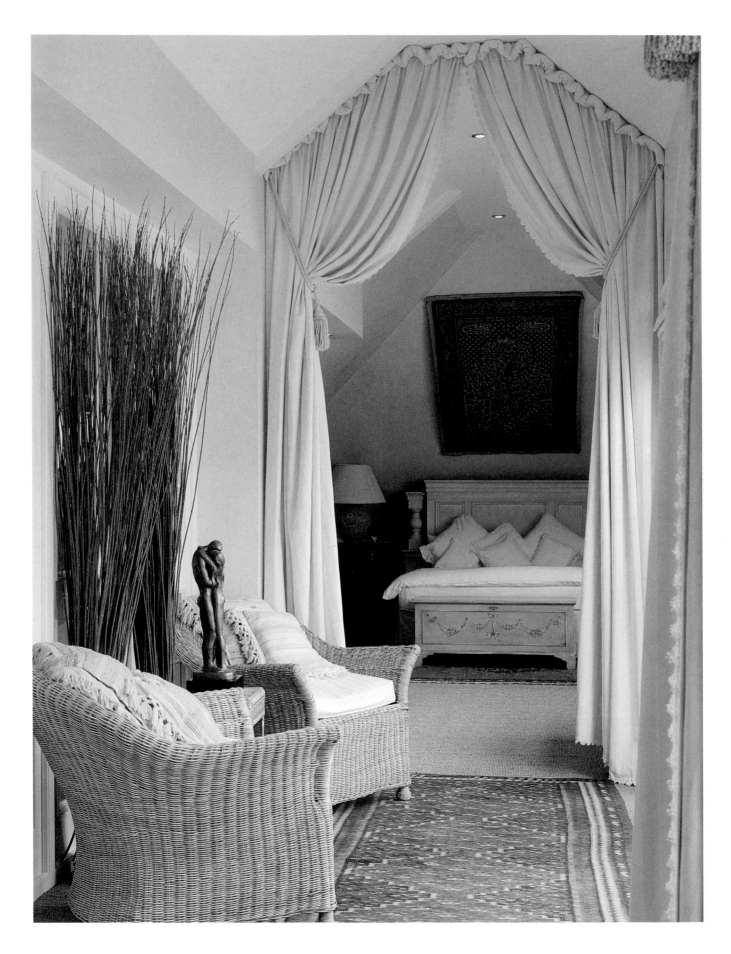

**198 With bathroom en-suite**

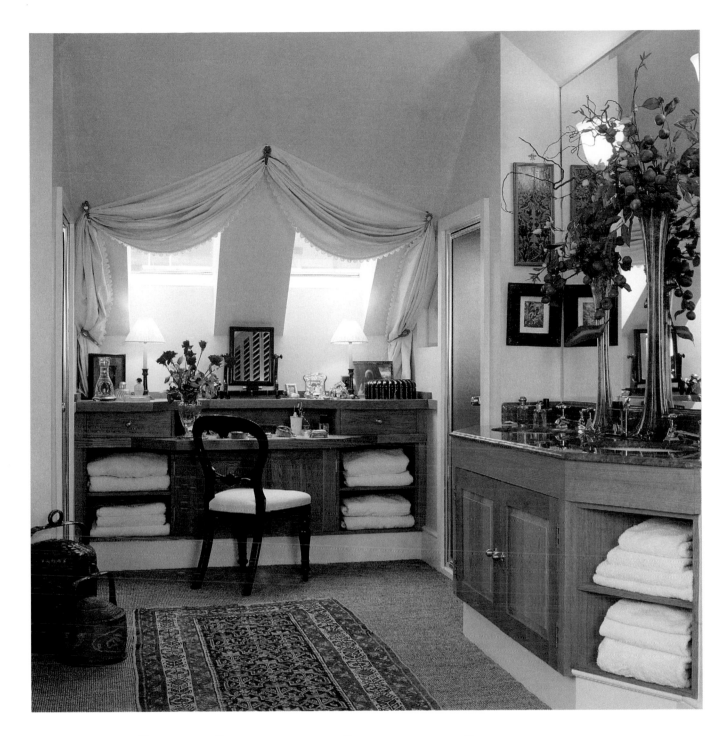

# Out-of-town colours and textures

Idiosyncratically-shaped rooms converted from spaces at the top of the house present a challenge to the interior decorator. In this house in central London, Simon Lowe has skilfully amalgamated urbane eclecticism with informal out-of-town colours and textures. The bedroom, bathroom and sitting-area form three interconnecting spaces, defined by two sets of floor-to-ceiling curtains. 'I didn't want to split up the space by using doors, but something was needed to break it up a little,' says the designer. He used a neutral palette and just a few pieces of furniture: cane chairs and a matching table furnish the sitting-area, for example, where a thirty-foot run of doors leads onto a terrace. The natural theme is carried into the bathroom where the cabinets are made of English oak. Seagrass floorcovering is used throughout.

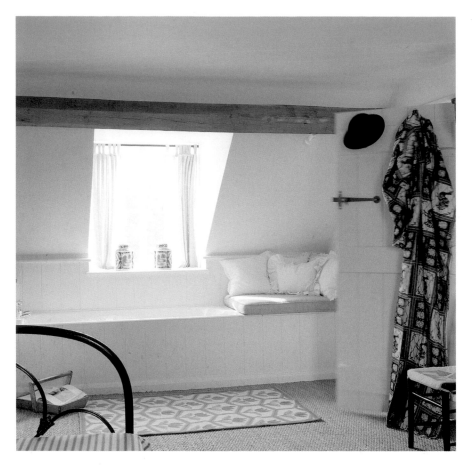

# Well groomed

Changing old buildings to new uses sometimes demands a radical approach to achieve the best result. The bedroom seen here is on the top floor of a coach-house, a space which previously was a dark warren of tiny rooms used by grooms. When interior design partners Hugh and Anne Millais planned its conversion to bedroom accommodation, they were determined to gain as great a sense of space as possible and, unconventionally, decided on a plan which incorporates a bath within the new bedroom. This solution provides the maximum floor area for the bedroom – a prime objective – and makes practical use of the sharp angle between the floor and sloping wall. At one end of the bath, a lift-up seat conceals useful storage and provides the room with an additional element of comfort. In deference to the modest style of the architecture, and in order to maximise the newly achieved airiness, the decoration of the room has been kept simple and bright: the walls and tongue-and-groove boarding around the bath are painted a soft white, while that ever-successful combination – blue-and-white – has been chosen for the striped bedcovers and rugs. Even the iron bedsteads satisfy the wish for a pretty, light, unaffected ambience.

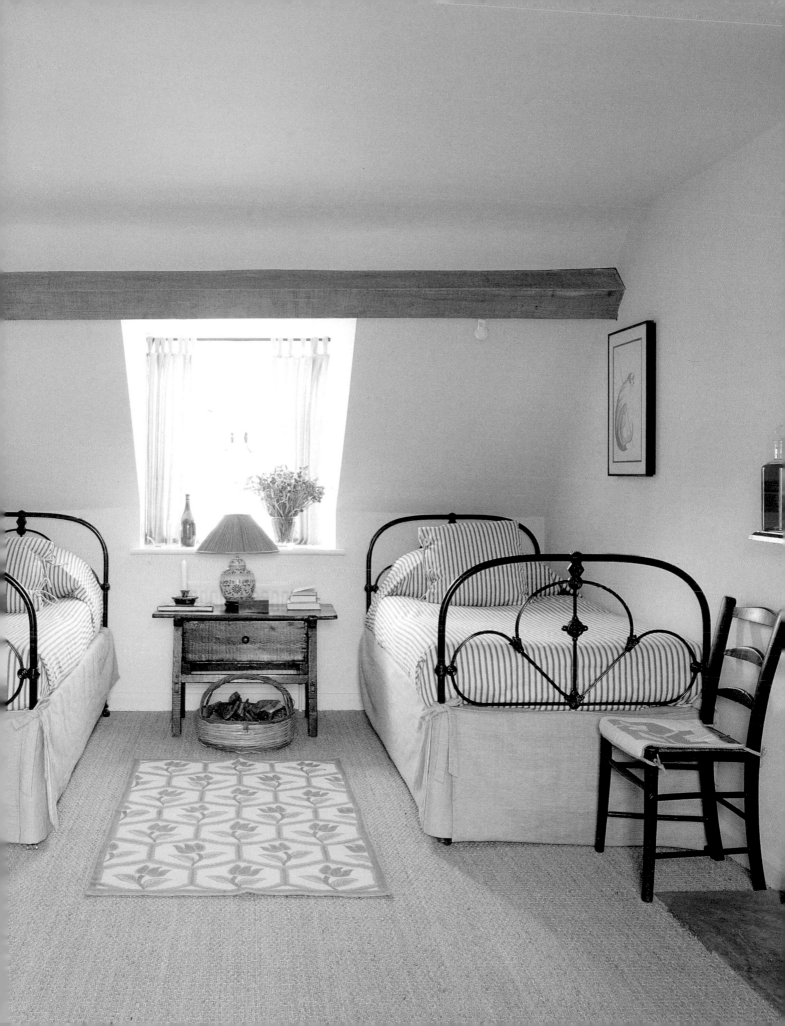

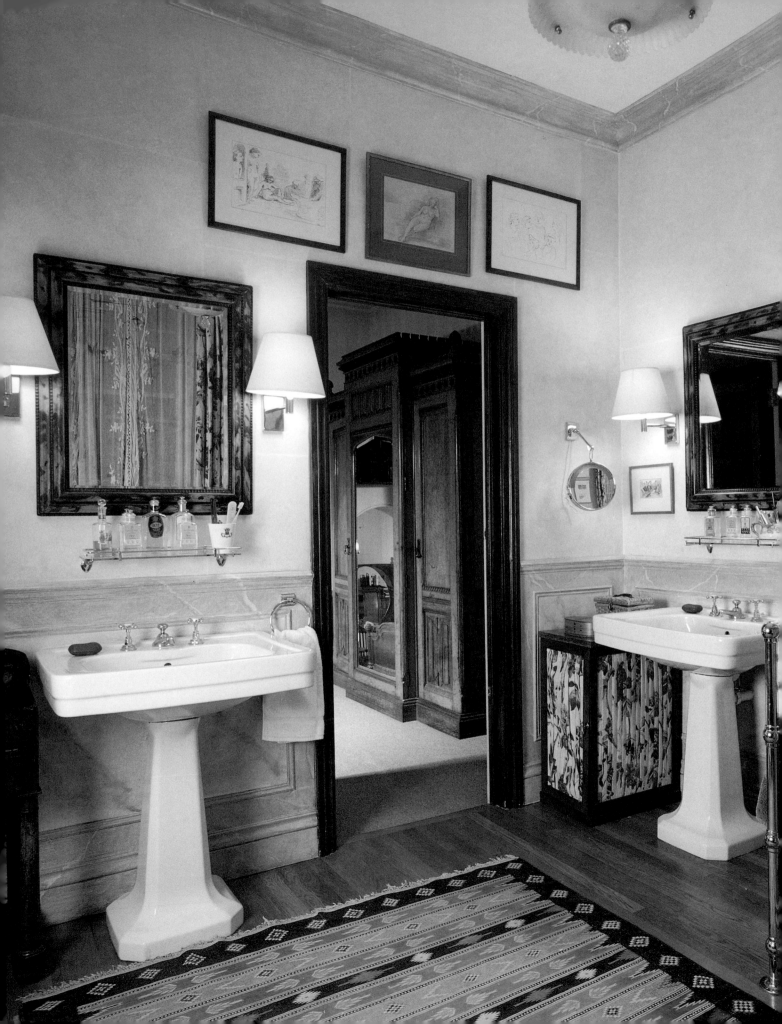

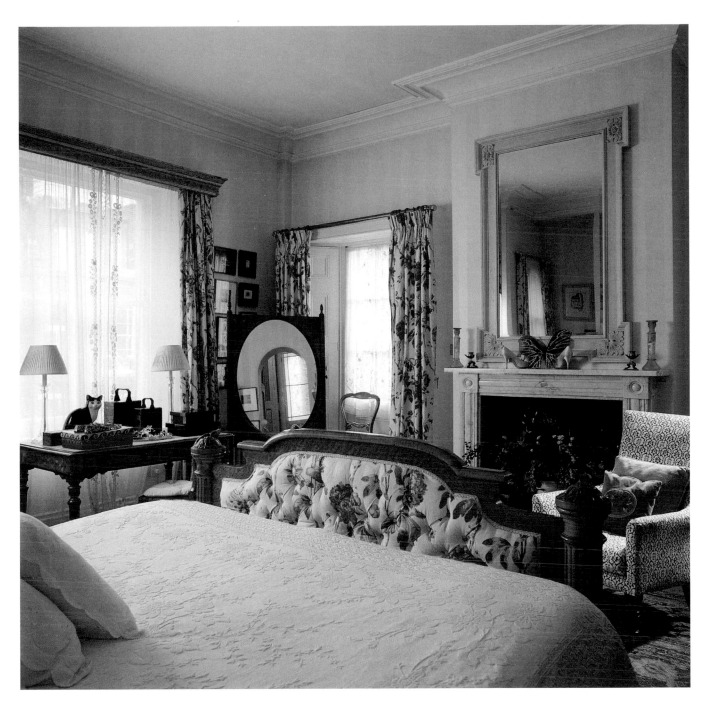

# Traditional comfort

Whilst taking into account all the requirements for a practical home for today, this bedroom and bathroom in a large, restored nineteenth-century house in Holland Park successfully incorporate traditional architectural details, appropriate furniture and understated comfort. With a deep-buttoned bed, cheval mirror and writing-table, the furnishing of the bedroom has an eclectic personality and, happily,

follows no clichéd formula. The dressing-room connecting the bedroom and bathroom has a handsome nineteenth-century, break-front cupboard with gothic ornamentation, and the bathroom has a pair of traditional pedestal basins. The restoration and furnishing of the house was carried out for Rodney and Jane Fitch by architect Philip Wagner and decorator Robert Kime.

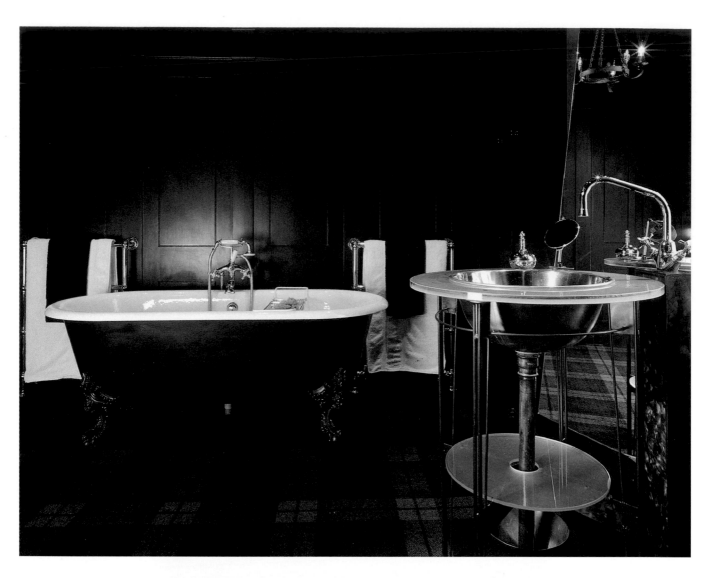

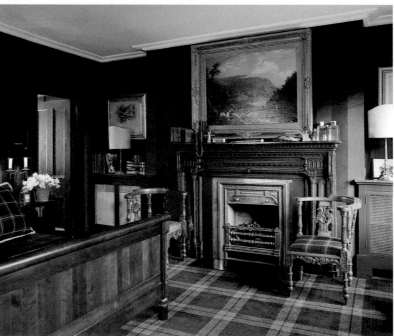

204 With bathroom en-suite

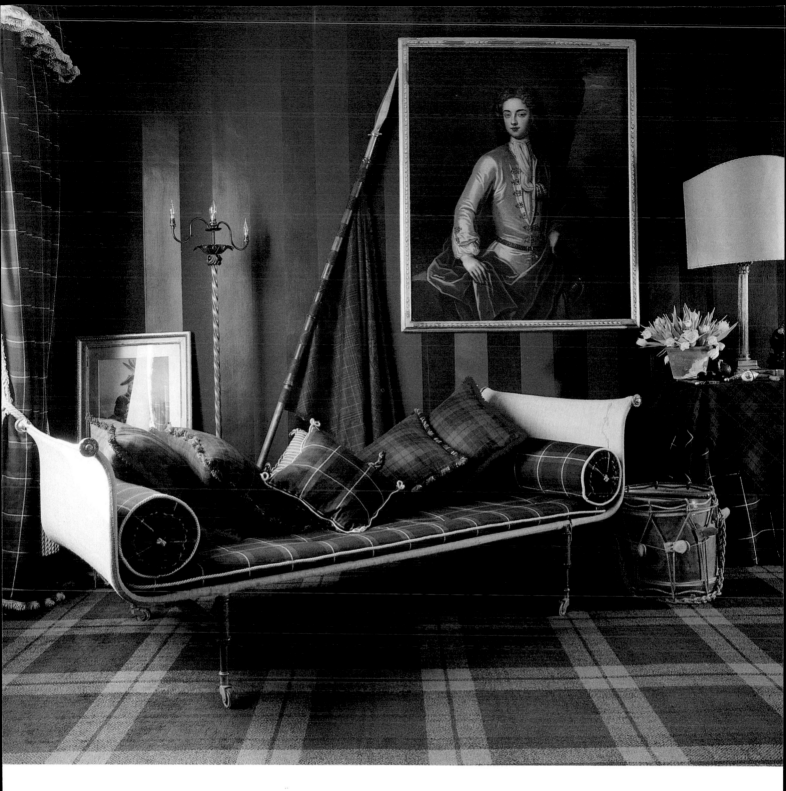

# A dark drama

This is certainly an audacious scheme: deep colours, big patterns and unusual objects are seen in a brilliant mix of antique and avant-garde design. In a London flat remodelled for a photographer friend by architect Brian Beardsmore, the idea for the tartan bedroom came from another friend, Cindi Leveson, a stylist who devised the scheme as an especially fitting background for someone who has Scottish antecedents and who likes things with an air of theatricality. The walls in the bedroom are painted in blue eggshell, with broad stripes added in varnish, giving the effect of fabric. The panelled walls in the adjoining bathroom are painted in the same deep blue, but without the stripes, creating a link between the two areas as well as a dramatic backdrop for the Victorian bath and modern, movable washstand. Designed by Brian Beardsmore, the stand has a stainless-steel bowl set in a circle of sandblasted glass.

# All in one

There is virtually no division between the bedroom and bathroom
in the converted apartment in Paris belonging to Cheska and
Robert Vallois. The Vallois are collectors and specialist dealers in
the decorative arts of the Thirties, and their passion for this
period, plus their wish for as quiet a home as possible in an
urban situation, dictated the layout and style of the conversion.
Carried out by architect Simon Taieb, the scheme was visualized
by the Vallois as an open, airy series of rooms with huge windows
opening onto an internal courtyard garden, well sequestered
from the busy world beyond. Wanting everything to be as light as
possible and a fitting background for their art and furniture, they
chose cream for the paintwork in the bedroom, and grey-veined
white marble to line the bathroom. All the textiles are pale and
soft, in order to harmonize with the natural light, which is
increased by the skylight in the bathroom. Beneath the skylight a
corner is set out with plants and stones, rather in the style of a
Japanese garden. To either side of the bed, on the parchment-
covered tables, are surrealist lamps by André Groult.

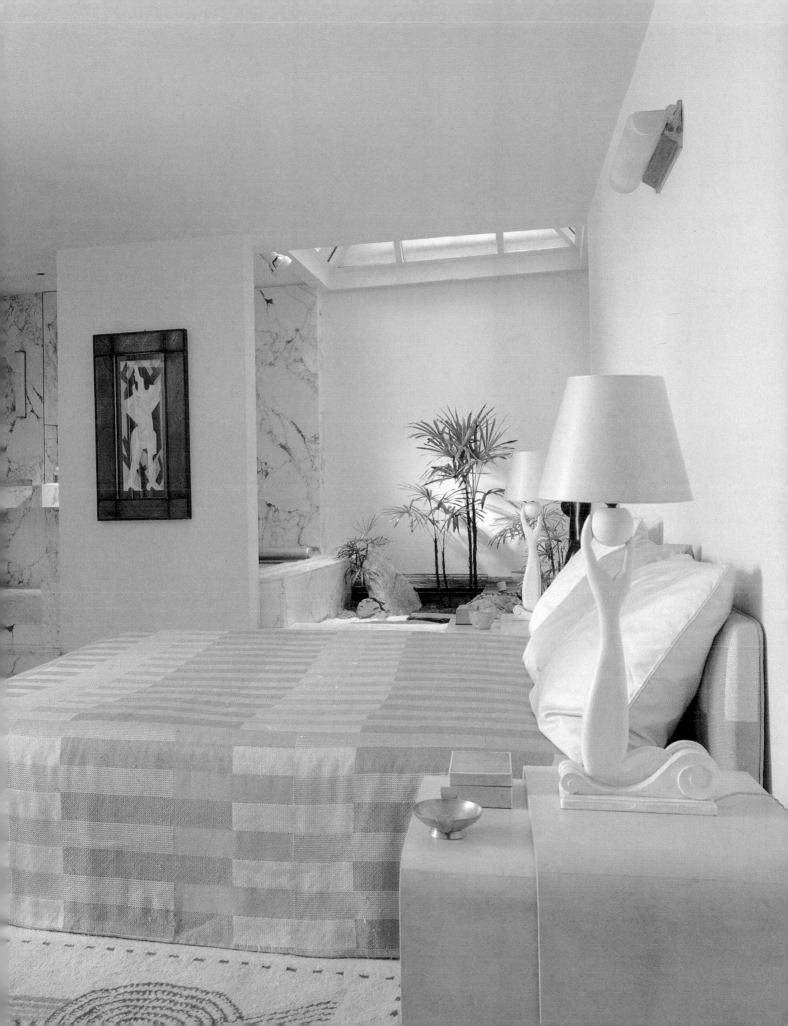

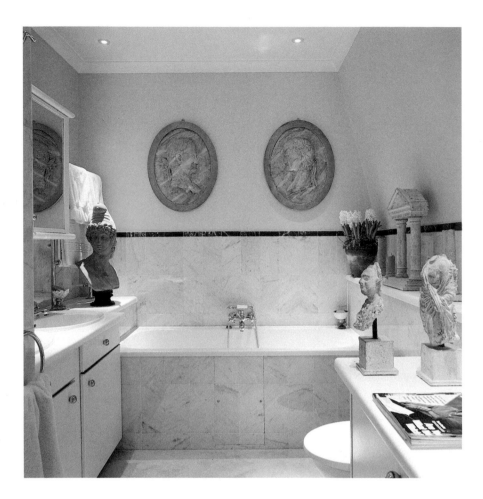

# Bold definition

For a bedroom with a poor view and very little daylight, a vibrantly sunny yellow and a positive style of furnishing are instantly elevating. Here, yellow is dynamically juxtaposed with black and with historical furniture which has bold definition: an Empire commode, a George II mirror and Regency stool. Yellow also forms a good partner for the grey marble in the bathroom where the neoclassical character is established by architectural models, busts and plaques.

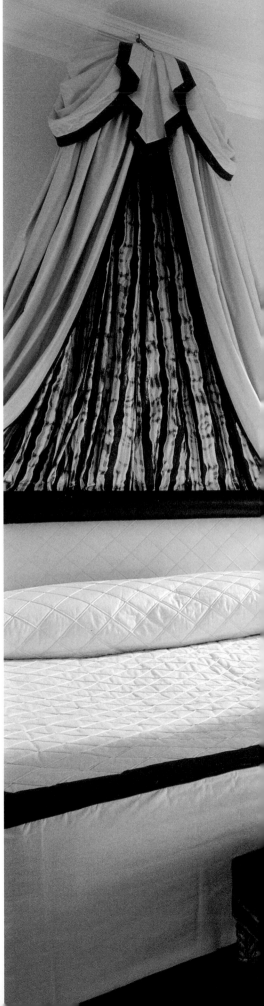

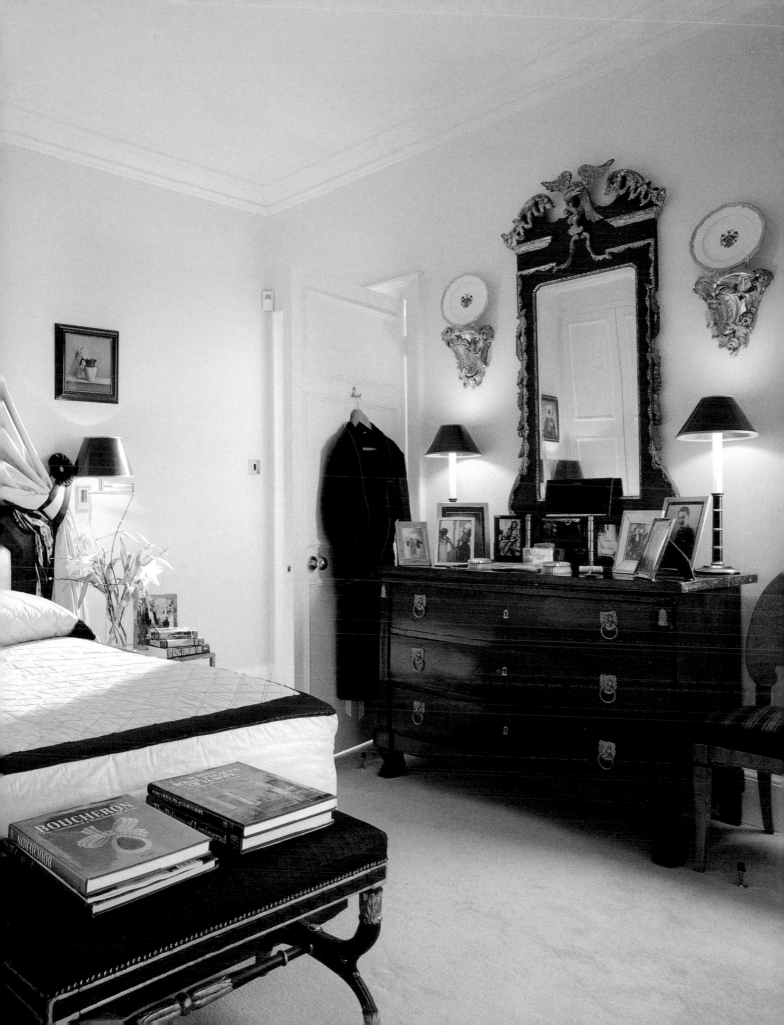

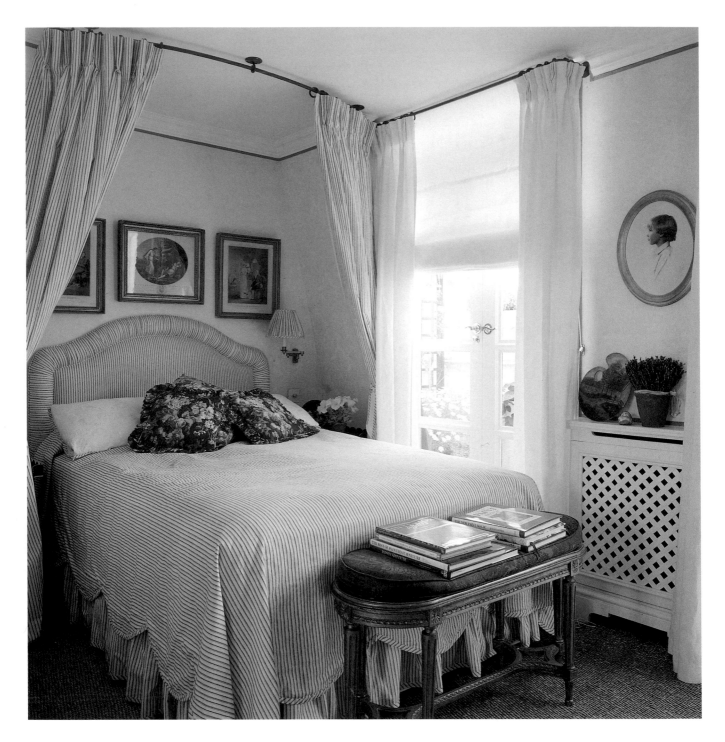

# Clarity of line and colour

It is hard to explain why blue-and-white never palls as a colour scheme when other combinations come and go according to fashion, but this bedroom in a small 1840s terraced house in Chelsea illustrates the point. Designed by Monika Apponyi of MM Design, it is light, chic and extremely refreshing – just the sort of room one would never tire of and always enjoy waking up in. The walls are lined with white damask outlined with braid in the same indigo-blue as the

fabric used on the chair, stool and cushions. The bedroom is separated from the bathroom by a mirror-paned door which matches the doors of the cupboards. The panes are bevelled to give an additional play of light reflected from the windows in the opposite wall. The walls in the bathroom are lined with finely striped blue-and-white cotton to co-ordinate with the bedhangings, bedcover and – a pretty detail – the shades on the wall-lamps to either side of the bed.

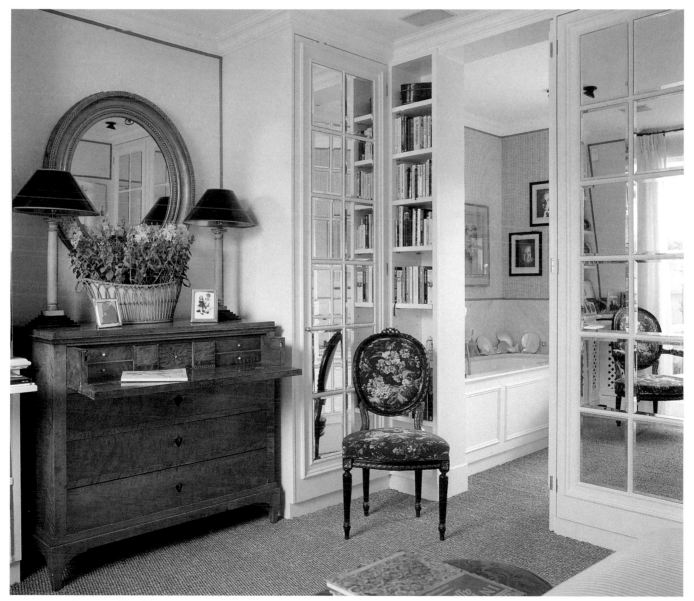

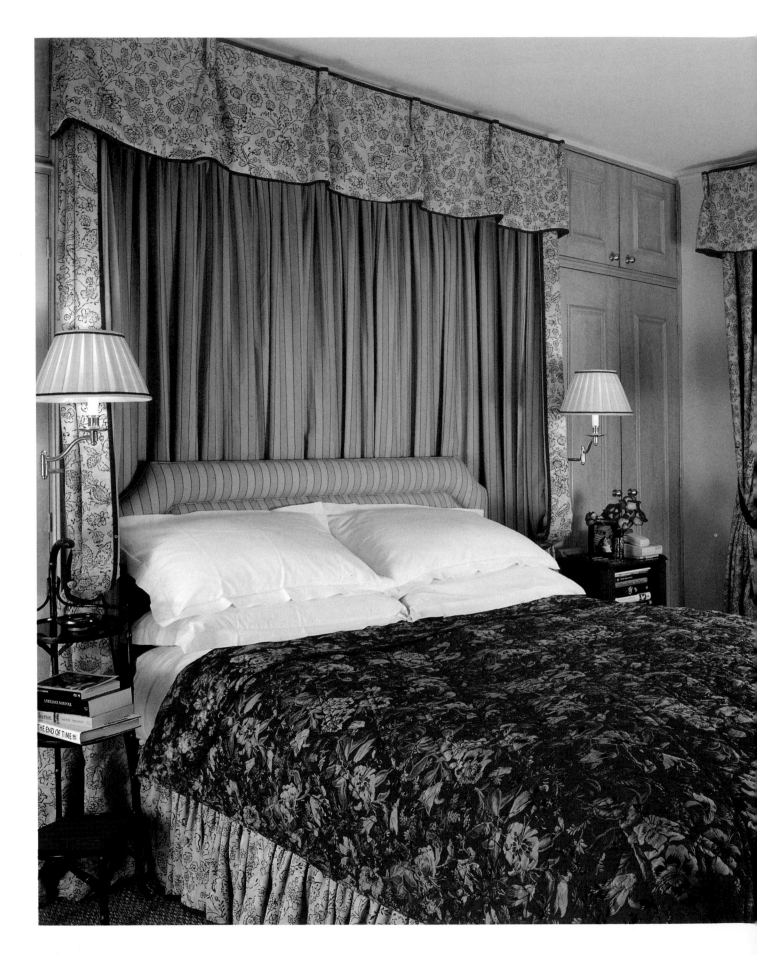

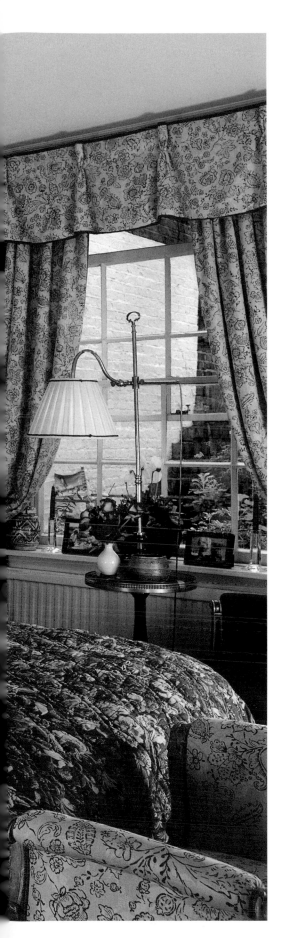

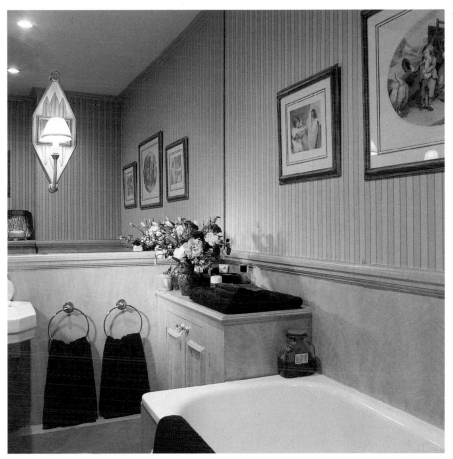

# An interchange
# of patterns

The combination of textiles in this bedroom decorated by
Christophe Gollut is subtle and sophisticated. The fine Victorian
quilt, with its clearly defined flowers on a red background,
cohabits very comfortably with the paler curtain fabric. Like the
pelmets of the window and above the bed – which are unusual
for having such widely-spaced pleats – the curtains have a
narrow, red edging. The headboard and backing wall are lined
with a striped fabric echoing the colours of the flower patterns
and repeated on the walls of the bathroom. The cupboards in the
bedroom already existed when Christophe Gollut took over the
flat's decoration, but he improved them with mouldings and
commissioned Douglas Perryman to give them a bleached
mahogany paint finish, which has also been applied to the
woodwork and dado in the bathroom. Here, a wall-lamp is
stylishly superimposed on a sheet of mirror.

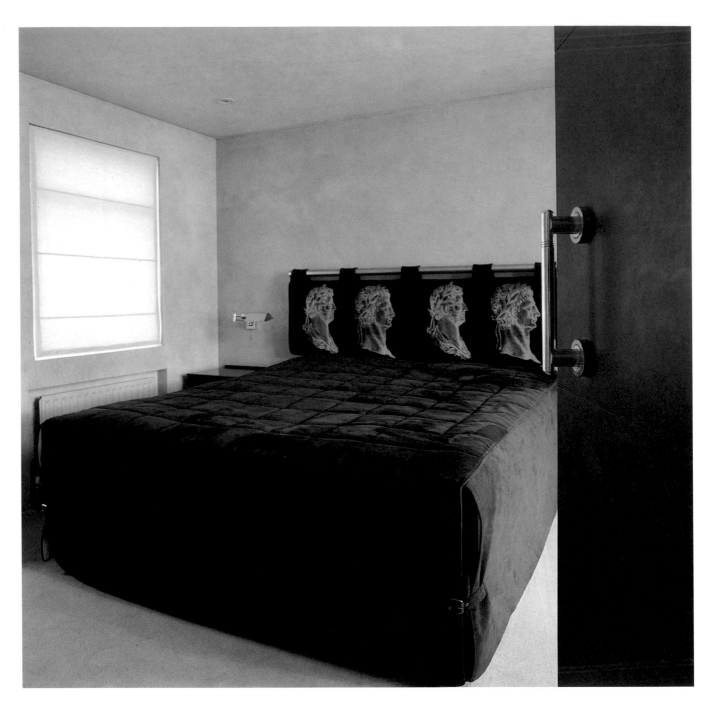

# Plain and perfectly finished

The concept of having a bedroom and bathroom en-suite is associated with luxury and, more often than not, suggests an elaborate style of decoration. Here, however, the scheme is strikingly 'undecorated' – in as much as there are no frills, no drapes - yet it appears anything but spartan. The key to its success is the use of interesting finishes and gentle textures as counterbalances to the sharpness of the architecture and the large areas of tonal contrast. The wall finish throughout is the work of the flat's owner and interior designer, Mauro Perucchetti, who has used a mixture of marble dust, lime,

pigments, glue and cement to create an effect that is reminiscent of the pinkish plaster seen in old houses in Italy. It is a wonderfully calm background for the scheme's intrinsically masculine design. The bed has a tailored, black suede-effect cover and an upholstered headboard using a fabric printed with busts of Roman emperors. The skylit bathroom and adjoining shower-room have an equally graphic character, with black being the choice for the Italian granite used on the units. Even the frames of the large botanical prints take up the black theme.

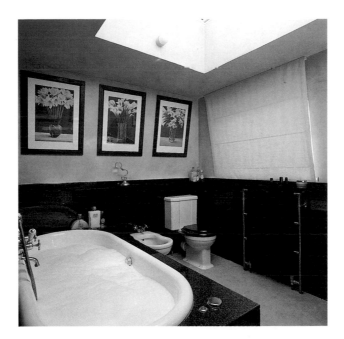

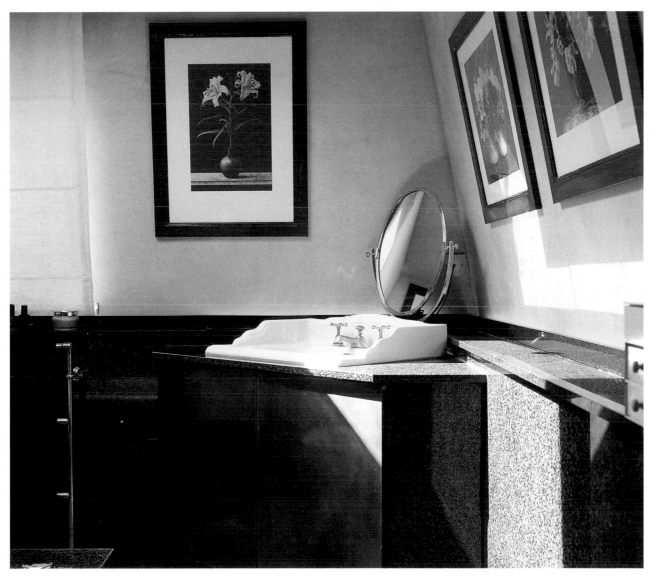

# Decoration detail: Cupboards

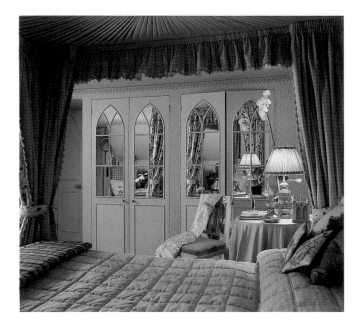

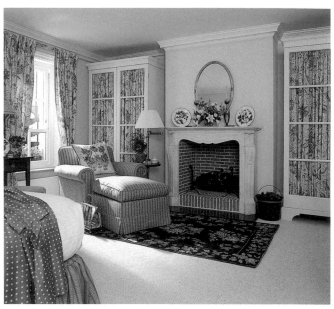

Following the lightheartedly gothic theme in her top-floor bedroom (see page 188), Louisa Pipe gave the mirror-faced cupboards a pointed-arch motif - an effective means of integrating the doors within the room's overall scheme and avoiding the blank, uniform look of ordinary fitted cupboards.

Rather than fill the alcoves to either side of the chimneybreast with conventional built-in cupboards, Joanna Wood designed free-standing wardrobes with panels of chicken-wire revealing a fresh blue-and-white print. Light and elegant, they are an imaginative and functional way of uplifting a room.

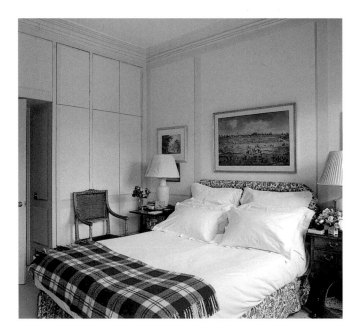

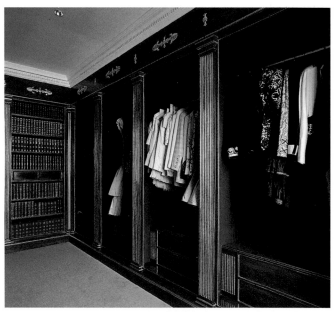

Paintwork which simulates panelling skilfully conceals cupboards on the wall to the left of the bed whilst giving the room an all-round harmony of design. The blue-and-cream colour scheme projects a cool, light ambience, enhanced by white linen. Interior designer: George Cooper.

André de Cacqueray gave this dressing-room a nineteenth-century Russian Imperial look. Melamine fittings have been painted to simulate mahogany, then polished and gilded by Francois Lavenir. The blue interiors of the cupboards and the leather bookbindings add to the exotic, regal splendour.

# Decoration detail: Cupboards

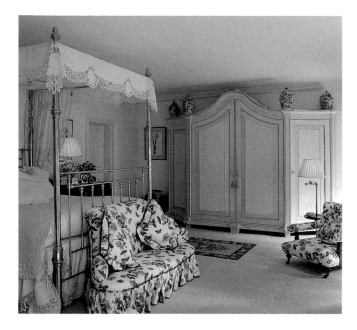

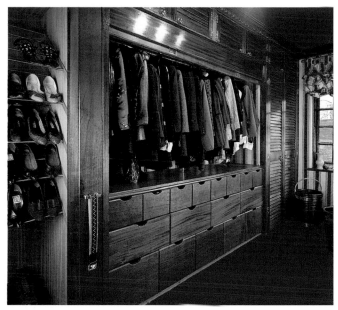

This impressive armoire with upswept top was designed by Victoria Waymouth as an alternative to fitted cupboards in a London basement bedroom (see, too, page 219) with a traditional country-house character. The wardrobes also make handsome staging for Chinese pots.

Designed by Martin and Judith Miller, this dressing-room is richly wooded and impeccably thought-out. The hanging-rail and shoe-rack are at a convenient height for access, and they allow for additional storage beneath. There is an ingenious full-length, pull-out mirror to the right of the shoe-rack.

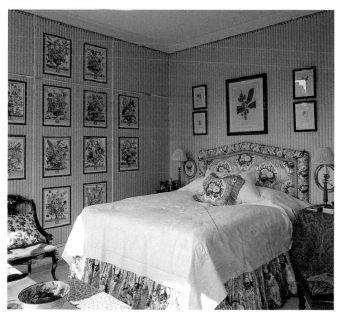

The art of disguise: Joanna Wood lined a tiny dressing-room with a pretty chintz, taking the fabric right across the cupboard doors to create an uninterrupted flow of pattern and conceal the room's essentially functional role. An antique stand provides a useful mirror and takes up very little space.

Striped wallpaper outlined with a fan edging creates a formal background for a mass of flowers in a bedroom designed by Katharine Fortescue. The flat-fronted cupboard doors have been transformed into a gallery of floral prints applied straight onto the surface and framed with a paper border.

# Decoration detail: Dressing tables

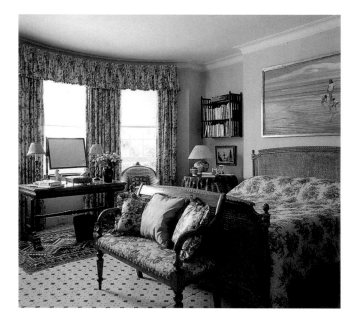

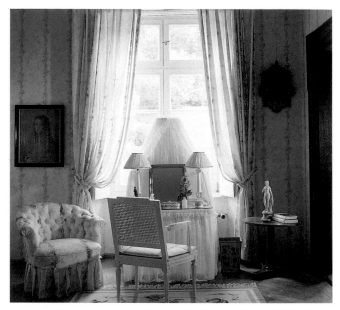

Not wanting a frilly, chintzy style of decoration, Jo Robinson chose plain walls as a background to a more temperate scheme incorporating a fine George IV burr walnut library table used as a dressing-table. Placed in the window bay, it receives good natural light and suits the proportions.

Swathed in a cloud of soft, white muslin, this feminine dressing-table in a Bavarian castle decorated by Alan Jones evokes the late eighteenth century. The crib-like canopy reduces the glare but allows adequate daylight to fall directly onto the face and thus give good definition.

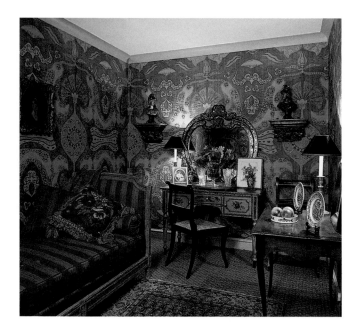

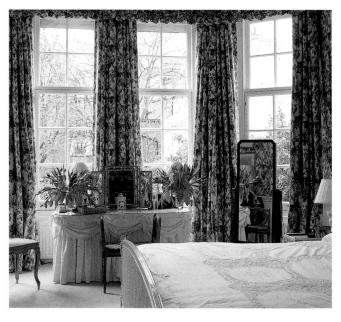

A painted Regency desk makes a masculine-style dressing-table in antiques dealer Charles Aubertin's bedroom. The lacquered Dutch mirror is appropriately flamboyant in context with an elaborate wallpaper and boldly striped fabric. A pair of Empire candlesticks has been converted to lamps.

This skirted dressing-table was specially made to complement the width of the window bay. Swagged fabric, held by bows, emphasizes the gentle curve of the table corners, while plate-glass is a practical protection for the fabric-covered top. A triptych looking-glass is decorative and gives good vision.

# Decoration detail: Dressing tables

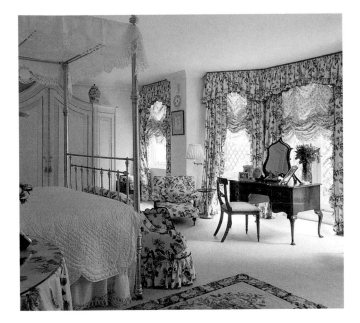

With knee-hole and drawers, this eighteenth-century table could have been designed for writing or dressing. Throughout the 1700s, 'toilet glasses' were very much in vogue, especially the oval and shield-shaped designs. The 'skeleton' one in this setting by Victoria Waymouth goes well with the furniture.

Combined with a check fabric on the walls, a gentleman's antique dressing-table with angular lines and inlaid decoration gives a masculine countenance to a bedrooom by Joanna Wood. The prieu-dieus, lamps and pictures are arranged symmetrically to maintain the orderly look.

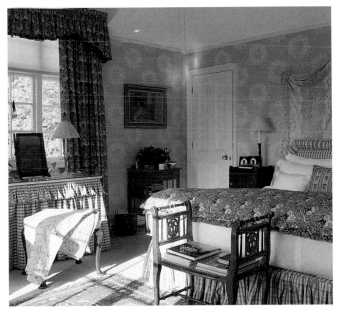

Hinged designs for dressing-tables were common in the late eighteenth century. This Edwardian reproduction in a dressing-room at Ralph Lauren in Bond Street has wings and flaps which, when folded in, disguise the furniture's function and create the appearance of an elegant side-table.

This curtained dressing-table is feminine without being over-flouncy, an effect achieved by the astute choice of an unfussy, check fabric in pretty but muted shades of yellow, blue and brown. The same fabric is used for the bed valance and headboard. The room was designed by John McCall.

# Decoration detail: Bedside tables

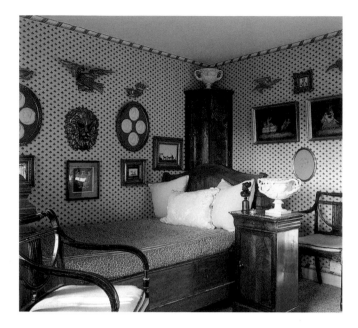

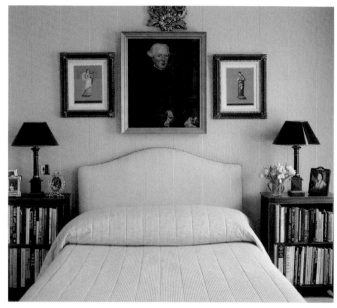

In a dressing-room decorated with marble reliefs, silhouettes and gilded ornaments against a boldly geometric wallpaper, the nineteenth-century bed is positioned centrally against the wall, and the bedside cabinet is placed alongside it in the middle of the room, in the traditional manner.

With their top surfaces at the right height for lamps, and with two shelves beneath for books, this pair of tables is the answer for anyone who likes reading in bed. Their setting, smartly decked in blue-and-white ticking, was devised by Kath Kidston for David Sassoon's apartment in Chelsea.

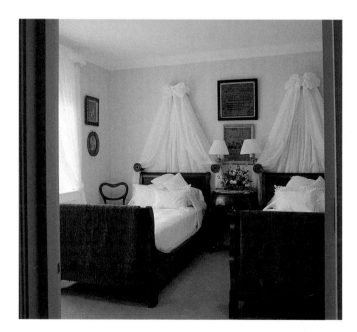

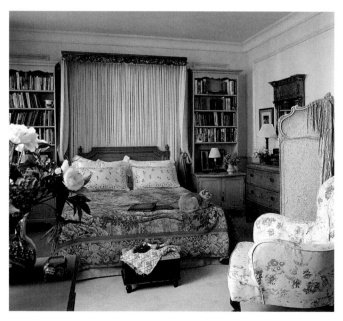

In a small guest-room at the top of a house in London, twin sleigh-beds are romantically canopied in white voile. To save space, there is only one bedside table - a marble-topped commode with a solid, continental character in affinity with the beds. Interior design by Joanna Wood.

Designed by Sasha Waddell, the tall, bedside bookcases in Sian Phillips' flat were given a special 'green stone' paint finish. The bookcases create an alcove effect for the bed, while the projecting cupboards at the bottom provide practical storage space as well as a surface for lamps, a clock, etc.

# Decoration detail: Bedside tables

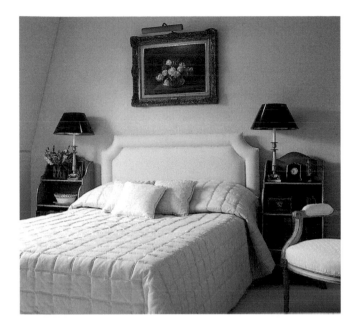

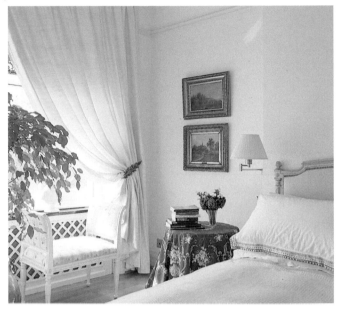

With stepped tiers and a single drawer at the bottom, the design of these bedside tables was inspired by Regency bookshelves. The tables were gessoed and gilded to simulate an antique look, in keeping with the other pieces in the room, which was designed by Marie-Luis Charmat.

White and cream are the main colours here, but the hint of blue on the pillowcase picks up the background of the cloth on the circular bedside table. In tune with the room's serene, light ambience, the fabric is pretty and bright, and it contributes a pleasing element of pattern.

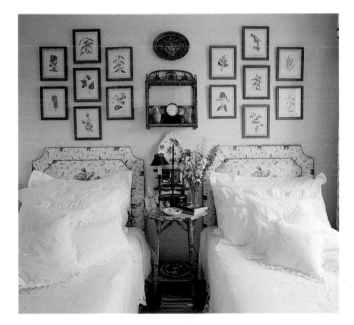

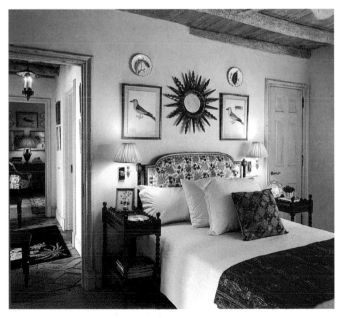

A Victorian bamboo table and hanging shelves are charming and appropriate in this guest-room in a small cottage in Wales. In combination with closely grouped flower prints, a light chintz and lots of decorative objects, they have just the right feeling in an informal setting.

With limited space between the doors, the bedside tables in this room decorated by David Easton needed to be very narrow. Rather than have uncomfortably small, square tables, he chose these rectangular ones, which have a particularly agreeable form, and he placed them end-on to the wall.

# Decoration detail: Bedheads

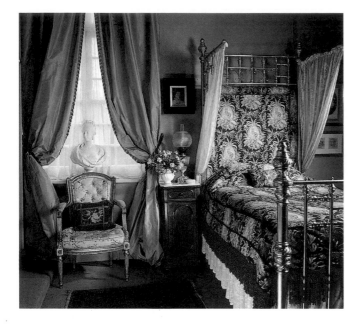

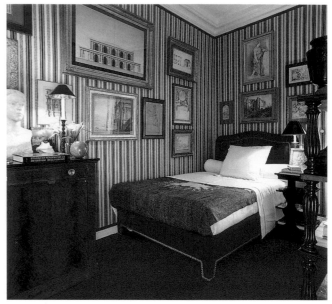

Ultimate nostalgia: this Victorian brass bedstead has antique lace curtains and an upholstered panel using the same fabric as the bedcover – a scenic print which tones with the grey silk taffeta at the windows. The bed has a valance of deep fringing and lace. Interior designer: Jonathan Hudson.

The brass-studded decoration on the felt bedhead in Etienne Dumont's apartment in Paris was designed by Pierre-Hervé Walbaum to complement the treatment of the base of the bed and to create an urban, tailored look which relates well to the formality of the striped wallcovering.

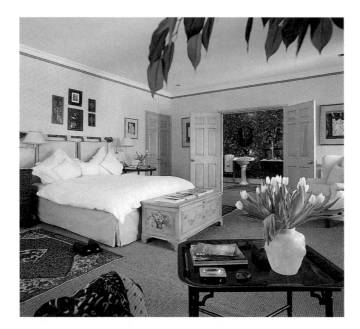

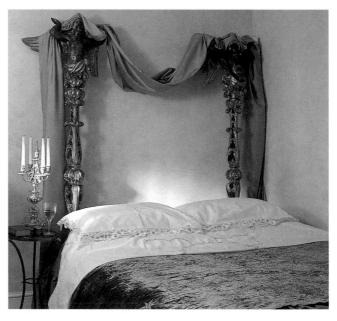

Simple and comfortable, this bedhead comprises two large cushions and a fabric-covered pole. The cushions are covered in the same material as the valance and are cheerfully piped in red. The blanket chest at the foot of the bed unites all the colours of the room, which was designed by Simon Lowe.

Two antique Venetian gilded and silvered bedposts support a swathe of grey-blue silk in this dramatic arrangement by Katherina Harlow and Paolo Antonio Guidi of Fine Art Interiors. To complement it, the silver velvet bedcover is hand-printed with silver stars.

# Decoration detail: Bedheads

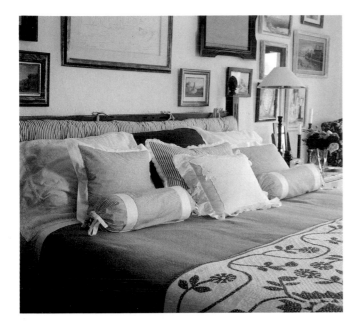

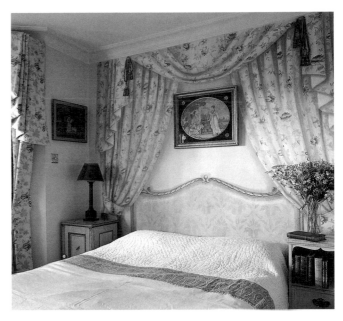

Blue-and-white men's striped shirting, interspersed with plain fabrics, makes an effective medley on this cushion-covered bed in a house in Majorca decorated by Princess Tatiana of Hesse. The blue-painted wooden headboard is softened by a thick pad tied to the upper rail.

It's all an illusion: unable to find a bedhead to his taste, Peter Farlow used his skills as an artist to paint a *trompe l'oeil* one on the wall, complete with 'curtains' copied from the real fabric at the windows. Only the black-framed Regency woven silk picture is not a fake.

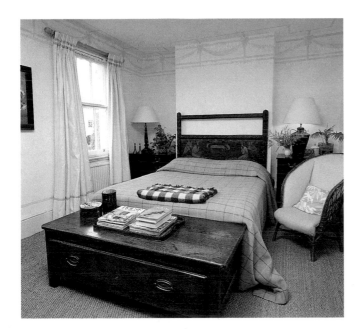

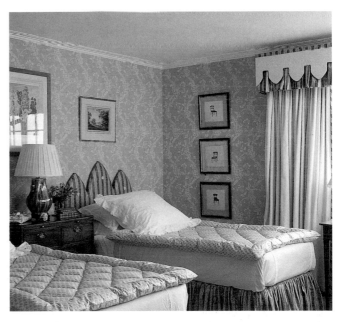

Off-set by neutral-toned checks and flooring, the angel headboard is a striking centrepiece in this setting designed by Tim Vaughan as a calm antidote to the city traffic outside. The wall decoration, continued as horizontal stripes across the curtains, is especially charming.

The points to note about this headboard are the amusing gothic outline (echoing the points of the window pelment) and the link it establishes between other areas of the room's decoration. The same fabric is used as a valance, curtain edging and pelmet backing. Interior designer: John McCall.

# Acknowledgements

## Photographs

Peter Aprahamian 64, 65, 96, 172, 173, 174, 175, 176, 177, 216 (top right), 218 (bottom left), 222 (bottom right)

Tim Beddow 219 (bottom right), 223 (bottom right)

Simon Brown 2, 19, 28, 29, 37, 40, 41, 168, 169, 190, 191, 214, 215

Henry Bourne 221 (top right)

Tim Clinch 18, 144, 145

Michael Dunne 223 (bottom left)

Andreas von Einsiedel 5 (middle), 6, 9, 16, 17, 24, 33, 38, 39, 44, 45, 47, 68, 69, 70, 71, 72, 73, 74, 75, 76, 77, 78, 79, 80, 94, 95, 108, 109, 114, 115, 116, 117, 118, 120, 121, 122, 123, 126, 127, 128, 129, 134, 135, 136, 137, 138, 139, 146, 147, 150, 151, 152, 153, 154, 155, 156, 157, 158, 159, 162, 163, 164, 165, 166, 167, 170, 171, 180, 181, 186, 187, 188, 189, 192, 193, 194, 195, 196, 197, 198, 199, 202, 203, 204, 205, 206, 207, 208, 209, 210, 211, 216 (top left, bottom right), 218 (top left), 220 (top right), 221 (bottom left), 222 (top left, top right, bottom left), 223 (top left),

Mark Fiennes 26, 27

John Hollingshead 219 (bottom left)

Tim Imrie 221 (top left)

Gavin Kingcome 30, 31,

Robin Matthews 5 (right), 32, 92, 93, 223 (top right)

James Mortimer 220 (bottom right)

Keith Scott Morton 10, 11, 12, 13, 20, 22, 23, 34, 35, 58, 59, 62, 63, 66, 67, 81, 82, 83, 85, 98, 99, 100, 101, 104, 105, 124, 125, 130, 131, 132, 133, 221 (bottom right)

David Radcliffe 14

Trevor Richards 15, 86, 87

Christopher Simon Sykes 42, 43, 49, 84, 112, 113,

Fritz von der Schulenberg 5 (left), 21, 36, 46, 50, 51, 52, 53, 54, 55, 56, 57, 60, 61, 88, 89, 90, 91, 97, 102, 103, 110, 111, 119, 140, 141, 142, 143, 148, 149, 160, 161, 178, 179, 182, 183, 200, 201, 212, 213, 216 (bottom left), 217 (top left, top right, bottom left, bottom right), 218 (top right, bottom right), 219 (top left, top right), 220 (bottom left)

Simon Upton 8, 25, 48, 184, 185, 220 (top left)

William Waldron 106, 107

Some of the photographs are by courtesy of The Interior Archive.

Many of the rooms illustrated in this book are from features researched originally for *House & Garden* by Lavinia Bolton (Locations Editor), Sally Griffiths and Amanda Harling. Gemma Imi assisted in collating them.